FULL TO THE BRIM WITH FIZZ, GINGER, AND FIERCE DETERMINATION

FULL TO THE BRIM WITH FIZZ, GINGER, AND FIERCE DETERMINATION

A Modern Guide to Independent Filmmaking

TORI BUTLER-HART AND MATTHEW BUTLER-HART

APPLAUSE
THEATRE & CINEMA BOOKS
Guilford, Connecticut

APPLAUSE
THEATRE & CINEMA BOOKS

An imprint of Globe Pequot, the trade division of
The Rowman & Littlefield Publishing Group, Inc.
4501 Forbes Blvd., Ste. 200
Lanham, MD 20706
www.rowman.com

Distributed by NATIONAL BOOK NETWORK

Copyright © 2021 by Tori Butler-Hart and Matthew Butler-Hart

Unless otherwise noted, all photographs are from the authors' personal collection.

All rights reserved. No part of this book may be reproduced in any form or by any electronic or mechanical means, including information storage and retrieval systems, without written permission from the publisher, except by a reviewer who may quote passages in a review.

British Library Cataloguing in Publication Information available

Library of Congress Cataloging-in-Publication Data

Names: Butler-Hart, Tori, author. | Butler-Hart, Matthew, author.
Title: Full to the brim with fizz, ginger, and fierce determination : a modern guide to independent filmmaking / Tori Butler-Hart and Matthew Butler-Hart.
Description: Guilford, Connecticut : Applause, [2021] | Includes index. | Summary: "An all-encompassing guide for any young actor, writer, director, or producer on making it in the modern independent movie business-from a team that's been there and done that" —Provided by publisher.
Identifiers: LCCN 2021010698 (print) | LCCN 2021010699 (ebook) | ISBN 9781493051298 (paperback) | ISBN 9781493051304 (epub)
Subjects: LCSH: Independent films—Production and direction. | Low budget films—Production and direction.
Classification: LCC PN1995.9.P7 B88 2021 (print) | LCC PN1995.9.P7 (ebook) | DDC 791.4302/3—dc23
LC record available at https://lccn.loc.gov/2021010698
LC ebook record available at https://lccn.loc.gov/2021010699

*Dedicated to the brave, bold, and
brilliant supporters of independent filmmaking.*

chock full to the brim with fizz and ginger

—*Bertie Wooster*

Contents

Introduction	ix
1 Waiting, Waiting, What Next? Creating Work	1
2 Buxom Strumpets and Believing in Your Script	23
3 Financing Films: Faking It and Making It	55
4 Pre-Production: Tackling the Traffic Lights	97
5 Production: From Country Houses to Sinking Ships	131
6 Post (It) Notes	169
7 Getting Your Film Out There	199
Glossary	249
Index	261

Contains conversations with the following:

Sir Ian McKellen (*Richard III*)

Stephen Fry (*Bright Young Things*)

Margaret Matheson (*Sid and Nancy / Shell / Iona*)

Gareth Jones (*Lock, Stock and Two Smoking Barrels / Four, Three, Two, One*)

Hong Khaou (*Lilting / Monsoon*)

Aki Omoshaybi (*Real*)

Louis Devereux (*The Rift*)

Kirsty Bell and Phil McKenzie (*Goldfinch*)

Tricia Tuttle (BFI London Film Festival)

Giles Alderson (*The Dare / The Filmmakers Podcast*)

Mike Chapman (*Blue Finch*)

Steven Adams (Alta Global Media)

Introduction

Everyone has a favorite film, for most of us it's probably a favorite few. It's hard to pinpoint exactly what it is we love about each one: the poignant performance of a Hollywood star, the timeless soundtrack that takes you back to wherever you were the first time you heard it; perhaps it's the cinematography, perfectly crafted images that capture your imagination and transport you to a totally different world; or maybe it just makes you smile.

There's no doubt films can be works of art, mirrors of our own existence. They can be life changing, mood altering, and breath-taking. They can also make a lot of money. A quick internet search will tell you that in 2017 UK films earned just over 20 percent of the thirty-nine-billion-dollar global theatrical market. And by 2018 the global film market, including box office and home entertainment revenues, was worth a staggering $136 billion, nearly forty-four billion dollars of which was in North America. That's an appealing pot of money to want to have a share in, but how do you go about it?

At the time that we're writing this book the world is going through huge shifts politically. These changes and uncertainties are being felt in

every field of business in every country, and importantly from our point of view, in the business of making movies. A lot of this book will be coming from a British point of view; Fizz and Ginger Films is a UK independent production company. But as we've begun to bridge the gap to North America, we've seen the similarities of low-budget indie filmmaking on both sides of the pond.

We started talking about writing this book after we realized we were meeting a lot of young or new filmmakers wanting to learn about the business, but often having nowhere to turn for answers. There are many books about filmmaking out there but most either assume you already have a basic knowledge of this huge subject and which only look at things from one perspective, or were written for a time that just doesn't exist anymore by people who were working in a very different landscape. How we've gone about making feature films is unusual and it's certainly not the recognized way of getting things done in the United Kingdom. But that's because if we'd tried to go down the usual route, we'd probably still be making short films.

Okay, but how do you go about making your independent film that is not only a masterpiece in the eyes of even the most discerning of cinema critics, but also a box office success that you actually see some real return on, so that you don't have to work part-time as a yoga teacher or move back in with your parents? What's the key to it? To be honest we're not sure there is just a single key, if any at all. After ten years of running our production company and releasing three feature films, we feel we're only just on the cusp of having a proper understanding of how to navigate our way through this hostile, horribly overcrowded and frankly batshit crazy industry.

In this book we'll delve into the ins and outs, the highs and lows of true independent low-budget filmmaking. This is not a step-by-step guide on to how to make your movie, because every one of your films will be done entirely differently, and in these modern, rapidly changing times,

everyone needs to find their own way of doing it. We're here to help you find that path.

To do that we are looking back on the past ten years of Fizz and Ginger Films' existence, examining our own experiences of producing four feature films that have sold across the world, enjoyed critical and audience acclaim, and exploring what and who has helped us along the way. Through these tales of sleepless months, missed wedding anniversaries, and adventures to film festivals around the world and uninhabited islands, we hope to take you on a journey that is amusing as well as instructive, sometimes by learning what not to do.

This book will give you a very honest guide on how you can go about creating work for yourself. If you're an actor, a writer, a producer, a director, or all of the above, you'll find tips on making a feature film from the beginning script stages of putting finger to keyboard, all the way through to having a movie open in cinemas across the country.

But who are we? We started Fizz and Ginger Films in 2009 after first working together in theatre, and we felt there must be an easier way of telling stories than playing to audiences of five in a tiny theatre behind a sports bar in South London (see figure 1). This set us on the path of making short films for our filmmaking education, which then led to a filmed adaptation of one of the plays we had been producing, which eventually led to full feature films. Both classically trained actors, we forced ourselves to learn as much as we could about all sides of the industry, trying to understand each unique perspective as we went along. After ten years of sacrifice, albeit usually fun sacrifice, we have now hit the 5 percent mark. That 5 percent is the percentage of British filmmakers that ever make three feature films, and we've managed to do it before we're forty (just).

We're not saying this to brag—we still often wonder what on earth we're doing with our lives as friends of ours who have real jobs jet off on another holiday while we're feverishly working away on a new script—but so that hopefully you'll trust us when we lead you through the failures as

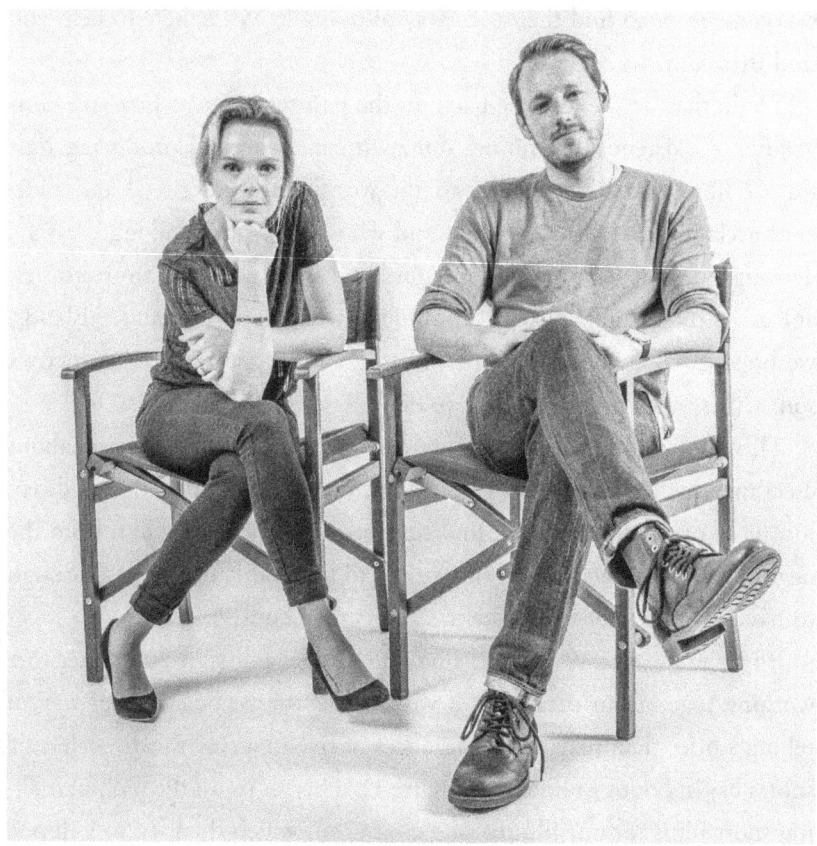

FIGURE 1
Tori and Matthew Butler-Hart (Fizz and Ginger Films)

well as successes, and know that we're still standing, still shooting. And along the way we'll have interviews with actors, writers, producers, and directors so you don't have to just take our word for it.

We are definitely not the holders of the secret key to success (we wish we were). By reading this you won't discover that there's a magic blueprint to filmmaking or an equation or algorithm to producing a sure-fire cash cow (Hollywood has proven that doesn't always work!). But hopefully you'll learn a few things that will help set you on your own film producing path and making mistakes all of your own.

INTRODUCTION xiii

Before we kick things off, we wanted to let you know that this book was finished just before the COVID-19 pandemic hit the world. We bring this up because we're aware that things in the industry have already shifted toward more online content being devoured, which has led to studios deciding to change how they release films. This won't hugely affect the indie world unless independent cinemas don't make it out the other side, and we really hope they do, and in fact it may even open things up more for filmmakers working in this part of the industry. What the pandemic has done has sped up what was already starting to happen anyway, which now makes this book even more relevant!

Another little note is that during the full summer 2020 lockdown in London, we managed to shoot an entire sci-fi feature film, *Infinitum: Subject Unknown*, with cameos from Sir Ian McKellen and Conleth Hill, with only two of us on set. Matt directed, shot, and lit it; Tori acted, production designed, sorted out costumes, and did pretty much everything else. It was a huge amount of work, and we were shooting for about six weeks on incredibly long days, but we've now sold it to countries all around the world.

We had an editor and a visual effects person reviewing the footage as we went along to make sure we weren't making too many mistakes but apart from that we were all alone—and it was the most liberating process we've ever been involved in. At first it was a way to stay sane during the pandemic as the industry had ground to a halt, but it was also a way to experiment with a couple of things we'd been wondering about—could we make a feature film with a tiny crew? (Though we hadn't imagined such a small crew!) And how far could we push an iPhone to make something that would stand up in cinemas. We don't have the space to chat more about the process here, but we wanted to make people aware that it is possible to make a film in this way and to sell it. Hopefully knowing that, along with what's in the rest of this book, will inspire you to go and take the film world by storm!

"The nice thing about independent movies and most independent movie makers is that they want to tell a real story, with real people in real places. They might be like *The Isle*, they might be something rather fantastic, something rather unknown, rather frightening, but that's true of the real world. It doesn't make it any the less real. And I think in a sense that's the crucial gift independent filmmakers can give to the world, is that they can tell stories that are truly credible because they are limited by reality. No one can fly, no one can go invisible, it's not fantasy."

—*Stephen Fry, actor/broadcaster/writer/filmmaker*

1

Waiting, Waiting, What Next? Creating Work

Before we get started properly, we just want to say thanks for reading this and also huge good luck. This, whichever side of the industry you're involved in, is not an easy place to work. And it is work, as much fun as the creative side can be; it's an industry and you have to put a huge amount of effort in, more than you can possibly imagine. But having some control over what you do, having a little power to shape your own future rather than hoping for the best and waiting for the phone to ring to say you're "allowed" to make the project, or be part of the project, feels amazing. We both took different paths to get here, which we'll start by talking about as it'll hopefully show you, for a start, that it's not easy for anyone and that you, from whatever discipline, can work out how to make your own work and then get it out there where it belongs.

We didn't train as filmmakers in the traditional sense of going to film school; we just love film and love telling stories, and we've been doing that with Fizz and Ginger Films since 2009. In the United Kingdom only about 20 percent of filmmakers ever make a second film and only about 5 percent ever make a third. By the time you read this we'll be on the fourth of our own, and we will have worked on various other people's projects

helping to put them together. This is not to boast, although it's bloody hard won so it's nice to say it out loud sometimes, but to show that it can be done and that we're writing this with the knowledge of actually being there and doing it. Not to say that we're going to write "do it like this and you'll succeed," but we're going to take you through the journey of what we've done on the different films, each of which had a very different path as there's no one way of doing it, to show you what worked and what didn't and what we learned from it. The best way of learning is by doing, but hopefully by reading this you'll be able to avoid some of the mistakes we made and get to where you want to be just that little bit faster.

We wanted to write this book because we were always being asked by people for advice on how to get a film made. We were speaking on a panel about how to fund your feature at The British Academy of Film and Television Arts (BAFTA) in London for the Triforce Film Festival, and someone called us "unicorns" (see figure 2). They explained that

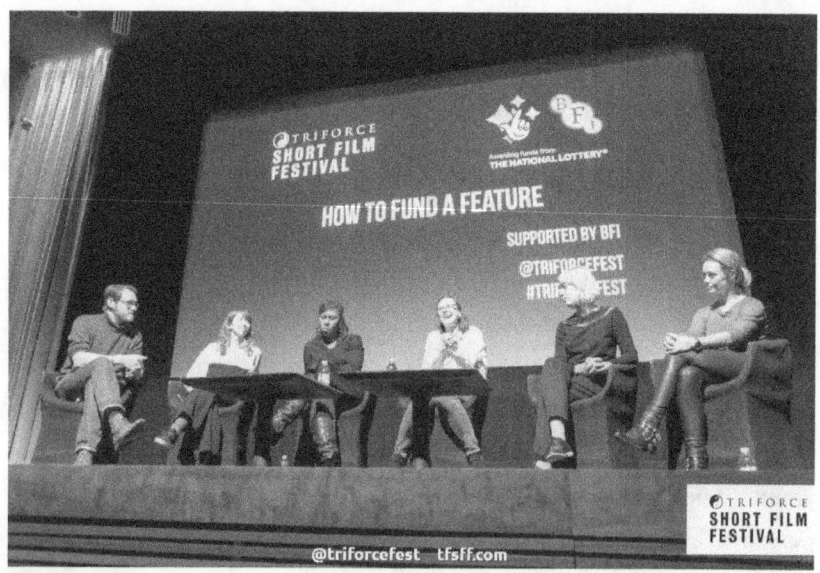

FIGURE 2
Tori and Matt on the Triforce panel at BAFTA

we're very rare in that we go through the entire process ourselves, from writing the script to gathering finance, to making the movie all the way through to festivals and distribution, and not once but several times. People suggested we write down what we'd learned to try and help people create something of their own without relying on "permission" from the powers that be.

We both came from acting backgrounds, so we'll start there and hopefully you'll see why that feeds into what we do, and that with hard work and dogged persistence it is possible to move between the worlds of in front and behind the camera and why having knowledge of all aspects of the industry can only help in whatever area you want to focus on. Although we say do it all and get the best of all worlds! Over to Tori:

I don't know about you, but one of the things I used to dread the most in the first few years after graduating from drama school was seeing old friends, mainly of my parents. It was their faces that said it all, before they'd even opened their mouths. A slight head tilt and furrowed brow followed by the inevitable question every actor (or indeed creative) dreads, "have you had any work recently?" The first question to anyone else who's chosen a career outside of the arts would never be whether you're actually in gainful employment at the present time. However, for those of us who chose a life of perpetual uncertainty, it appears to be considered by some fair game to ask about, what I think, is a fairly sensitive subject.

Either way, there it is, "are you working?" waiting to be answered, every second left hanging, ready to be scooped up along with your self-esteem. There have been many times that I've wanted to answer truthfully, to say "in all honestly I'd prefer it if you didn't ask me that. It makes me feel like a massive failure as more often than not I'm not working as an actor, I'm not auditioning and I'm praying every day that my agent will call with something, anything. On top of that I have the inner voice to remind myself of how much I'm not succeeding, and it's really good at it. And right now, with that seemingly innocent question, you're feeding it." Then

I want to follow on by telling them that a lot of the time I'm battling depression, constantly fighting feelings of jealousy, anger, and injustice.

Instead you smile (you are after all an actor), on goes the mask and you reply, "it's been good, bits and pieces here and there, busy auditioning." You're not, you haven't heard from your agent for about two months, and think to yourself, "shit, must call her. Bloody deckchairs on the *Titanic!*"* There's that expression again as they answer, "It's a tough industry." You have no bloody idea.

What if your answer could instead be, "I'm writing, creating my own work"? There's no longer a stigma attached to actors being writers, producers, or directors. As many have proved and platforms like Netflix and Amazon have championed, you don't have to stick to one job title. We live in a world where competition is fierce, but the business that we've chosen to be a part of (and it is a business, it's important to think of it that way) produces a huge variety of content which the consumer (us, you, everyone on the planet) is watching at a pretty rapid rate. So why shouldn't there be space for your ideas, for your own creation to manifest and sit within the never-ending library of moving pictures?

One of the most daunting things I felt when I first started to write was that there's no way I could. I was quite dyslexic as a child and found reading and writing incredibly challenging. My parents spent a lot of time and effort to help me with my schooling and to overcome my dyslexia, for which I am eternally grateful. Many hours were spent in Oxford having extra lessons, and my wonderful teacher Mrs. Reed (I know, the irony was not lost on me) encouraged me to learn by puzzles and rhymes to help me remember spellings, working out which letters went together to make up which words. Reading and the written word became a journey of discovery for me growing up, and I think it taught me to be inquisitive. This

*This is a phrase that the actor Conleth Hill once used when he was describing a previous agent he'd had in his career, referring to the fact that a lot of agents seem to be as much use as a deckchair would be on the sinking *Titanic*. It's stuck with us.

is not to say that I don't still struggle, but Matt and I write together and he helps to keep a handle on my excessive use of the comma and unusual sentence structuring. We work as a team and that has been the key to how we've achieved what we have.

Matt started writing from a very early age; he was writing plays and making short films from the age of fourteen. That's where I, Matt, jump in; I grew up in various middle-of-nowhere places that offered very little for teenagers to do. It was either hang around bus stops making a nuisance of yourself or go and write silly sketches or short films and put them on at school or film them and force your family to watch them. Well, I'm sure there were other options—no one else was making short films—but you get the idea. Being the outsider forced me to find different ways to entertain myself, and being creative was certainly an outlet. I also learned how to be able to talk to all sorts of different people from different backgrounds, which is very handy when you're working on set with a crew of people from all over the world.

At school, my friends Phil and Adam also loved drama and we would write pretty much every day after school and then we would borrow Phil's uncle's huge old video camera and make little short films, usually horrors from what I remember, and edit them in camera as we didn't know any other way of doing it. I think this may be why I'm so specific about what visuals I choose to be shot for our films as you learn to be very precise when you have to edit that way.

None of these survive as we usually taped over them with more films and eventually things like *Dune* and *Blade Runner* from television. I mention those films because I discovered a way of escaping the little towns we lived in through film, which I think is the case for a lot of filmmakers, getting wrapped up in faraway adventures and extraordinary stories. As I got older this love of watching movies turned into wanting to be a part of them. At first, I thought that was through acting because we were in our plays and films, so we were advised to go off and train as actors. Great,

I thought, I get to be living in that adventure not just watching it; after drama school (I went to a place called Rose Bruford in London purely because Gary Oldman went there!), I acted for about ten years in all sorts of mad films, most of which will never see the light of day. I continued to make short films though, mostly just for fun, but I slowly realized that being an actor wasn't letting me be part of the storytelling enough. You get to do your little bit, which is lots of fun, but I realized it's such a small part of the process and that I actually had very little say over the final story.

So, when I met Tori who was also busy creating her own work, albeit in the theatre, I think we both found someone who could help take the other on the path that we were both looking for. On that note, I'll hand you back over to her, partly because her story of drama school and what happens next is quite similar, so you'll get the idea of where we both came from before we get to the meat of why we're here writing this book.

I, Tori, didn't start writing until I'd left drama school. I remember vividly the first day I arrived at what is now known as The Royal Central School of Speech and Drama in Swiss Cottage, London. The head of the drama school gave us his opening speech and it went something like this:

"You are all talented. That is not in doubt. The twenty-six of you have been successfully chosen from over a thousand applicants to be part of this BA Acting hons course at one of the top drama schools in the world. You are at the beginning of your careers, by the time you leave in three years' time one or two of you will probably have dropped out [I thought to myself, not me]. Just one year after graduating two or three more of you will have given up [not me]. Five years and half of you will no longer be working as actors [not me]. Ten years and only between five to ten of you will still be working in the industry [that'll be me]. One of you might be a star [that's definitely me]." The thing is we were all thinking the same thing of course. We were young, ambitious, and had no idea how tough it would be.

It was a pretty good speech, and much better than how I've just paraphrased it, but you get the idea. And he was pretty much spot on. The

problem was that after the three years of a really excellent training in acting, we were totally unprepared for the business that awaited us. Getting a good agent was the be-all and end-all and after that, you just had to keep your fingers crossed and hope to get the auditions that would come rolling in. And for a select few, that's exactly what happened. For the rest of us it was disappointment after crushing disappointment. Rejection after rejection from agents. Auditions that were so infrequent that you were a nervous, babbling, desperate mess by the time you got in front of a casting director and lacking the confidence to believe in yourself and your ability. An age-old saying that I still remind myself of occasionally is "there's no deodorant for desperation," and it's true, but more for your own sanity than anything else.

But above all, I was so ill-equipped to deal with the mental pressure of being an unemployed actor. In my final year of drama school, I suffered from an eating disorder which became my coping mechanism to deal with a career that felt so totally out of my hands. I couldn't control what job I would be doing or audition I would get, but I could control what I fed myself. And that uncertainty and anxiety made me feel so full up, that there was no possible space for anything else, including food. Not to mention the physical aspect of wanting to be the thinnest and the prettiest because that's what gets you the top agents and the top jobs (of course, it doesn't).

We were totally let down by the failure to be introduced to the idea and possibility that we could create our own work. Where was the workshop on script writing? Or the seminar on how a set works and who does what? Receiving instructions on how to act or how you might move as an animal* is all well and good but is next to useless when you're faced with the inevitable stints of unemployment. It was actually my dad who came

*This might seem totally obscure but for a lot of drama students many hours are spent scrutinizing the poor long-suffering animals of London Zoo. Weeks are spent in the freezing cold on all fours crawling around while bemused tourists watch on.

up with the idea to start a theatre company. He hadn't been involved in the theatre at all previously; I don't come from a long dynasty of acting greats. My dad was a businessman, but he was hugely supportive, not just of me, but also my peers, and it frustrated him to see so many talented actors not working. The death of repertory theatre in the United Kingdom has diminished many opportunities for young actors to learn their craft. Gone are the days when the likes of Sir Ian McKellen would tour around the country performing up to eight plays in rep, each with their own challenges and company camaraderie that comes with it.

"I'm less frightened of films than I used to be. I used to be terrified of the whole thing. Such a strange country, so different from the theatre . . . now with modern technology I say to kids all the time, make your own films for free! If I was starting out now I think I would be filming myself and my friends all the time. You can learn how to act for the camera without going to a class just by watching yourself. It's amazing! The greatest gift young filmmakers have is that they can make a film for free on their phones."

—*Ian McKellen, actor/producer*

Being a creative, be it an actor, a writer, or a director, can be extremely lonely. It is also, in order to successfully execute any of these roles, dependent on having other people around you. A crew or company. An actor can't do anything without a script, so cue the writer. A writer's play or screenplay won't do anything sitting on the kitchen table; it needs a cast and director to bring it to life. And a director has nothing to do unless they have their crew and actors ready and waiting to shoot the film or rehearse the play. And yet it's amazing how often we hear from people asking us "what should I be doing to make my own work?" or "where do I start?" First of all, find your team. Find someone who will encourage you to keep writing or give helpful and constructive feedback. Or find someone to write with, who picks up where you've left off, who complements your

weaknesses with their strengths. Find someone who has a similar vision for a play or a script, who wants to help you create something. Because it is so much easier in a team than trying to make something happen on your own.

"I love working with other people because you get better results; I'm envious of you two working together. To any young filmmaker try and find partners to work with and you'll go on different journeys, and that's fine, because it can be lonely."

—*Giles Alderson, director/actor*

My journey began with my dad, Chris. He had a fascination with the 1700s and with the wealth of plays that the period has to offer. Historically it was an affluent time for theatre and the Georgians loved farcical, larger-than-life characters with fabulous costumes and somewhat meandering plots. They would go to the theatre for an entire evening's entertainment and see not just one play, but two. To begin, something fairly highbrow and well known, like a Shakespeare, and then following it would be an afterpiece. This was a short, second play, that would be cheaper and a little easier to follow, so the poorer members of society could pay to see just that afterpiece. There are hundreds of these short plays and my father, after reading many of them, wanted to bring them back, in the open air of glorious English summer evenings. Needless to say, most of our performances were in the pouring rain, where the British stoicism shone much brighter than the sun, as our audience sat shivering, huddled under umbrellas, eating soggy smoked salmon sandwiches.

This is where my producing began. The company was based more on an original touring company, with one of the actors directing the piece. We would do two afterpieces, with an interval in between the two. The second would be directed by someone who had acted in the first. Once we had our willing directors, we then cast the remaining roles from people I had trained with or by putting a call out on Mandy (an online casting database).

We then held auditions and organized small and (importantly) very cheap spaces to rehearse in. Everything was on a very low budget, but what we did invest in were some amazing costumes. Most were handmade, whereas others were hired just for the run. My mother, an artist and art historian, made sure that the costumes were true to the period and was head of design for costumes, props, and set.

In 2008 we put on our first play, *The Rivals*, and that's where Matt and I met. In fact, we very nearly only met just the once. We'd put a call out for auditions which were held at The Central School of Speech and Drama where I'd trained and Matt was coming along to audition for the role of Faulkland. However, he had competition and one of the other actors was successfully offered the role instead of Matt. Not because he was any more talented, but because another cast member who was sitting in on the auditions fancied the other actor. We were the height of professionalism back then of course and the prospect of spending several weeks of the summer rehearsing, touring, and camping with a potential fling far outweighed who was more suited to the part.

Luckily for us the actor who was set to play Faulkland was offered a higher profiled and much better paid job that clashed, so quite sensibly he took that. It was then down to me as the producer to have the awful job of calling our "runner-up," having only a week before said that we'd decided to go with someone else, and plead with him to consider taking the role that we were now offering to him. Matt, being the lovely, understanding, and self-effacing man that he is, said he'd be delighted to.

And that was the beginning of us working together. While standing in the pouring rain, with the dye from my blue feathers running down my face and us all shivering with the cold but pushing on regardless, Matt had a flash of inspiration. "What if we were all dressed like this but zombies?!" And that was really where the idea of wanting to make films began, in the rain in Oxfordshire in the middle of an open-air production of *The Rivals*.

The little theatre company that I ran with my dad produced four plays: *The Rivals* by Sheridan, *Love's Last Shift* by Colley Cibber, *A Will and No Will* by Charles Macklin (the first and last time I have ever directed), and *Miss in Her Teens* by David Garrick. I won't say that I'll never produce theatre again, and quite often I have a sudden urge to want to produce my own one-woman show, but to be honest it's an incredibly easy way to pour money down the drain and once it's gone it's gone, the show is over and that's it. Now this is definitely not the point that we say, "whereas with film you make so much money you don't know what to do with it!" No. It's just you've still got something to show for it afterward, a commodity that you can continue to sell for years to come. At least that's the theory anyway.

So Matt's idea of us all being zombies evolved into the short film, our first together, called *E'gad, Zombies!* This twenty-minute short was filmed on next-to-no budget. The costumes were from the theatre company, the actors were all friends, Matt directed, and our locations were places that we knew, such as Wroxton Abbey in Oxfordshire—we'd performed the plays there and it was close to my parents' place, so camping in the garden was our accommodation, and catering was by Chris, my dad, who still to this day caters for the odd shoot. As the classic saying goes, we begged, borrowed, and stole to make this film, and made sure that it was all in manageable locations that were close and that we knew so could adapt the script to.

The synopsis of *E'gad Zombies!* goes something like this: 1700s-ish, Oxfordshire, England. In the sleepy town of Upper Trollop there lives a poet named William Filthe. He is in love with the beautiful but slightly terrifying Vanity Banks and although she is engaged to his brother, William is blinded by love. One night, however, an illness breaks out and turns all men into beasts. All thoughts of love understandably vanish when you're running from an unstoppable foe in rather a lot of lace . . .

We shot it on a Canon XL5, which filmed onto mini DV tapes. Yes, old school! It took us about five days in total and the bulk of the film was on location in Oxfordshire. However, to finish the film we decided that a small cameo from a well-known actor would be a great way to get the film noticed and out there. This is a tried and tested trick of the business, and it really does help. Bankable is a term that is used a lot in the industry; it basically refers to if an actor's name, once on a poster, will help sell the film or not. An actor's bankability will change, and there's always space for new rising stars, but then they too can quickly fade; in fact it's kind of amazing how few actors are really "bankable" these days. However, if you have access to a well-known name who might just do a favor for you if they like the script and turn up for an afternoon's filming, then take the opportunity and grab them.

If you don't know them personally, do your research and see if there's a way you can get a script to them, maybe through an agent or manager. Most actors want to act at the end of the day, and a lot of well-established names like supporting new and emerging talent, so it's definitely worth doing the research and asking. The worst they can say is no. And you're a creative, you're used to hearing that all the time anyway.

When Matt was a young actor, recently having graduated from Rose Bruford, he lived in Rotherhithe in South London and just over the river from him lived Sir Ian McKellen. Matt bumped into him a few times in a local shop and somehow (he'll explain in a bit) they started talking. Ian offered Matt the job of helping him learn his lines for a little film he was about to go and shoot in Paris called *The Da Vinci Code*.

Hi, Matt here. Well, it wasn't that quick, I helped Ian learn lines for a few things and for a while got to read through scripts to see if they were worth bothering Ian with, and being a young actor I loved listening to stories of the days of repertory theatre, trying to learn anything I could. One day I got a panicky phone call late at night from Ian saying they'd changed the schedule of *The Da Vinci Code* because of the weather and

instead of having two more weeks to learn his lines somewhere in France, they wanted him the next day for some huge scenes. So he asked if I was free and could come to set as his assistant and help him learn his lines. This was too good an opportunity to miss and for the next few months I sat around set ready to rehearse the next section, which they kept changing much to Ian's annoyance but my joy as it meant I was kept around for longer! While I was there, and it was the biggest production I'd ever been in close contact with, I started talking to people behind the scenes finding out what they did and how they did it. Sometimes someone would think I was an actual assistant and try and get me to do something, the fools, which I would usually mess up, but on the whole if I wasn't going through lines with Ian I wandered around trying to learn as much as I could.

"Can you believe people can spend a whole career acting in front of a camera and not understand the lenses and I'm one of them. Well how much more interesting people who do understand, they're much more engaged than I am. They're interested in the process and understand more. Your best friend on the set is probably not the director but the DP, the good DPs will ask you to inch over and you ask why and they say come and have a look and they'll show you the frame. It makes it more interesting and less terrifying."

—Ian McKellen

I was also able to watch brilliant actors like Tom Hanks, Audrey Tautou, Jean Reno, and Paul Bettany, to name a few, and see how they approached the script and why. And, of course I could watch Ron Howard at work, and I should have realized that I wanted to be on the other side of the camera as I was fascinated by watching him slowly create the story, putting it together piece by piece. Ian knew I was loving learning while I was on set but I don't think he realized that I was becoming more and more interested on all the other things that weren't necessarily connected directly with acting. OK, back to Tori.

FIGURE 3
Ian McKellen playing the Narrator in *E'gad Zombies!*

Ian is a wonderful man and supports huge numbers of amazing causes and charities, as well as many young people in the arts, and he has been an invaluable support to us. Among these occasions was when he agreed to play the role of the "Narrator" in *E'gad, Zombies!* (see figure 3). We wanted that classic moment at the end of the film when someone wakes up and it was all a dream. Yes, a little naff and predictable, and yes it was probably because we couldn't really think of a strong enough ending, but also because we just thought it would be great to get Ian McKellen in bed with a zombie. And that's exactly what we did. Because of this we suddenly had a unique selling point to our short film. It wasn't just a zombie comedy, and it wasn't just a zombie comedy in period costume, but it was a zombie comedy in period costume with Ian McKellen. This meant that our little, tiny, no-budget short got way more press and exposure than either of us had expected. We were proud of our film; it was well put together; it looked great because of the locations that we'd had access to, giving it a more expensive look; the people we had working on it knew what they were doing; the acting was great; and it was pretty funny on the whole. If anything, it wasn't short enough, at just over twenty minutes it was definitely on the long side. When you get to festival submissions, which we'll discuss in much more detail later on in the book, the longer

your short is the trickier it is for festivals to schedule them into group screenings with other shorts, hence why a lot have length restrictions.

Unaware of this at the time, we decided that we would hold a screening for our short film, and what better place than The Soho Screening Rooms on D'Arblay Street. We booked it into an early evening slot and invited an insane number of high-profile people from the industry, eOne, Ingenious, Lionsgate, casting directors, agents, producers, public relations people, press; anyone we could think of who we felt might be able to help us, assuming we could find their email address on IMDB Pro. And to our amazement people actually came to watch it. They were perhaps as bewildered as we were as to why they were there or what exactly they had been invited to but enticed no doubt by Gandalf's involvement. We'd met Cameron McCracken at Pathé prior to organizing the screening, and he gave us some rather brilliant advice. Clearly recognizing that we had no idea what we were doing, he suggested that we find ourselves a mentor. Someone who did know what they were doing and had been in the industry making independent films for many years. He suggested that we contact Margaret Matheson (producer of *Sid and Nancy*, *Shell*, and dozens of others).

"I like working with people who are newer at the game, partly because it helps with my view of the world to give this person space, give them support. But that only works if that person's any good. And some you discover are very nice and you've enjoyed talking about it but the actual outcome isn't that great, but that's ok, it's art, sometimes it's shit!"

—*Margaret Matheson, producer*

Margaret came to the screening and helped steer us away from some more undesirable connections who had come to prey on young, clueless filmmakers, and toward the genuinely helpful ones. Sometimes it's very hard to tell which are which. There are a lot of sharks, bullshit artists,

and wasters in this industry. We're fully aware that we've been incredibly lucky to have had mentors to help us navigate our way through the beginning of our career, Margaret being one of them and Gareth Jones (you'll hear his name crop up a few times throughout, he worked on *Lock, Stock and Two Smoking Barrels*, among many other films). It's partly because we recognize the importance of having someone who's been there and done it, who understands the lay of the land to help you, that we're writing this book. Like anything when you're starting out, this industry is daunting and intimidating, and you can easily get swallowed up or taken for a ride. There isn't always someone there to help give you some guidance along the way, so that's what we're here for.

"You look to the filmmakers behind it, the director, what they've done. I've worked successfully with people who have come out of theatre because they're good with actors, so not just people who have done ads and things like that."

—*Gareth Jones, executive producer*

Most of the guests who had come to the screening of *E'gad, Zombies!* were under the impression that they had been watching a teaser for a soon-to-be-completed feature film, because no one would really hold a one-off industry screening of a single short film. Ah, we thought to ourselves, better get on with writing the feature-length script then, and that's how we came up with the idea of *The Curse of The Buxom Strumpet*. We'll talk about the writing of the screenplay in the next chapter, but what it meant was the beginning of setting up our production company, Fizz and Ginger Films, and the beginning of a journey that would teach us all sorts of ups and downs of independent filmmaking. The name of our company, and this is a question we get asked a lot, is not because Matt has a bit of a ginger beard and Tori loves downing fizz. It's actually a quote from P. G. Wodehouse's *Jeeves and Wooster*. Bertie Wooster describes a girl, Bobbie Wickham, as being full to the brim with fizz and ginger. It seemed like a

pretty good description for any story or creative entity, conjuring images of excitement, fun, intrigue, and something with a bit of punch to it.

While we were writing our first feature, we were also making a series of short films. The idea was to educate ourselves as we were not graduates from film school and we didn't know much about the history of film genres or the physical aspects and rules to making films. We began with French New Wave; why, we can't quite remember. But perhaps it was because we'd been to the Cannes film festival the previous year when *E'gad, Zombies!* was in the Short Film Corner. There we went to the Un Certain Regard screening of Jean-Luc Godard's *Film Socialism*. For what felt like an eternity, the opening sequence forces the viewer into a mesmeric state of watching the waves continually, as if staring intently at the sea. For our cast and crew, the shot was held for so long that it surpassed feelings of comfort, repetition, even boredom and ended up in the ridiculous, sending us into uncontrollable giggles. To the French audience in black polo necks (no joke), it was not acceptable that we were giggling through their film god's masterpiece. By the time it got to a woman lying on a bed watching cat videos on YouTube and meowing to them, we were no longer welcome in the audience and stern "shushing" forced us to shyly leave.

Although *Film Socialism* is not in our top ten movies of all-time list, it did introduce us to the abstract, absurdism, and existentialism within film and from there to French New Wave cinema, a subject we'd previously been fairly ignorant of. It encouraged us to watch French films of the 1960s like Godard's brilliant *Breathless* and Truffaut's *Jules and Jim*, with long takes, jump cuts, and obtainable locations on a low budget. As part of educating ourselves we wrote *Claude et Claudette*, the first of our short comedy homages. The plot was simple, writer Claude tries to come to terms with the loss of his love, Claudette. We filmed it over a couple of sunny days, in black and white, in our small flat in North London, using the bedroom, living room, and garden, and we paid people with barbecue and booze at the end of it. It is by no stretch of the imagination

a masterpiece nor did it bring us great acclaim or awards, that was never the aim. But it got us making stuff instead of talking about it and at the end of the day the more you do the more you learn. Every time you're on set, no matter how big or small, you're bound to learn something new because no two experiences on a film are ever the same.

From French New Wave it made sense to continue to explore what had influenced that and so from there we moved on to film noir and researched by watching brilliant, timeless classics like *The Maltese Falcon*, *The Big Sleep*, *The Third Man*, and *Double Indemnity*, among many others. We knew that it was impossible and foolish to try to recreate or mimic these enduring works of motion picture history; instead we looked at the rules by which film noir adhered to and created our own little homage to the genre in the form of *The Humpersnatch Case* (see figure 4).

A lot of these aren't hard and fast rules, but more common aspects of noir films. For example, shot in black and white seems a no brainer. The

FIGURE 4
The Humpersnatch Case with Actor Ben Lee and Tori

central character is usually a private detective or someone who's fallen into a life of violence. These melodramas are usually American set crime dramas, a small town in the back of nowhere, where the central character often falls in love with a femme fatale figure. This is where a few of the weirder rules pop up because of the time in which these films were being made. In the 1940s and 1950s, an unmarried couple having a heated affair was pretty risqué, so to avoid anything getting out of hand, the unmarried couple could never end up together by the film's final scene, and if there was a love scene on a bed the man had to have a least one foot still on the floor.

One of the most distinct visual elements of noir is the strong lighting and use of dramatic shadows that came from influences of the German Expressionist era, notably Fritz Lang's *M*. (See figure 5.) We never got around to making our German Expressionist short, but I guess there's still time! The term chiaroscuro, meaning stark light and dark contrasts and patterns of shadows (the classic window-blind stripes of shadow across a face), we found particularly helpful in creating the overall look and feeling

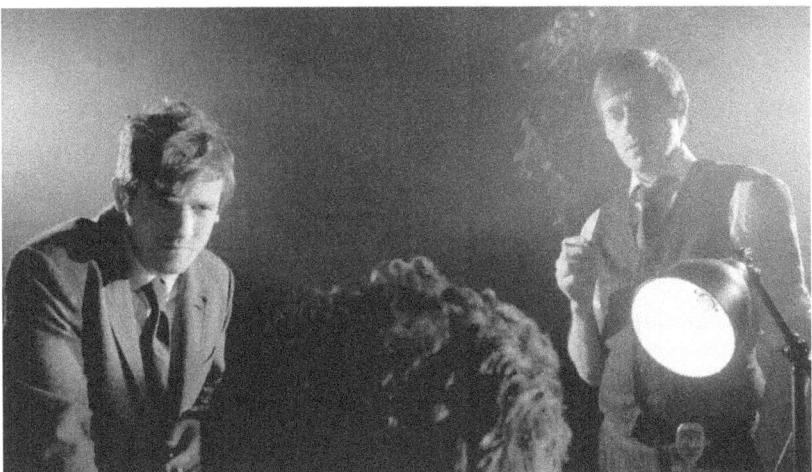

FIGURE 5
The Humpersnatch Case with Actor Graham Butler and Matt

of a noir film. The genre also introduced us to a better understanding of different uses of angles and shots, such as low, wide, tracking, and skewed (aka Dutch) camera angles.

We attempted to cram as many of the clichés into our short as possible, heightening the acting, taking full advantage of the melodramatic style, and deciding to set our scene within the 1950s studio world; Hollywood always enjoys a good pastiche of itself. In our little noir scenario, number one Private Dick, Frank Nino (Ben Lee), is called to investigate the murder of film-producing legend Burt Humpersnatch (Gil Sutherland). Leading lady Stella Dixon (Tori) has disappeared, and she's top of Frank's lists of suspects. However, things don't go according to plan and Frank soon finds himself "making a strudel outta mincemeat!"

Unlike *Claude et Claudette* this time we used our credit cards to give us a bit more of a budget, about two thousand pounds. We actually paid our cast and crew, a small amount but something, and we built sets. We created a motel room in a small studio in east London that we could shoot at night and which was on the ground floor, enabling us to shine light through the window to create the all-important noir shadows. It also had a small back room with no windows, which was perfect for an interrogation room. And then armed with a painted backdrop and a small smoke machine we headed to a rehearsal room off Brick Lane, The Rag Factory, and created the sets for the train station and film studio. To help sell the studio we hired a couple of key props like some old film cans and a couple of period film lights and that was about it. All the costumes were either already owned by us, borrowed from the actors, or from charity and vintage shops.

There's something really special about making short films on a shoestring budget, and although it's stressful and we'd all like to be paid more, it's the experience of creating something almost out of nothing that's taught us to always be resourceful. To look outside the box and work out ways of doing things that aren't necessarily the usual way of doing it.

> "I think people should make things all the time, especially now you can make them on your phone. Get your hands dirty, work, work, work, write, write, write about what you think about the world now, this year, because you might think differently in ten years' time but what you're thinking about now is going to be the thing that is interesting to other people, and if it isn't move on, put it in the trash."
>
> —*Margaret Matheson*

We transferred this ethos and way of working into our features, not because we don't want to work with bigger budgets, oh no, we do, but because we'd probably still be waiting to make our first feature if we'd gone down the path of how it's usually done. By this we mean if we'd applied for grants and funding, aka soft money in the United Kingdom (which doesn't really exist in the United States), or waited for that illusive pot of gold that is just impossible to track down, or if we'd made an exceptional short film through one of the brilliant schemes that are available and then gone on to be BAFTA (British Academy of Film and Television Arts) nominated. We didn't do that, not because we were actively avoiding that way of starting out in the industry, but because we simply didn't know that was at the time the usual way of doing things in the United Kingdom. Instead, and we really aren't condoning this or recommending it in any way if it can be helped, we used a lot of our own money, rented equipment on credit cards, got ourselves into debt, and tried and often failed to raise budgets through crowdfunding campaigns.

Whatever budget you have will set parameters within which you need to work, and yes, that will dictate how you can shoot your film, where you can shoot, what kit you use, and at the end of the day the most important thing we've learned is to try to put as much of your budget on the screen as possible.

That means not paying yourselves a large part of that hard-earned budget, but it does mean paying your cast and crew. And yes, actors should

be paid, even if you find people who are prepared to work for free, but everyone, cast and crew, is providing you with their expertise and service, for which they should be compensated. What this does not mean is that talented actors are expensive. So many times, we've heard filmmakers complain that they can't afford talented actors. I'm not really sure what they mean by this, but I think what they're saying is that actors who are better known, have a recognizable established profile, are the most talented and unaffordable on a low budget. This is untrue on two counts. One: fame does not equal talent, likewise lesser-known actors are not necessarily untalented actors. Two: as we mentioned previously, having a "name" in your film does of course help with exposure and getting your film noticed, but this doesn't mean that you need a massive budget to pay for a big name. We've said before and it's true: actors like acting and it's amazing how often a well-known actor will happily do a short film for a small amount of money if they love the script and/or they like the team making it; they may even offer to work for free and you'll at least know they can afford to do that. Write your short and cast a brilliant, not necessarily famous, actor as the lead and then think about including a great cameo role for a more known actor that will take just one day to film. And then be super slick, professional, and organized on that day of filming!

"All I want to do is create and whether that's me writing or directing or acting, I just want to be a part of that process and tell stories. Obviously I want to be artistic but at the same time I want to make money!"

—*Aki Omoshaybi, actor/writer/director/producer*

2

Buxom Strumpets and Believing in Your Script

Sitting down to write a screenplay can be a daunting thing. (Not as daunting as sitting down to write a book, but close enough!) Where on earth do you start? We try and start with the characters, probably because we come from an acting background. It's what attracts us to any script when reading it. Do we like and invest in the characters? Do we care about them and, most importantly, do we believe in them? A good lead character can be the heart and soul of your script, the viewer's window into the world that you're going to create. Whether you end up hating the lead character or loving them, they have to be compelling, and that has to start from the page. You can't just leave it up to the actor to make the character enigmatic and interesting—that's an impossible ask for anyone, especially if the script isn't enigmatic or interesting in the first place.

We still haven't been able to make the first feature film script we wrote. This is for a number of reasons, mainly that the budget size was just too big for us at the time. It was just over three million pounds, and we discovered that's a pretty hefty budget in the United Kingdom for a director's first feature, which for Matt it would have been. We in fact managed to get a great cast to sign up and we raised 60 percent of the finance but

after about five years of trying to get it green-lit (have all the budget promised or in place in order to go ahead with pre-production) we were forced to give up, put the screenplay back on the shelf, and turn our attentions to other projects.

This was prompted by a meeting with Nick Manzie at Lionsgate. We were ushered into a large room with life-size boards of Jennifer Lawrence in a rather large movie towering behind us. We'd sent Lionsgate the script, and he got us in for a meeting. This was insanely exciting for us—we were sitting in the offices of one of the largest distributors in the world, waiting to talk about our script. We'd just been chosen by the film magazine *Screen International* for their "Stars of Tomorrow" edition, so we thought that was why they wanted to see us. Nick sat down and told us that zombie films were big (we knew that—that's why we'd written one), but the bubble was beginning to burst and they had the "costume drama" zombie film all wrapped up. In polite but no uncertain words, he told us that there wasn't any space in the market for two zombie comedies in period costumes.

Lionsgate was about to shoot *Pride and Prejudice and Zombies*. The book, a mash up of Jane Austen's original classic, had been an immediate bestseller the year before and so things looked pretty good for the film. He also proudly told us that they had Lily James attached to play Lizzy Bennet. Hot out of Downton Abbey she was "majorly bankable," and they were planning on spending around ten million pounds on the press and advertising of the film alone. So, yes, about three times the amount of our entire budget put together. We left that meeting feeling utterly gutted, having been basically told to back off and give up because there's no way we'd be able to compete with this giant.

It's probably not surprising to hear that we weren't hugely heartbroken when *Pride and Prejudice and Zombies* didn't do brilliantly at the box office. It did teach us a few things though. Don't put all your eggs in one basket, a classic saying but particularly helpful for a writer or producer

starting out. You never know when the screenplay you've worked on for the past five, ten, fifteen years will be made by someone else and as heartbreaking as that is, you've got to move on to something else. That's not to say that you'll never make that film. Not at all, it just means you need to pop it away for a bit and wait for people to forget, or the bubble to come back around. And it will. Famously Christopher Booker wrote that there are only seven basic plots that are reworked and retold with different characters, locations, and predicaments. All stories ever told can, in his opinion, be boiled down to seven categories or frameworks: overcoming the monster, rags to riches, the quest, the voyage and return, comedy, tragedy, and rebirth.* This is particularly evident in films, nearly all of which are rethinkings, reworkings, or retellings of other films, just set in a different time or place or told from a different perspective. It's impossible to make something that is totally 100 percent original. Don't put that kind of pressure on yourself and don't think the world has ended if something comes out that's similar to your screenplay—it won't be exactly the same and people do forget.

After *Pride and Prejudice and Zombies* didn't do too well, we realized that we'd have to wait for things to settle. People weren't going to want to invest in another historically set zombie comedy. The period, storyline, characters, and setting are all totally different, but people would still draw comparisons, and there was nothing we could do about that. But that's not to say that people would never again want to invest in *The Curse of The Buxom Strumpet*; in fact quite the opposite, we believe in our script and we believe that we will make it one day. The main reason being that we had an incredible cast attached, not because we'd promised them loads of money, but because they liked the script—it's well written. The characters are big and bold but believable, and they all have clear and unique voices. Ian McKellen was attached to play

*Reference: *The Seven Basic Plots: Why We Tell Stories* by Christopher Booker, 2004.

Lord Fortitude, Gillian Anderson was attached to play Betsy Foxer, and Imelda Staunton to play Mrs. Halfpint.

The writing process wasn't an easy or quick one; we spent about a year, in fact probably longer, writing it. But I think that level of work and rewrites, the hours spent on it, show for something. We started by finding our characters. We knew from running the theatre company and studying eighteenth-century plays that there are "stock" or typical character types that you would find in any work of that period: the hero, his love interest, the villain, the fop (comedic character who is overly concerned about fashion and his appearance), and the rake (a wealthy man with questionable habits and immoral gotten gains). We also knew the types of people that would reside in a small English town in the 1700s. There would be a large house where the lord would live; he might have children or very often a ward that was under his care. She, in turn, would have a nurse or serving maid. She would also probably be enamored with a completely unsuitable gentlemen that the lord disapproved of, so enter the rake. And there might be a foppish character, in love with the young ward, whom she is oblivious of.

There would also be a tavern or pub, a gambling house, and a church. We decided that we would set it by the sea, so there was a port with boats coming and going, bringing produce from the East Indies. The idea that our lord would own his own shipping company was a nod to the East India Shipping Company so prevalent at the time, and it gave us a historical link connecting our fictional world to the tangible world of reality. And so, slowly we built up our characters, their backstories, and the places they frequented, all loosely based on the archetypes of the time.

There are loads of scriptwriting books out there that break down how you should set up your acts and storyline, when there should be conflict and when it should be resolved, but we don't write like that and don't follow any hard and fast rules and neither did we before people started writing books on how to write scripts! Instead, we find our characters

and let them dictate the story. If you genuinely really know your characters, then you know how they would react in any given situation. So when you give them a choice as to how they will deal with the problem you've created for them, you'll know exactly what they'll do. Will they go down to that dark cellar to investigate the noise, or will they run away and hide under the bed?

With *The Curse of The Buxom Strumpet*, we knew our characters would have to battle a zombie breakout. Some would perish, whereas others would survive and prevail. Our way into this was to work out a geographical plotline. By this we mean that we literally drew out a massive map of our imaginary town and then were able to plot out the journey that our group of characters would take. The big house was at one end of our town and the port was at the other. Our characters had to fight their way across town to get to the harbor where *The Buxom Strumpet*, our hero's prize ship, would be waiting so they could sail away to the safety of France.

In between was the big square with the town hall, a theatre, the gambling house, the tavern, and the church. We drew all of these onto our map and then plotted the route they would take. Inevitably they got split up, some characters going one way and some the other, before they managed to meet up again at the end for one final epic battle to board the ship.

Once we'd got our journey laid out on the map in front of us, we could work out where the conflict points and key moments would occur and therefore when and where key scenes would be. We wrote the scenes we knew we wanted and had to have for the plot journey to progress onto little cue cards. We use these a lot when writing because it's easy to add scenes in between and to shift the scenes around. You can lay them all out or pin them up on a board and actually see where the holes are in the plotline.

We like to run the idea through the imaginary cinema that lives in our head and play ideas like we are watching it. It's a good way to see what is flowing, where the blanks are in a scene or sequence, and what are the

points that jump out and make an impression. It's usually those moments that should be in your story, at least at that point in the process. Filmmaking is a visual medium, and you have to remind yourself of that as you write: how do I tell this story, and the story of my characters, visually. The imaginary cinema is a good way to see if it's clear and what needs to be singled out in the script to get your story across for the medium.

On the cue cards, we'd write the main points of the scene: characters, location, what was being discussed or the action that was taking place, and then the result of the scene before moving on. Once we had all our key scene cards, we started to formally type out the screenplay and dialogue. Our characters already had their backstories and so we knew who they were and how they would behave, allowing us to use the dialogue to slowly reveal aspects of personality and the relationships to one another, while driving the plot forward.

One piece of excellent advice that we picked up along the way is that if you can shift your scenes around and it still kind of makes sense, then the character arc is not clear enough or strong enough. Your character's emotional arc should start in one place and finish in a totally different place. Through the experiences and situations that they have faced during your story (their journey), they will have grown, learned, developed, and changed. Be they the good guys or the bad, audiences love to see how these events, and the choices that those events force the characters to make, have affected the protagonists and antagonists.

If you've got a scene that sits at the beginning of your story and you then shift it to the end of your story without it horribly sticking out, then that clear line of emotional structure isn't there and it might mean that your screenplay ends up lacking an authenticity and believability. For example, taking the "overcoming the monster" scenario, your lead "Barry" is battling with the monster of depression. He seeks help by going to speak to a psychiatrist; by talking through the issues in his life that are affecting his mood, he is able to shift the black cloud that has been hanging over

him and his mental state begins to brighten. By the end of your screenplay, Barry feels he is in a much better place and so has his closing session with the psychiatrist.

Taking this simple plot line, each session that Barry is with his psychiatrist he talks about another aspect in his life, past or present. These sessions or scenes could be in any order really: one day he talks about his relationship with his mother, the next time he talks about getting caught stealing booze from a supermarket when he was sixteen. Each little conversation and inquest into Barry's life doesn't necessarily corollate to the last—he could talk about his mum at the end of his journey or at the beginning. But it's important to remember that in each session Barry's emotional and mental state is developing and changing, in order for him to arrive at the final scene and the resolution. As Barry progresses through his journey, his reactions and the way he responds to things will change. If that emotional journey is clear enough in the script and dialogue, how Barry reacts at the beginning will be very different to the end and therefore if you shift the scene when he talks about his mum from the beginning to the middle or end of the screenplay, it will stick out like a sore thumb, because Barry just isn't like that anymore. You'd have to alter his dialogue and behavior to fit in with where he presently is in his emotional journey.

Your characters have to be believable, which doesn't necessarily mean they're realistic; half the movies out at the moment aren't a slice of real life, so that means they must have their own truth in the world you've created, so that you believe them. They need to have flaws and failings as much as they do the good points. The audience has to care about these people; it doesn't matter how amazing the action is, or how intrigued or scared we are about the story if the characters don't make us care that they're in that situation in the first place.

To create a believable person that will live on the page you need to spend time on their backstory; they can't come out of nowhere. To know where they're going you need to know where they've come from,

because that's going to dictate how they proceed on their journey in the movie. What has happened that has brought them to the point we're meeting them in the story? But don't explain this to us if you can help it. We should be allowed to find out who they are by what they do. Their personality should be drip fed to us through actions, interactions, and relationships. Always remember that this is a visual medium. Knowing each character's backstory, even the smaller characters that turn up in one scene as a device of some kind, is not just going to breathe life into them and make them feel realistic, but also help you by knowing how they'd react in a situation. Are they the sort of person to go into the basement after hearing the strange noise, or are they going run and hide under the bed? They can help you tell the story.

Events in the story happen because someone has made a choice; you need to give them that choice. Again, it's a visual medium so they need an action to deal with, which they have to make a choice about, which results in a consequence, which results in another action because the character has had to make another choice. They don't need to be huge actions or choices, but this is what drives any story on, no matter the template you've created.

The most important thing to remember, and this will keep you on track when you're writing, is what does the character want? And what are they going to do to get it? They must have a strong urge, or need, to do what they do. And this is the point at which we meet them, to see what they're going to do to achieve it. We say *do*, because film is all about the visuals, and we have to watch them actively doing something. It doesn't need to be huge and action packed, it can still be a film about three old men talking about the past in a retirement home, but they still want something, and they're still doing something about it. It does help if you can find a way to show what your character's need is so we as the audience can track how close they are to getting it, so when there's an obstacle, whether physical or internal, we can see them getting over it and moving

closer to the tangible need. This doesn't need to be a huge thing—it could emotional freedom from a situation—but that has to manifest as some physical, symbolic something so we know when they've attained it, like moving away from the abusive relationship, for example. Or it can be as literal as with *The Isle* in that they want to get back to the mainland and away from the strange island.

The need, whatever it is, creates some kind of action, which our protagonist has to deal with to achieve what we've all paid to see.

Then there's the plot and story structure. We don't sit down at the beginning of writing a screenplay and think, okay, what happens in our three acts? We've never broken it down to Act 1: setting up the characters and initiating the first plot point; Act 2: increasing the action to a confrontation and introducing the second plot point; Act 3: the resolve almost happening, it doesn't quite, final climax of action and then the resolution. We just don't write like that, probably because we didn't train or study script writing. However, if we sit down and break down one of our scripts, it might well fall into the three-act structure because from as far back as the Greeks, stories need certain elements to push them forward. But to write thinking "on page twelve this needs to happen, and by page forty we really should have done this" creates such a rigid structure that you're not being creative and allowing the characters and incidents to speak to you; you're in a script factory. When you're writing you can feel the beats of a script and the momentum of a story, where it needs to build in action, when we need an obstacle to force the character into making a choice, and where the quiet moments of calm and reflection can sit so you can see the character's growth. But stick to an exact template, which is often what is taught, of when precise things should happen, and you're just churning out a copy of a hundred films done before. At the end of the day, however, remember that there's no right or wrong way to write your script, use what works for you!

"What's happened is the old paradigm of white men on top and everyone below has been broken down. One attractive woman and then other title roles are guys. That whole thing is going out of the window now. People want to see other things . . . and it doesn't matter about the ethnicity or gender or the sexual proclivity, people are hungry for variety and it's truer to real life and I think that's a great thing that's happening right now. . . . People have to be careful about trends because we all, who analyse film, will know that anything I'm seeing right now that's trending has a three to five year history behind it. So if you're copying that, you're actually copying something that started in 2016, so by the time you do your film it'll be dead. There's a fine line between acknowledging the market and being market savvy, and then whoring yourself to the market which means you're putting your creativity in the back seat and you're focusing only on profit. . . . Following trends is great if you're in the position that you can replicate something immediately and have it out in the market in three months and acknowledge that it's going to be a lower copy, and that's fine and people do that. But the reality is it's not worth investing much of your life into something that's catering to that, you've got to be original."

—*Steven Adams, producer*

The script is the most important thing. It's the blueprint of your story, which will of course be added to by filming, but knowing that you can never have a great film (no matter how good the director and actors are) without a great script, it's best to spend time over it. Don't rush it; go over and over each scene and line, and get other people to read your script; constructive criticism is immensely helpful, whether it comes from yourself or others. But don't just get your mom and your best mate to read it, unless they make films or are used to reading hundreds of scripts or work for the British Film Institute (BFI) or a finance company that invests in film. Get people who actually know what they're talking about to read your script, but also be aware that sometimes notes can be more of a hinderance than a help. Do a table read with actors so you can hear

what the lines actually sound like rather than what they look like on the page. And get someone else to read all the action in, so all you need to do is listen and take notes. It's hugely helpful to hear your script being read aloud; how the rhythm of it is flowing and how the dialogue sounds being actually spoken by real people. We do this with all of our scripts and helpful stuff always arises from it that we've never noticed before.

"They (Film London) were very involved on script level, they clearly liked the script (of) *Lilting*, I sat down with one of the execs and we combed through the script page by page and then I did my final rewrites. . . . For the four years of writing it you go through various different stages and problems and sometimes I think, well this isn't really worth having a fight about yet. You know people say choose your battles wisely, and I think, it's a small thing, but I wonder if I would do it differently next time. I think I would fight every battle, and maybe do it with a smile. I don't know if I'm right, but I wish I hadn't made some of the decisions I made in the early drafts and losing some of the stuff that I really loved, but I think that's more about me and how I work and learning who I am as a film maker and director."

—*Hong Khaou, writer/director*

Some scripts are of course much better than others, although that doesn't necessarily dictate which scripts will be made and which won't, and which will be huge successes and which won't. Often, we'll watch a film and think the cast was great, it was beautifully shot, but the script let it down a bit. Or vice versa, the script was amazing, okay, they didn't have a massive budget and the effects could have been better, but the film sticks with you because of the script. It's those unforgettable lines or a character you totally invested in and fell in love with, or a story that drew you in and transported you to another place and time that stay with you long after the credits roll that are down to the script—not how much money you had to make it.

> "The rule for independent filmmaking, or any kind of filmmaking or any kind of art, is if you're going to put all this energy and all this effort, you have to make a film that for good or ill no one else on the planet could have made. You're telling a story that only you can tell. Not because it's personal, or autobiographical, but there's something about the mode and manner of the story and the narrative that is your story."
>
> —*Stephen Fry*

When we're sitting down to start on a new script, we try to remind ourselves of certain pointers. We hope you find these helpful, but take what you you what want and make your process your own.

KEEP IT CLEAR

This is particularly useful for writing a short or feature film script; television is a whole different ball game that we're just starting to explore, so this point is very much about movies.

It can get very confusing to keep track of what's what and who's who, especially when you're reading a screenplay for the first time. We often have in our minds who we want to read our script, such as finance parties, distribution companies, and actors. You want to make sure your screenplay is as clear as possible to any potential investor or distributor. They will likely only read it once and even then they may well skim read it.

1. Places and Times:

 We've been sent scripts that are fascinating stories, quite often based on a true event or historical figure and because they have such interesting and complex lives, the script reflects that. That's great and makes for a good film, but it can be hard to follow if it isn't set out clearly and concisely.

 When you make a film, you can use all sorts of different styles and choices to differentiate between story lines, but on the page it's just the black and white written text. So if we do have a lot going on in a

screenplay, like different time zones (past, present, future), memories, or even different worlds, we'll devise a clear way of setting it out and make sure we keep reminding the reader at the top of each scene.

For example:
EXT. THE GREENHOUSE—MORNING—PRESENT DAY
Then on to the next scene INT. THE GREENHOUSE—MORNING—PAST (1969)
Then to INT. THE LIBRARY—EVENING—PAST (1984)

It may seem obvious, but when it's your script, it's easy to know what character is in which storyline or timeline and forget that if you're new to the script it can get very confusing trying to work out.

2. Character names:
The other thing we try to remind ourselves when aiming for clarity for the reader is the choice of character names. Very often we've read a script and there might be a Jack, Jamie, Joey, and Jay, and the Jamie is a girl and the Joey is a boy. And by the time you get to the sixth scene you don't have a bloody clue who's who and what's what. Again, it might seem obvious but give your characters very different looking and sounding names.

Names are important as they can impart information to the audience about them. Certain names have specific connotations to them, or certain sounds within the names conjure up the kind of person they are. We put hidden messages in the character's names sometimes, which is mostly for the actors, but is a helpful tool: Cailean Ferris in *The Isle* means "young pup" and "rock," respectively.

If you're dead set on the names all sounding similar, you can always change them further down the line, or if it's a style choice then make it clear in the script. It helps to begin with a breakdown of the characters and who they are when you meet them in the screenplay before the scene begins.

For example:

JACK and JAY are twins. They look nothing alike, although people often confuse them because of their similar names.

JACK wears plaid shirts, is six feet, three inches, and was an all-star American football player. Jack is easy to remember because he looks like a lumberjack.

JAY is shorter at five feet, ten inches. He got all the brains, a civil engineer who has been dating JAMIE since they were sixteen.

At least that way the reader is prepared from the get-go that they have to pay attention. You, the writer, is aware that the names are similar and they, the reader, should be prepared for some confusion; it's deliberate.

3. Action:

This is a great little tip that we picked up. If we have a large action scene or a big chunk of exposition, we'll break it up into smaller chunks. It's super easy to do; you can spot them as you scan through your script and just break them up. It won't add too much to your overall page count, but it will help your reader retain clarity. Of course, you should always aim to find the most economical way of writing the action, which lets the reader see what's happening, and in the least amount of words, but this is a way around big passages you just can't reduce.

In an age when we're all used to reading blogs, posts, and tweets, our brains are becoming more used to seeing content broken up into smaller bite-size paragraphs. So why shouldn't your script reflect that as well? Instead of the brain seeing a huge chunk of text and being overwhelmed by it, give the reader smaller more manageable sections to read. They're far more likely to take it in and not skip over what could be an important pivotal turning point in your story.

For example:

The horse stops grazing for a moment and looks up at her. She freezes. The white flash on its forehead has a deep scar running through it, the exact same scar that she'd seen in her dream. It's a sign. Mary holds out her hand and the horse comes closer to her. Slowly, closer and closer until she can stroke his neck and run her finger down the scar. A shot fires in the distance, breaking the moment of peaceful unity between the woman and the horse. Instead of flinching and bolting the horse remains close to Mary. Slowly she moves around him and climbs on. Holding tight to his mane and with a quick nudge of her heel, the horse is away, galloping across the plain. Heading for the safety of the forest.

Instead:

The horse stops grazing for a moment and looks up at her.

She freezes.

The white flash on its forehead has a deep scar running through it, the exact same scar that she'd seen in her dream. It's a sign.

Mary holds out her hand and the horse comes closer to her. Slowly, closer and closer until she can stroke his neck and run her finger down the scar.

A shot fires in the distance, breaking the moment of peaceful unity between the woman and the horse.

Instead of flinching and bolting the horse remains close to Mary.

Slowly she moves around him and climbs on. Holding tight to his mane and with a quick nudge of her heel, the horse is away, galloping across the plain. Heading for the safety of the forest.

BELIEVABILITY

We always try to keep the actions of our characters believable. This doesn't rule out writing fantasy or sci-fi; it just means that we try and avoid falling into the trap of wanting to make our story interesting and exciting by making the characters do something that is totally against type

and unbelievable in the world that we have created, and all the parameters that go along with that.

If a character has been established as eating fast food for every meal and never done a day's exercise in their life, it's unlikely that they will get up one day, eat a burger for breakfast and then in the afternoon win an Olympic gold medal for anything, let alone a triathlon. It's an extreme example, but you get the idea.

If they are going to do something totally from left field, why? What's their motivation? And the answer can't be "because they felt like it" or "it'd be cool to see in the movie." There has to be real reasoning and purpose. You have to allow your audience to believe in it in order for them to invest in it.

It doesn't need to be realistic, but it has to be believable. It depends on the template that you've set up within your script. Our film *The Isle* is a mythological ghost story set on a remote Scottish island in 1846. A ghost who haunts an island and uses a young woman as a channel to carry out her vengeful killings isn't necessarily realistic, depending on whether you believe in ghosts, but the backstory that we created around the character of our ghost Persephone made it easier for the audience to invest in and therefore more believable.

Spoiler alert if you haven't seen *The Isle*. When Persephone was alive, she was Lorna Elliot. As she was walking home after the Maybon dance in the village, she was attacked by Billy Innis. He attempted to rape her but was disturbed by someone passing nearby. Lorna tried to call out for help, but Billy covered her mouth to stop her screams. He held on so tightly to her that he ended up smothering her to death. In death she seeks revenge and justice for the violence against her by killing young men and drowning any passing sailors. She does this by using Lanthe Innis and Korrigan McLeod, her two friends who had not protected her in life.

We used the Greek myth of Persephone and her sirens as a device to help the viewer invest in the story, because it was one that is familiar to

a lot of people. On the whole people like things that they recognize and have already accepted. It links back to the seven basic plots: similar stories just reimagined and told differently.

The fast food junkie one day decides to give up the burgers because the doctor tells them they have halved their life expectancy. They start to eat healthily and train every day, eventually building up the strength to compete in their local marathon. One day, after years of hard work, they represent their country at the Olympics and win gold. We're invested in their achievement because we've followed their story. It's still exciting and interesting, but it's also believable.

"Imagine you are that homeless person, imagine that's you and tell the story of that, that's imagination putting yourself in the soul, the boots of someone else. It doesn't have to be grey and dreary and earnest. . . . The good films are when you imagine what it's like to be someone else . . . those people can be aristocrats. With *Bright Young Things*, tramping around Soho (to find the investment) people were asking, 'why should we care about these upper-class people?' Because they have livers and kidneys and souls."

—*Stephen Fry*

NAFF, CLICHED, OR REPETITIVE LINES

This is with our actor hats on. Quite often, we will write with certain actors in mind to play certain characters. We try not to fall into the habit of writing naff, clichéd, and repetitive lines. Yes, people have a certain way they talk and a speech pattern that they might follow, certain words or phrases that they like to use and that's great, it helps to establish a character's unique voice, but we try to avoid them repeating the same words or phrase over and over again because it just gets boring. And we make sure that that repetition doesn't bleed into other characters, so they don't all end up sounding a bit the same.

It still bothers us when we watch *The Isle* that one of the characters has a couple of lines with the word "weird" in it. When we were writing the script, we checked that "weird" was used in the 1800s and it was, despite it sounding too modern. It's not the fact that the character uses the word, but it's the repetition of it that sticks out, it just seems a bit like lazy writing to us.

This has happened in other films as well, when repetition has crept in, but not through our script writing, instead through the actor. An actor, when learning lines, might fall into a rhythm or speech pattern and start paraphrasing lines. It's easily done and if it starts to happen a lot you might find yourself sitting in the edit with a lot of the lines sounding the same. We'll talk about this more in the production stage, but this is how we first learned one of the many advantages of having a good script supervisor on your team. If you're lucky enough to be on set as the writer (i.e., you're also the producer or director), don't be afraid to stand strong on your script and ask for the lines to be spoken as they are written. You can always do a couple of takes, one with the line as it's written and one with the line spoken with the actor's interpretation.

This is a double-edged sword really, because actually sometimes an actor will have great suggestions and input. They have put the work into creating your character and have developed their unique view of how the character walks, talks, and behaves. But they might also be missing something that applies to the bigger picture, the pacing for example, or some piece of symmetry that the writer was going for in a scene that the actor in question might not even be involved in. This also applies to actors cutting lines. We've been in the situation where actors have suggested that they could do a line with a look, instead of actually saying the line. This makes sense as it's a visual medium, but hopefully the writer has taken that into account and knows when the visuals are needed and when text is. So it might work that the actors can make that moment happen visually, but again it's worth getting both versions, be-

cause you never know what might happen in the edit. We've found that out the hard way and then had to find ways to re-edit to make sense of a scene, which is a shame. At the end of the day, believe in your script and stand by it. You've worked hard on that script and many hours of writing and rewriting have gone into it, so there should be a good reason why that line is there.

Naff and clichéd lines are tricky because what can be considered naff is very much subjective to the individual. I guess for us this is more about being a critic of our own work and asking ourselves if we're being lazy by writing it. Is there something else, more intelligent and more original, that we could use? We try not to settle for a line, "oh, that'll do." Sometimes we do, in order to get the scene out and on to the page, but we'll return to it over and over again to refine the dialogue.

GETTING IT ON THE PAGE

This seems obvious and something everyone always says, but it's true. If you have an idea for a script, just start writing it. We probably have about twenty different scripts at different stages between us. Most of them are by no stretch of the imagination at a stage for anyone else to read except us. But the kernel of the idea is there and down on paper, ready for us to return to at any point.

We've often been at filmmakers' events, on panels, or even at parties when people have come up to us and started pitching their idea for a screenplay. That's great to have an idea, but no one else is going to have as good a grip on that idea as you. Nor are they probably going to invest in just an idea. It always helps to have something tangible (i.e., an actual script), and if you're not a writer then find a writer who you can work with, or at the very least bash out the idea on paper in a simple one-page document, or "one-pager." It doesn't have to be properly drafted into a script, but lay out your story: beginning, middle, and end. Time and time again, people will tell us their story idea and then wait for a response,

which nine out of ten times is, "and what happens at the end?" to which they reply, "Oh, I don't know, I haven't worked that out yet."

We regularly struggle with the ending. It can be really tricky, perhaps because there's any number of ways you could end something. A happy ending, tragic ending, a character's seemingly disappointing resolution to their predicament or a satisfactory one. It won't be perfect the first time, nothing is, that's the beauty of drafts, but at least get something down on the page: beginning, middle, and end.

Our ideas come from all over the place, and we've never limited ourselves to one genre type, although writing to a genre can be really helpful and genre films are always popular—they sell. The term genre can be tricky because really anything can and will be classified and pigeonholed into a "genre type" (e.g., action, thriller, comedy, drama). But now when distributors and sales companies refer to wanting genre content, they're probably referring more to horror, sci-fi, or fantasy.

We've made an adaptation of a David Garrick play, so a "light period drama," and we've made and written a "dark comedy thriller" and a "mythological folk horror." We've also got on our slate a zombie comedy, a comedy heist, a supernatural thriller, a vampire comedy, an adaptation of a nineteenth-century novel, and a drama set in the 1990s and present day. All of these have been ideas that have come to us by all sorts of different ways and means.

We were approached to make *Miss in Her Teens* into a film after we did the theatre production of it. In fact, it was while we were sitting in a pub in South London, having just performed it at The White Bear in Kennington, that the idea came about. This is a tiny pub theatre, where sport for the regulars takes precedence, so if there's a big match on, your cue might well be obliterated by the sound of football fans' cheers coming from the bar. It's an interesting experience to say the least, especially when battling through the crowded bar in full wigs and eighteenth-century cos-

tume to get around to the other side of the theatre for your next entrance. Not that any of the football fans noticed, as they were too engrossed in the beautiful game. Even Ian McKellen who came down to watch our play remained fairly incognito, only when he came away from the bar did the guy standing next to him do a double take, nudged his mate, and said, "Here, that's Gandalf isn't it?!"

It was Ian in fact who suggested that we make *Miss in Her Teens* into a film, more for posterity than anything. The play's writer, Garrick, was in his time a giant of the theatre and one of the most famous actors that has ever been; his writing, however, is much less known, partly perhaps because he was a much better actor than he was a writer. My father agreed that it should be filmed and felt that schools and colleges might be interested in a filmed version of the work for educational purposes. We also wondered if it might work as a one-hour television pilot, the idea being that we could make a series of these forgotten plays. The market for that unfortunately wasn't entirely there; we'd adapted the script into a screenplay sticking as closely to the original text as possible (see figure 6). In hindsight, it would have been more sensible to have allowed ourselves a little more freedom and artistic license with the adaptation, enabling us to make it more commercial for a modern television audience.

When a sales company in Canada approached us for the rights to *Miss in Her Teens*, they asked if we might be able to extend it by another ten minutes, therefore enabling them to sell it as a feature film. Sixty minutes is a tough sell, but anything over seventy is classified as a feature.

So, having stuck strictly to Garrick's original words and story, we then had to fabricate a war scene for the beginning, a flashback to show Biddy and one of her oddball suitors, and then a wedding scene at the end (see figure 7). We gathered all the cast and crew back together again, after over a year of completing filming the first time around.

2 EXT. A FIELD IN ENGLAND - DAY 2

...And into this scene. He is now in a field. Lots of noise in the distance from a battle. He walks and we move with him.

> PLAYER
> (Continued)
> ...whose hopes on comedy depend, Must strive instruction with delight to blend, While he, who bounds his less-aspiring views, To farce, the combrush of the comic muse, With pleasantry alone may fill the scene; His business chiefly this - to cure the spleen: To raise the pensive mind from grave to gay, And help to laugh a thoughtful hour away.

He stops and gestures towards a small building where there is movement and smoke.

CUT TO:

3 EXT. FLANDERS - DAY 3

Low camera shot. Lots of smoke, the noise of guns being fired, cannon balls flying through the air, men shouting. Men's feet run past the camera as CAPTAIN LOVEIT slumps down behind a folly to catch his breath. He is covered in dirt and gun powder. He pulls out a letter from his jacket and we slowly move forwards.

> BIDDY V/O
> Dearest darling Rhodophil, my love for you remains fixed and ardent. These long six months past since your being called away, have weighed heavy in my heart. My ears tingle, my face flushes, my heart beats and I tremble every joint of me until your return.

PUFF runs into shot and flops down next to him. CAPTAIN LOVEIT hastily puts the letter into his jacket.

> CAPTAIN LOVEIT
> Puff, what news from the Commander?

> PUFF
> It should be one final push to break the line, Sir. Pray, Sir, may I be so bold...

(CONTINUED)

FIGURE 6

Miss in Her Teens extra scene script page

FIGURE 7
Miss in Her Teens War scene still

For *The Isle*, the idea came from someone who had worked on *Two Down*. Louis Devereux was a spark on our lighting crew and asked us if we might consider looking at an island that his family owned in Scotland. He was desperate to make a film up there, and so we agreed to go up for a recce. We flew via Glasgow to Fort William, from Fort William to Coran, a short ferry ride, and another couple of hours' drive to eventually arrive at the magical Eilean Shona, only accessible by boat (see figure 8). The island has no roads and is unspoiled with spectacular scenery wherever you look. As soon as we saw this incredible location, we knew we had to write a screenplay to shoot there; in this case, it was the place itself that dictated what kind of story it was going to be. We looked into the history of the place, of stories from the area, and various things stuck with us, like the food plight of the 1800s, and that is what was the springboard for the idea.

Our other ideas have come from all sorts of things, such as reading books suggested to us by friends and family, although always be mindful of rights to stories. Books and biographies can be tricky to get the rights to, and the estate will often ask for a lot of money even if they agree to let you

FIGURE 8
Eilean Shona, location for *The Isle*

do it. And even when you think you might have agreed rights to something with a family, you never know who might appear out of the woodwork and make claim to it. We tend to stay away from projects like this unless they are out of copyright. This is easy to find out, but on the whole books published between 1923 and 1978 are protected for ninety-five years from the date of publication in the United Kingdom. If the work was created, but not published, before 1978, the copyright lasts for seventy years after the author's death. We have up until recently only written our own original fictional screenplays, but there is a wealth of material to be gathered from other works. Some of the greatest films ever made are adaptations of novels, plays, or autographical pieces about real people or events.

"When I said to Richard Eyre, can we film it? He told me we needed a script. So when I showed him the script he said well this won't do, this isn't for the TV, this is for the cinema. How do you think you're going to get this made? I can't direct it, I'm running the National Theatre, you're on your own. . . . So it

was me, my sensing it would make a good film and I think I was encouraged by Branagh, having done Henry 5th. When I saw how wonderful it was and how well received it was and that it was possible to challenge (Laurence) Olivier's pre-eminence in Shakespeare on film, I was able to go around to people and say, look it worked with Henry 5th."

—*Ian McKellen*, Richard III

"As you know, story is the architecture and the structure of what happens, the scenes and sometimes you have to collapse scenes. And there's a thing which is surprising which is repetition, we've had this scene before. It might be different characters in a different place, but somehow the rhythm of it, the meaning of it has been expressed, you're not really learning anything new from the scene, it's just reiterating . . . in books it doesn't seem to matter because so much can be papered over with language. . . . *The Godfather* is so special because he had the freedom to say fuck that scene. . . . If I did *Vile Bodies* again, I'd probably be less nervous about the book. . . . If you want to make the film, you have to make the film . . . otherwise if you want to please the author and people who love the book, then the best way is to put it on a lectern and point a camera at it and every minute turn the page. But if you want to make a film, you have to get rid of that idea."

—*Stephen Fry*

We might also get ideas from what is popular or trending, or from articles that we've read on certain subjects. For example, we became fascinated with quantum physics and the idea of parallel universes, so we wrote a sci-fi thriller based on the quantum theories we researched. I, Tori, developed an interest in a particular music genre and wanted to write something incorporating that, and Matt was inspired to write a comedy horror after listening to a story my grandfather told in his nursing home. We've seen the slow development and gentrification of Soho in London and wanted to write something that highlighted the changing landscape and diversity of the capital city. Whatever and wherever an idea might spring from or develop into, make sure you get it down on the page. And from

there, do your best to copyright it! In the United Kingdom, you can use something called The Script Vault, and the United States has the Writer's Guild of America. We tend to register with both, just in case.

WE ALWAYS WRITE WITH BUDGET IN MIND

Because we are producers as well as writers, we can't ignore the more practical side of filmmaking when we're writing: how it's actually going to be made and how we're going to find the money to make it. A lot of writers don't have to think about the aftermath and practicalities of budget and cost, but it can be a very useful thing to bear in mind, especially if at the end of the day you actually want your screenplay to be made. Often, we'll have an idea and think, yes great, the protagonists could totally do that, but then think about how you might actually go about filming that and what that might cost. Even from the script stage we will rewrite certain action scenes or descriptions of sets to give a greater idea of how it might be filmed in order to keep costs down. For example, instead of writing "the hero pushes the villain out of a window, it smashes into hundreds of pieces and as the villain falls our hero looks out to see him plummet ten storys to his death," we might break up the action and alter it slightly by writing "the hero pushes the villain who staggers backward toward the open window. Cut to: the hero's eyes widen and he rushes forward toward the window, the villain no longer there. Cut to new scene: the street, and the villain lying dead on the pavement. Camera pans up to an open window and our hero."

It tells the same story but we're now going to have to rely on the actors to sell the story, and we've saved on computer-generated effects of a man falling ten stories and the shattering of sugar glass, which you'd need several of for each take. Those simple few shots could end up costing a lot if done properly, and they could look terrible and cheap if you haven't the budget to support the idea fully. To any potential producer or investor reading your script, in their mind they're clocking up how much it'll cost. It could be a factor as to whether your screenplay gets made.

Big crowd scenes are another one, especially in epic historical pieces. Do we really need to see the coronation of Elizabeth I when the film is actually about her lady in waiting Bess Throckmorton and her secret marriage to Sir Walter Raleigh? If most of the screenplay consists of small, contained scenes showing the two characters' enduring love for one another, then this period drama becomes much more doable on a smaller budget. But a sudden massive scale scene thrown in with hundreds of extras, costumes, wigs, makeup, horses, and coaches suddenly makes the scene totally impractical compared to the budget level of the rest of the film. We try to almost keep a number in our head when we're writing and write the scenes within that budget parameter.

"You have to look at a screenplay if you're going to finance it or sell it, you have to have the screenplay as 'right' as possible, whatever that means. Scripts are often too long, they're often too wordy, too much dialogue. When you make a film, every page you've got costs money, so the shorter the screenplay the less money the film will cost. It's an important factor when you're starting out, and usually what you find is you film too much and then edit it down anyway. If you find a screenplay an interesting page turner, you want to keep reading, that's a good sign, if it starts to become laboured that's a bad sign."

—*Gareth Jones*

That's not to say that we might not include a scene that may require a bit more money and will up the overall production value of the film. By this we usually mean thinking cleverly about our locations. We might set a scene outside a large country house or super slick modern beach house. You can shoot the exterior scenes at the location for just one day of filming and get some great "money shots" and then place the rest of the action inside which can be shot anywhere, in a studio or another room that can be dressed to look like the interior of the country house.

For another example, you can give your indie thriller movie some more production value by adding a fight scene that will require a stunt supervisor

and some choreography. It will up the pace and action of the overall piece and, if the fights are executed, shot, and edited well, transform how the buyers see it, partly because they can now put some of it in the trailer, which is ultimately how they'll sell the film to the public.

WE TEND TO WRITE AROUND LOCATIONS WE KNOW WE CAN GET

This particularly applied to *Two Down*, our first original screenplay which has been made and is our second feature film. After working for five years on *The Curse of The Buxom Strumpet*, with little to show at the end of it, we were determined to make something. We'd realized that it couldn't be a big budget thing if we wanted to make it soon, so we wrote a script that was as close to a play as we could make it. The idea was to have three people in one room. It was really as a challenge to ourselves to see if we could actually write something that was that contained, especially after writing *Buxom Strumpet*, which has something insane like fifty locations and thirty characters. The answer, however, was no we couldn't. We're not good enough writers to do that and keep it compelling and interesting to watch, but we got pretty close. It's also the wrong medium for a ninety-minute film to be set in one room really, so it got a lot bigger than we first intended.

Two Down is a dark comedy about an Aspergic hitman. John Thomas (Alex Hassell) is injured in war and forced into an underworld of contract killing. His brother, Sam (Nick Rhys), introduces him to Harry Montague (Conleth Hill), a wealthy businessman with "a lot of fingers in a lot of pies." Harry has an old debt he wants to settle and sends John to kill Psycho Jones (Gil Sutherland). John can't go through with the kill when he discovers Jones is a very old man who is practically blind. When Harry hears about this, he orders a hit on John. No one disobeys Harry Montague, and he gets John's own brother, Sam, to do it with the help of his right-hand woman, Rhona (Emma King).

All of this is told through flashback scenes. The main action of the film happens when John is injured, not killed as hoped, and seeks refuge

in a safehouse he used to use. However, instead of his old friend he finds Sophie (Tori Butler-Hart), a young woman who seems angry and upset to be held at gunpoint in her own flat. While she patches John up and he tries to work out who is after him, they are interrupted by Luke (Graham Butler), delivering the food Sophie had ordered before John's arrival.

We're then left with our three characters in one room, John the hitman, Sophie the awkward hostess, and Luke the lovable young writer. The three eat, talk, and eventually work out that it was in fact Harry who ordered the hit on John and that Sam and Rhona are coming for him. The film flits between Sophie's flat and Sam and Rhona, either in a coffee shop or in a car. Three locations. The rest of the story is told through flashbacks: Harry in a restaurant, which we filmed in a pub we knew we could get; Sam telling John about Harry, at a pub around the corner from our house; and Psycho Jones's flat, which was filmed in the flat below us that hadn't been redecorated since the 1970s. It still had the amazingly dated wallpaper and was pretty much a readymade set (see figure 9).

And that's what we did; we wrote the screenplay around places we knew we could get for free, or if not free, very cheaply, and we also made sure that most of it was within a mile radius of our own place as we could use that as a unit base. All costume, makeup, and production offices could

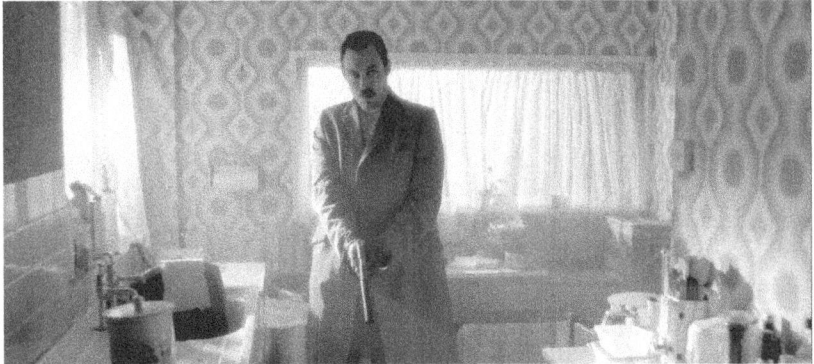

FIGURE 9
Two Down Psycho Jones's flat

be there while we were grabbing all the little flashback scenes and then we relocated to the apartment, a mile from our flat, that we'd hired for a week to shoot the bulk of the action. The only time we ventured further afield was to shoot the scenes with Conleth Hill. We wanted a very different look for his plush restaurant and apartment and so we asked Ian McKellen if we could use his pub, The Grapes, in Limehouse (see figure 10). It's right on the River Thames and so gave us that little bit of extra production value. The point was, by writing the screenplay to fit around locations we knew we could get and by keeping those locations contained, we saved on time and money and, in the end, enabled the film to be made because the budget was kept so low. How low you ask? Matt won't let me say but watch the film and see what you think. We did the same with our films *Miss in Her Teens* and *The Isle*. Both films we shot in locations we knew we could get for not crazy amounts, because what we've found is that at the end of the day writing a screenplay with a budget in mind really helps to get it made. If we couldn't get a location we wanted, we'd

FIGURE 10
London skyline in Limehouse with Actor Conleth Hill

rewrite the scene to work somewhere else. We didn't lose any of the story or characters beats or arcs, and that meant we weren't trying to recreate something without the money to make it work properly.

However you write your script, and there are hundreds of books that will tell you how to write a screenplay, no matter if you adhere to the three act template and track your plot points and moments of conflict, or create your characters and see where they take you, whatever it is, you have to believe in your script. Not to the point of total oblivion—know when and where to take constructive criticism and use it. But then again, everyone will always have an opinion so try to also know when to say "thanks very much but I believe that it needs to be like that and this is why." At the same time be prepared to adapt, you might have to sacrifice the image that you have in your head as the writer, for the obtainable image that can be achieved in reality due to budget restrictions or production choices. One of the most helpful things we've learned as filmmakers, and this includes as writers, is the ability to wear many hats. Always keeping a producer's, a director's, an investor's, and an actor's perspective when writing.

3

Financing Films: Faking It and Making It

This is the one part of being a filmmaker for which we all wish there was a golden ticket. We wish there was a quick, easy step-by-step guide, a simple fund with an easy application process, or a key to the palace doors. Every filmmaker is searching for the answer to that eternal question, "how do I get my film financed?" Unfortunately there isn't a straightforward answer, or at least we certainly haven't discovered it, nor have we met anyone who has.

What we have found is that there are many different ways to gather the money together to make a film, some of them we've done, some of them we haven't. We'll attempt to break them down and look at which ones have been successful, which we've totally failed at, and which are quite simply unsustainable.

There are myriad ways of generating finance for your movie: credit cards and your own money; other people's money like family and friends, perhaps through a crowdfunding campaign for which you offer no monetary return for your backers; through private equity, money that a friend or family member invests in the project and from which they expect, at some point in the very distant future, to see returned to them, preferably with

interest; and money from companies that invest in film like Great Point Media in the United Kingdom, which has a range of projects that they put into portfolios for their investors. These portfolios will hold television shows, small low-budget indie films and bigger-budget indie films. There are tax incentive schemes that can be used to help finance a film by setting up a special purpose vehicle or by setting up a company for your film and gathering investors who will benefit from investing in your company (the film) by getting a tax rebate. There's "soft" money (i.e., money that you apply for and is then awarded to you from a governing body like the BFI or Creative Scotland in the United Kingdom and few grants in different states in the United States [although there's a lot less soft money in North America]). There is gap finance—this can come from any number of sources but it comes in last, to fill the "gap" in your finance, and it usually requires the most or highest interest in return. There are ways of finding money through a post-production deal or a pre-sale deal with a sales company. In the United Kingdom, there is a 20 percent tax break that you can get cash flowed, and in the United States, a lot of individual states have their own tax incentives, all a little different from the others. All of these we will attempt to delve deeper into and explore the ins and outs of obtaining them, juggling the enormous Jenga game of film financing. However, before you even begin that joyous struggle, you need a budget and a finance plan. You need to know the value of your film and your team. You need to be realistic in that valuation. And you need to be respectful of your investors, the people who have placed their trust and money in your hands.

"Independent filmmakers have long made the mistake of having the 'by any means necessary' mind set about filmmaking and 'once you have the money, you're the king and fuck the investor, what do they know anyway, and I got to make my movie.' Well the truth is anyone who's got that kind of money is probably pretty damn smart. Money moves, it will go away, so you have to have some intelligence in order to maintain wealth, there's no two ways about

it. And that has to be respected. If somebody is putting in 2 million dollars that's not a small amount of money."

—*Steven Adams*

"As we know, lots of producers don't pay attention to the investor. They take the money and run and it's sad in a way. I also think that sometimes they think that they're entitled to the money in some way, it's almost like 'I can be as creative as I like because you've given me the money now.' So, one of the other things we are very keen on is that we like commercial films. That's not to the detriment of not winning awards. If it's commercial and artistic then we're interested. If I was going to prepare someone coming out into the industry, that would be my first lesson. I'd assume they were very creative, I'd assume their eye for detail would be good, but that eye for detail in the film needs to be for business affairs as well."

—*Kirsty Bell, Goldfinch founder and chief executive officer*

How much your film is going to cost is a bit like asking yourself the question, how long is a piece of string, because as a piece of string can be any length, so can a film really be done for any amount of money, within reason. Yes, of course there is always a baseline, a bare minimum that you would need to get your film made. But everyone's bare minimum is different. Quite often we'll be asked to look at a budget and see if there's a way to reduce it. More often than not, the answer is yes of course, but how much does the producer, writer, and/or director want to make their film?

"The first thing you need to think about is the scale of your film, the next thing is does it occupy a genre, because genres sell and genres can be horror, thriller, comedy, even romance. Are you occupying a particular genre? Just straight drama is not particularly sellable. Then you have to measure up your filmmaking talent, your director in relation to what your budget is. So if it's a first-time director and you're trying to make something for three million, that's not going to work. A first-time director makes something for a few hundred thousand perhaps. Then can you get any acting talent on board? Another

thing to consider is if you're going to attach a name to a project, even if they only work for a few days. Can you attach someone as a cameo, or a smaller role, and use their name as part of it and give credibility to the project and to get other actors involved."

—*Gareth Jones*

In a budget there are lines; each line item on the budget equates to a different aspect required to make the movie. This is where the title "Line Producer" comes from, because they are in charge of the budget. They will often be the ones who have created the budget and will oversee it through pre-production, production, and through to completion of photography and sometimes through post-production, to make sure the money has been spent where they predicted it should be and that no line is going over budget.

A budget is split between the above-the-line and the below-the-line (see figure 11). The above-the-line tends to be referred to as the figures that aren't going to change. They're the buyouts or fees that the director, writer, producers, and main lead cast are expecting. It also includes main cast accommodation and travel. The below-the-line figure is everything else; your crew costs, camera equipment, lighting, sound, production design, art budget, costumes, makeup, facilities, set builds, travel, transport, food, crew accommodation, supporting artists, stunts, visual effects, special effects, edit, grade, music, publicity, festival submissions, and distribution deliverables. This is the figure that can fluctuate drastically depending on the script and what level of budget you're aiming for.

Often, we'll see that a small indie feature film budget might have a disproportionately high above-the-line figure. This might be because of two reasons. First, the filmmakers are hoping to get some "big names" and so therefore want to set aside a large amount for key cast fees. That's totally understandable. You want—in fact, unfortunately more often than not, need—big names to sell your film. Names attract sales companies and dis-

Budget Title :

Script Dated :
Budget Draft Dated :
Production # :
Start Date :
Finish Date :
Total Days :
Post Weeks :
Holidays :
Travel Days :

Producer :
Director :
Location :
Prepared By :

Acct#	Category Description	Page	Total
1100	STORY RIGHTS & DEVELOPMENT	1	£60,000
1200	PRODUCERS	1	£60,000
1300	DIRECTOR	1	£20,000
1400	CAST	1	£73,575
1500	ATL TRAVEL & LIVING	3	£13,350
	Above-The-Line Total		**£226,925**
2000	PRODUCTION STAFF	4	£86,940
2100	EXTRAS & STANDINS	5	£3,800
2200	SET DESIGN	5	£21,125
2300	SET CONSTRUCTION	6	£3,000
2400	SET DRESSING	6	£5,000
2500	ACTION PROPS	6	£2,000
2600	SET OPERATION	6	£9,700
2700	WARDROBE	7	£18,400
2800	PICTURE VEHICLES & ANIMALS	7	£2,650
2900	HAIR & MAKEUP	8	£12,575
3000	SET LIGHTING	8	£23,900
3100	CAMERA	9	£42,225
3200	SOUND	10	£13,300
3300	TRANSPORTATION	10	£20,650
3400	LOCATIONS	11	£94,600
	Below-The-Line Total		**£359,865**
4000	EDITING	13	£8,000
4100	MUSIC	13	£40,000
4200	POST PRODUCTION SOUND	13	£10,000
4300	POST PRODUCTION VIDEO	13	£17,000
4400	VFX	14	£5,000
4500	DISTRIBUTION EXPENSES	14	£12,000
4600	ADMINISTRATIVE EXPENSES	14	£41,500
	Post Production Total		**£133,500**
5000	Contingency	16	£30,000
	Total Above-The-Line		£226,925
	Total Below-The-Line		£493,365
	Total Above and Below-The-Line		£720,290

FIGURE 11
Budget topsheet example

tributors, because names sell to a wide audience. We all do it—when we're skimming through the massive amount of content that's available to us on demand, we look for who's in it or at least who's made it. Because for some reason we think that that's an indication or benchmark of a film's quality.

"Down on the more independent level you have to cast well, cast as visibly as you can. Because the difficulty I guess is, is that we're in an era, a noisy era, and it's never been easier to make movies, as hard as it still is, but generally it's easier as we're not dealing with film and laboratories, people are making great films on iPhones. . . . When you approach a major star and say you have $10,000 to offer them, but they make 5 mil, the difference represents an investment on their part in your film, because they're bringing that level of value to your film. If you don't have the money you have to acknowledge that, what are you going to give them to compensate for that? That I think is the missing link often when people approach talent. Come in open to negotiating with someone who is valuable. You know they're valuable, that's why you want them, so your business model needs to reflect that. . . . A lot of distributors will vet cast with you before you make offers and you can still be creative with it, you don't have to be forced into a corner. You've got to get that magic balance of the story being told with the right people telling it and still make sense to the market."

—*Steven Adams*

"We were making our first feature on an insanely low budget and . . . we found Ben Whishaw and approached him and he said yes he wanted to do it. And then we went to the execs and said, look Ben Whishaw wants to do it and therefore we'd like to shoot in November because that's when he's available. And one of the execs said 'oh I don't think you should shoot it this winter because I don't see it as a winter film.' And I was like, 'I'm sorry but I see it as a winter film and . . . we have Ben Whishaw, by January he'll be in a play' and the exec said 'well it's a testament to your script that Ben likes it, so he might not be in it but you can find another person.' It doesn't work like that, we might not get another actor of that calibre."

—*Hong Khaou, talking about the casting process on* Lilting

"Cast, you're just stacking up sales verses cast, and so if you want to pay an extra £100k, is that going to come in under sales, and when you plug it into your spreadsheet, how much of those sales are you actually going to see back to contribute to your budget, rather than thinking, oh it doesn't matter because

we're going to get an additional 1 million in sales for spending another 500k on cast. Actually, does that net down to that 500k, what other hidden stuff is in there like SAG with extra costs and fees."

—*Phil McKenzie*

Another tricky thing with getting big names attached to your film is that along with them comes an expectation from their agents that they will receive a certain level of travel, accommodation, and on-set facilities. This will all add up and increase your overall budget, especially if all of your main cast end up requiring their own trailer, five-star accommodation, and individual cars for driving them to set each day.

The second reason that the above-the-line can creep up is because of how much the producers, director, and writers are all paying themselves. Yes, making a film is bloody hard. It takes a long time. Years. And when those years of development are over and the tiny amount of time spent on production is through, you then have more years ahead trying to sell your film and get it out there for people to see. A producer's job is never done. In fact, it's taken us ten years to realize why producers pay themselves so much even from a small independent film, because although it seems a lot of money at the time, that money has to cover the time spent over the years and years of work that's involved and allow you to be able to devote the time needed to get it done.

We have never paid ourselves a whopping big figure, the reason being, we love working for free?! No, but we wanted to make a film. We wanted to make more than one film; we want to make lots of films. And how we've made the ones that we've made so far is by keeping the budget down. Unfortunately, that includes keeping our fees down as well. If you, the director or producer, are really passionate about your project and about making your film, we believe nothing speaks louder than taking a smaller fee. It shows that you believe in your film and you're prepared to make sacrifices to make it happen. You're expecting people to invest their

hard-earned money in your film, so why shouldn't you be prepared to invest your own time into your film. Yes, it would be wonderful to be paid enough to comfortably support ourselves by just making independent films—that's the dream and the aim. But we're not going to get there by starting out like that. Quite simply, the more you pay yourself, the bigger the budget is, the more money you have to raise, and the longer it will take to raise it. And speaking to people like Sir Ian McKellen, Stephen Fry, and countless others, it's not just us who have had to sacrifice fees to get our films made, which is nice to know.

"There's a tension between us as artists and people who just want to make money. Three days before the end of the film, Richard and I had to give all our fees back to make sure we could finish the film. Thank goodness we hadn't spent it."

—*Ian McKellen*

"Someone pulling a plug . . . we had a little office in Pinewood and I was writing thoughts out for each scene and the phone went and there it was, I had to put some of my own money in for a short time. Everyone always tells you not to, it's a disastrous idea, but it was for a bridging moment and fortunately it turned out alright."

—*Stephen Fry*

"There's a bitterness about the scheme because I felt it was so little money, and it's only with hindsight that you can say this, I didn't get paid, right, me and the producer didn't get paid. . . . And if we were to pay ourselves it would have been about £1000 or something, but we put it back in for catering or whatever. All the execs really benefitted from it, they put on talks and events on how to make indie features, how to distribute indie features and everyone was making little side money from it and I'm still working in a pub part time. For about two years after completion of the film, I felt I was still struggling with money."

—*Hong Khaou*

> "You've got to cut your cloth with these things, you have to create a family that wants to make the film and there has to be a degree of egalitarianism otherwise it won't work . . . e.g., pay the producer the same rate as the [heads of department]."
>
> —*Margaret Matheson*

The next aspect that we take into consideration when looking at reducing the budget of a film is the script. Is there anything that jumps out as being a potential money pit? Are there any scenes that require lots of special or visual effects or things that could easily go wrong or be problematic to shoot, like underwater scenes or big stunts or action vehicles? Is there anything that will take more time to get, like working with children due to hour restrictions? Sometimes getting the performance that the director wants can take longer when using younger actors or animals; they really can take ages to get the right performance, no matter how trained they are. All of these elements will contribute to either more cost, more time, or both. So, we ask, is the scene absolutely vital to the story, or is there another way that it could be shot or story be told to achieve the same result? Often the answer is yes, and you can reduce the budget that way.

The other main factors that will affect your production budget are your crew size, how much you pay your crew, and your locations. These elements will have a knock-on effect to the rest of your budget. For example, take the number of crew you have: you have to feed them all, at least two meals a day, and if your location is far from where they live, you have to accommodate them and give them a per diem for any additional meal that you haven't provided. The more crew you have, the more expensive it will all be. You also need to pay them and then you have to decide what rate you're paying them. Is everyone on the same pay rate, or does the pay rate slide depending on their job title and level of responsibility? For example, your cinematographer will usually be paid a much higher pay rate than one of your runners: more crew, more fees, more budget.

And then there's locations; if they're close to where your crew live, say, London in the United Kingdom, then you don't have to pay for accommodation, but you do have to pay higher location fees usually. Are your locations close to one another, saving time with less travel and therefore the number of days needed to shoot the film? Save on time, you save on budget.

"Have a budget that's achievable, £5 mil is a lot of money, if you're trying to make something for a million that can be more achievable. As long as you have sufficient production value for what you're trying to achieve . . . is there a way of writing something interesting that keeps the budget low? More contained environments, or using natural locations rather than builds."

—*Gareth Jones*

"Here what you really need for a filmmaker to succeed is to actually work with someone who really understands business and treat each film as a little business that needs to show how to get a return on a business and make yourself appealing to a potential investor. That means a certain kind of thinking, taking the fat out of budget, being as clever as you can about your locations and getting as much as you can get for as little as you can get it for."

—*Steven Adams*

These are all aspects that we take into consideration when looking at saving on a budget, but how do you even start to budget a film in the first place? This is something that we've taught ourselves because we didn't want to keep paying someone else to do it for us. In addition, it's useful to be able to work and adapt a budget to fit a screenplay that might go through several different drafts and budget levels. (By budget levels we're referring to: [in the United Kingdom], "no budget"—under around fifty thousand pounds, "micro or very low budget"—under £250,000, "low budget"—up to one million pounds, "mid-level budget"—up to five million pounds, and that's as far as we'll think about covering!)

HOW TO BUDGET YOUR SCREENPLAY

Tori is the one that does the budgets, so this part is written in the singular person rather than plural!

I'm not a professional line producer, so the way I budget a film might be very different to others who do it for a living. I've used two different pieces of software: one called Movie Magic which is pretty much what everyone in the industry uses and the other is Gorilla. I personally prefer using Gorilla, just because I find it a little more user-friendly. I'm terrible with computers and technology and anything that requires any kind of tech-savvy knowhow; the fact that I've called it that might be an indicator as to how clueless I am about this stuff! So I've taught myself how to be able to get by using this software. The internet is a wonderful thing with many, many useful videos for when you get stuck!

Before you draw up a budget you need to know how long it's going to take to shoot your screenplay. Now, I think a lot of people will decide on a four-, five-, six-, or seven-week shoot and then just budget according to that. Because we are more often than not looking at all possible ways to save money, I tend to want to have a clearer idea of exactly how many days we'll need. So, although your first assistant director (AD) will do their own brilliant schedule I like to draw one up at the budgeting stage to know exactly how many moving parts there might be and any problems that might present themselves.

What I've often done is use Excel to begin with. It's nice and easy to plot out a diary of your shoot; from the ideal date that you want to start your prep, to get-in days at your locations, travel days, shoot days, days off, more shoot days, travel days, get-out days, more get-in days, etc., . . . you get the gist. I'll do this before I put the script into either software to schedule. Even though the amazing software will do all this, I like to have a timeline in my mind before I begin, and I'll continue to use that throughout the prep process, adding in notes like location recces, cast availability, rehearsals, contact info and addresses for locations, etc.

Then I upload the script into the software and begin the process of creating a stripboard. This is when your clever software breaks down all your scenes into strips. We've discovered that if your writer, in our case us, has not formatted their script correctly with the EXT/INTs, same headings for the same locations and said what time of day each scene is set, then this will not transfer over to your scheduling. Meaning that you have to manually then go through and check the location, time of day, INT/EXT, and the characters in that scene are all there, present and correct. Making sure the characters in each scene are listed properly is particularly important because you'll want your software to create a DOOD. This is a Day Out Of Days list of all your characters and will tell you how many days each of your actors are required and what days off they'll have. I'll come back to this, but it's very handy when budgeting.

Once all the information about each scene is all there, I'll go through the strips and take all the scenes that are in the same location. They'll go together in their own blocks, as in the following:

INT. LIVING ROOM—DAY

INT. LIVING ROOM—DAY

INT. LIVING ROOM—AFTERNOON

EXT. LIVING ROOM—EVENING

INT. LIVING ROOM—NIGHT

EXT. LIVING ROOM—NIGHT

INT. KITCHEN—NIGHT

INT. KITCHEN—EARLY MORNING

INT. KITCHEN—DAY

Then I'll look at the other scenes that might be in various different places, but usually we have a fairly good idea of what our locations are going to be, so I'll have an idea of geographically what's close to what. They can go in another block, like this:

EXT. GARDEN SHED—DAY

EXT. SWIMMING POOL—DAY

EXT. DRIVEWAY—AFTERNOON

INT. COFFEE SHOP—MORNING

EXT. THE CASH POINT—DAY

There's something else that's extremely helpful to look out for when scheduling and that's the page count. Each strip will tell you how long the scene is by breaking it down into eighths. When I first saw this, I had no idea why or what this fraction was, but it's incredibly simple. When you look at a page of text it quite simply breaks down the page into eight equal parts and your scene will take up any number of those parts. It might be just a small action or establishing scene, so on the page it'll take up just one-eighth. Or it might be a long dialogue heavy scene and be four pages and two-eighths.

If we don't know any of the locations when I'm first plotting out the schedule, I'll look at the length of the scenes. If it's a nice long five-pager then it'll have its own day. If I've got three half-pagers then I'll group them together as another block, like the following:

INT. KITCHEN—NIGHT (5/8)

INT. KITCHEN—EARLY MORNING (1)

INT. KITCHEN—DAY (1 4/8)

EXT. GARDEN SHED—DAY	(4 1/8)
EXT. SWIMMING POOL—DAY	(2 3/8)
EXT. DRIVEWAY—AFTERNOON	(1/8)
EXT. COUNTRY LANE—NIGHT	(6 1/8)
INT. COFFEE SHOP—MORNING	(3)
EXT. THE CASH POINT—DAY	(2/8)

Once all the strips of the entire script are rearranged in accordance to their locations and page counts, I can start to add in the day breaks. This is when I'll look at the average pages per day. If we're working a script that's one hundred pages long and with a micro budget figure of roughly £230,000, we might try to shoot it in eighteen days, so three six-day weeks (one day off a week). But with get in/get out and travel days, that might only leave you with fifteen days to shoot, averaging 6.6 pages per day. That's totally doable if you've got some longer dialogue scenes or if your screenplay is fairly contained with few locations and moves. But if every scene is an eighth here and two-eighths there (meaning you're traveling a lot or have lots of different set ups within a location), you might struggle to make your six to seven pages per day.

On *Two Down*, our record was shooting fourteen pages in one day. But that was three very still and dialogue-heavy scenes in the same location. We did long takes, with tracking camera movements and very few shots and only a few choice close-ups. And the actors knew all of their lines!

So you've got your day breaks in and your screenplay is now divided into eighteen days: fifteen shoot days, a get-in day, a get-out day, and a travel day. This is when there starts to be a slight juggling act because you

have to weigh up wanting to save on time, and therefore money, with the way your shoot is going to flow. For your actors and often your director it might be preferable for them to shoot as much as possible in chronological order. For the actors it's easier for them to keep a track of their emotional arc throughout the film by starting at the beginning and finishing at the end, and for your director it might be easier to keep a track of how the film is shaping up and how the look and visual continuity of the film is developing from beginning to end. This is, however, often not possible for any number of reasons: actor availability, location availability, or if your script jumps from one location to another and then back again. If you're working to a tight timeframe, any unit moves and changes in locations will always eat up huge amounts of time.

Once I'm reasonably happy with the schedule and I've got it to fit into the timeframe of shoot I was hoping for, I'll draw up a DOOD. This is the schedule of days that any character is needed for and will show up from the stripboard that I've done, and when their days off are.

Again, this is another juggling act because ideally you want an actor's days to be as consecutive as possible. It's not ideal, especially if you're filming on a location far from where they live, to travel them down to shoot for one day, then back home for three days, then back for two days, then home for two (or keep them on hold for two), then shoot for one, then home for four, then back for one. The DOOD for that would look like this:

SW H H H W W H H W H H H H WF

SW stands for start work, H stands for hold, W stands for work, and WF stands for work finish.* In this scenario your actor is required for fourteen paid days, but only five days on set. There are SAG rules in America that say how long an actor can be "held" on pay and when they

*There are other abbreviations that crop up; these are listed in the glossary section.

can be "dropped" (i.e., not paid for the days they're not needed). In the United Kingdom, it's slightly more lenient and on a micro budget film, you can probably negotiate with the agent as to what days are paid held days and what days are dropped unpaid days. This can all come down to whether you want to keep your actor on the days in between just in case you run over and need them for a scene the following day. If they've gone home and you've released them, then you obviously can't shoot that scene.

If you are paying your actor a day fee instead of a buyout fee, then it can make a big difference to your overall budget as to how contained your DOOD is. For example, if you are paying your actor roughly equity minimum, that's about £150 per day so £2,100 in total based on the example DOOD we're using here. But you can move your schedule around slightly so that their shoot days are more consolidated, like so:

SW H W W H W WF

This way, you're only paying for seven days, so a total of £1,050. If you've got ten cast members and you do the same for each of them, then that's quite a saving. You'd also be saving on accommodation costs: instead of fourteen nights in a hotel room, it's down to seven, again a potential big saving.

From your DOOD you can start to put into your budget software your above-the-line figures for your main cast, as well as the other amounts for writer, director, and producers.

These will either be worked out via a day rate and the number of days required, or as a buyout. It can be helpful to think of everyone being on a day rate, so your buyout figures don't go wildly out of proportion. Taking our eighteen-day shoot scenario, the director might be on £175 per day, plus he will be required for prep days and rehearsals and some post days to oversee the edit and grade. Say you allow three weeks of prep (fifteen days)

and two weeks of post (ten days), that's a total of forty-three days at £175, equaling £7,525. So, a buyout figure of between seventy-five hundred and eight thousand pounds wouldn't be crazy. Obviously, the edit and grade on a film takes months not days, but on a micro budget of £230,000 you don't have the money to pay your director for every single day that they work alongside the grader and the editor. This is again when you have to ask yourself, how much do I want to make my film? And sacrifices just have to be made if you actually want to get it done.

Once you have your above-the-line figures in, you can get your total above-the-line amount. Then you move on to your below-the-line. This typically works through each department, and each department will be broken up into the different sections within it. For example: Camera will comprise of (1) the wages for the camera team; (2) materials and supplies, so consumables and hard drives; and (3) rentals, that's all the camera kit that you're renting. Within each of these categories listed are each of the items and their cost. So when you've finished your budget, every element that you can think of to make your film should be listed on a line in your budget and be accounted for. We'll go through this in more detail in the production section.

Of course, there are always things that you can't account for or that unexpectedly crop up, and that's why with every budget you have a contingency. A pot of money that in independent filmmaking, especially micro and low-budget, you will inevitably end up spending. The contingency is real; it is still very much a part of your budget and still money that needs to be raised. Even though it is not necessarily accounted for before you begin filming, it will definitely be accounted for by the end. We always aim to have a 10 percent contingency, that is an extra 10 percent of your overall budget set aside. On the very low budget of say £230,000, you set twenty-three thousand pounds aside for your contingency, leaving you with a figure of £207,000 accounted for within each line of your budget, both above- and below-the-line. We are the first to admit that often that

10 percent has had to be squeezed down to 8 percent or sometimes 5 percent. But there always has to be a small cushion there because you never know where you might need it.

After we've done all this, you're left with a stripboard schedule (see figure 12), a DOOD, and a budget breakdown that comprises of a top sheet, that is, all the totals of each category and the grand total of your budget, and then a detailed breakdown, which is every single line of your budget in each category and the grand total of it all. The next stage is to put together your finance plan. Simply put, how you're planning to raise the finance you need!

When someone first asked us for this, we felt incredibly daunted and a little bit sick. We still do but that's because we know how hard it is to raise it, but at the beginning we just didn't know what a finance plan was! There isn't really a go-to plan for independent films; every single one is financed slightly differently, but as it has become increasingly hard to get pre-sale deals, certainly since the golden era of the 1990s, and it seems even harder to find any soft money, private equity has become a bigger player in financing a lot of indie films.

If you're lucky your finance plan may look something like this in the United Kingdom:

UK tax credit (20 percent less commission = 17 percent)—£39,000

Pre-sales deal—£50,000

BFI or other regional funding (soft money)—£115,000

Private equity—£36,000

Or GAP if needed

TOTAL—£240,000

Sheet #:	Scenes: 4	N/A 0 2/8 pgs	EXT. Morning	SAM'S HOUSE	NORTH LONDON HOUSE 3	Scr. Pg.:	Unit:	
Sheet #:	Scenes: 5	N/A 1 5/8 pgs	INT. Morning	SAM'S HOME OFFICE	NORTH LONDON HOUSE 1, 22, 55	Scr. Pg.: 3	Unit:	
Sheet #:	Scenes: 9	N/A 1 4/8 pgs	INT. Afternoon	SAM'S HOME OFFICE	NORTH LONDON HOUSE 1, 4	Scr. Pg.: 6	Unit:	
--- END OF DAY 1 ---					--- 3 3/8 pgs. Est. Time: 0 min			
Sheet #:	Scenes: 12	N/A 3 /8 pgs	INT. Evening	SAM'S KITCHEN	NORTH LONDON HOUSE 1, 4, 49	Scr. Pg.: 8	Unit:	
Sheet #:	Scenes: 71	N/A 0 3/8 pgs	INT. Evening	SAM'S KITCHEN	NORTH LONDON HOUSE 4	Scr. Pg.: 62	Unit:	
Sheet #:	Scenes: 13	N/A 0 2/8 pgs	INT. Night	SAM'S HOME OFFICE	NORTH LONDON HOUSE 1	Scr. Pg.: 11	Unit:	
Sheet #:	Scenes: 15	N/A 1 7/8 pgs	INT. Night	SAM'S HOME OFFICE	NORTH LONDON HOUSE 1, 4	Scr. Pg.: 12	Unit:	
--- END OF DAY 2 ---						--- 4 5/8 pgs. Est. Time: 0 min		
Sheet #:	Scenes: 107	N/A 0 2/8 pgs	EXT. Sunrise	LONDON	NORTH LONDON HOUSE	Scr. Pg.: 99	Unit:	
Sheet #:	Scenes: 108	N/A 1 6/8 pgs	INT. Morning	SAM'S HOME OFFICE	NORTH LONDON HOUSE 1, 4	Scr. Pg.: 99	Unit:	
Sheet #:	Scenes: 97	N/A 0 7/8 pgs	INT. Evening	SAM'S HOME OFFICE, LONDON	NORTH LONDON HOUSE 1, 4	Scr. Pg.: 93	Unit:	
Sheet #:	Scenes: 105	N/A 0 2/8 pgs	INT. Night	SAM'S HOUSE	NORTH LONDON HOUSE 1, 4	Scr. Pg.: 97	Unit:	
Sheet #:	Scenes: 104	N/A 0 2/8 pgs	EXT. Night	LONDON STREETS	NORTH LONDON HOUSE	Scr. Pg.: 97	Unit:	
--- END OF DAY 3 ---					--- 3 3/8 pgs. Est. Time: 0 min			
Sheet #:	Scenes: 18	N/A 0 5/8 pgs	INT. Day	TRAIN	TRAIN 1, 42	Scr. Pg.: 15	Unit:	
Sheet #:	Scenes: 109	N/A 0 2/8 pgs	EXT. Day	TRAIN	TRAIN	Scr. Pg.: 101	Unit:	
Sheet #:	Scenes: 111	N/A 1 /8 pgs	INT. Day	TAXI	TAXI , 1, 4	Scr. Pg.: 101	Unit:	
--- END OF DAY 4 ---					--- 1 7/8 pgs. Est. Time: 0 min			
TRAVEL								
--- END OF DAY 5 ---					-- 0 0/8 pgs. Est. Time: 0 min			
Sheet #:	Scenes: 17	N/A 0 7/8 pgs	INT. Morning	D.I REEVES' OFFICE, POLICE STATION	POLICE STATION 9, 10	Scr. Pg.: 14	Unit:	
Sheet #:	Scenes: 21	N/A 0 2/8 pgs	EXT. Day	POLICE STATION	POLICE STATION 1	Scr. Pg.: 16	Unit:	
Sheet #:	Scenes: 22	N/A 1 /8 pgs	INT. Day	POLICE STATION	POLICE STATION 1, 9	Scr. Pg.: 17	Unit:	
Sheet #:	Scenes: 23	N/A 0 5/8 pgs	INT. Day	INTERVIEW ROOM	POLICE STATION 1, 9	Scr. Pg.: 18	Unit:	
--- END OF DAY 6 ---					-- 2 6/8 pgs. Est. Time: 0 min			
Sheet #:	Scenes: 24	N/A 0 7/8 pgs	INT. Day	POLICE STATION CORRIDOR	POLICE STATION 9, 10	Scr. Pg.: 18	Unit:	
Sheet #:	Scenes: 25	N/A 2 3/8 pgs	INT. Day	INTERVIEW ROOM	POLICE STATION 1, 10	Scr. Pg.: 19	Unit:	
Sheet #:	Scenes: 27	N/A 0 3/8 pgs	INT. Morning	INTERVIEW ROOM	POLICE STATION 1, 10	Scr. Pg.: 23	Unit:	
--- END OF DAY 7 ---					--- 3 5/8 pgs. Est. Time: 0 min			
Sheet #:	Scenes: 99	N/A 0 1/8 pgs	EXT. Day	NORTHERN LANDSCAPE	NORTHERN COUNTRYSIDE	Scr. Pg.: 95	Unit:	
Sheet #:	Scenes: 100	N/A 0 2/8 pgs	EXT. Day	POLICE STATION	POLICE STATION	Scr. Pg.: 95	Unit:	
Sheet #:	Scenes: 3	N/A 0 7/8 pgs	INT. Day	POLICE STATION	POLICE STATION 13, 56	Scr. Pg.: 2	Unit:	
Sheet #:	Scenes: 101	N/A 0 2/8 pgs	INT. Day	POLICE STATION, INTERVIEW ROOM	POLICE STATION 13	Scr. Pg.: 95	Unit:	
Sheet #:	Scenes: 103	N/A 1 1/8 pgs	INT. Day	POLICE STATION, INTERVIEW ROOM	POLICE STATION 9, 10, 13	Scr. Pg.: 96	Unit:	
--- END OF DAY 8 ---					-- 2 5/8 pgs. Est. Time: 0 min			
Sheet #:	Scenes: 87	N/A 0 7/8 pgs	EXT. Morning	TRAIN STATION	TRAIN STATION 1, 4	Scr. Pg.: 77	Unit:	
Sheet #:	Scenes: 88	N/A 2 2/8 pgs	EXT. Morning	STREET	NORTHERN STREET 1, 13	Scr. Pg.: 78	Unit:	
Sheet #:	Scenes: 20	N/A 0 5/8 pgs	EXT. Day	TRAIN STATION	TRAIN STATION 1, 54	Scr. Pg.: 16	Unit:	
Sheet #:	Scenes: 19	N/A 0 4/8 pgs	EXT. Day	TRAIN STATION	TRAIN STATION 8, 20	Scr. Pg.: 15	Unit:	
Sheet #:	Scenes: 77	N/A 0 3/8 pgs	INT. Day	SAM'S CAR	SAM's CAR - NORTH 1	Scr. Pg.: 68	Unit:	
--- END OF DAY 9 ---					- 4 5/8 pgs. Est. Time: 0 min			
Sheet #:	Scenes: 10	N/A 0 4/8 pgs	EXT. Morning	THE PARKER'S HOUSE	PARKER'S HOUSE - NORTH 17, 57	Scr. Pg.: 7	Unit:	
Sheet #:	Scenes: 74	N/A 0 5/8 pgs	EXT. Day	THE PARKER'S HOUSE	PARKER'S HOUSE - NORTH 1, 17	Scr. Pg.: 64	Unit:	
Sheet #:	Scenes: 75	N/A 2 4/8 pgs	INT. Day	THE PARKER'S HOUSE, KITCHEN	PARKER'S HOUSE - NORTH 1, 17	Scr. Pg.: 65	Unit:	
Sheet #:	Scenes: 14	N/A 1 3/8 pgs	EXT. Night	THE PARKER'S HOUSE	PARKER'S HOUSE - NORTH 2, 8, 12	Scr. Pg.: 11	Unit:	
--- END OF DAY 10 ---					--- 5 0/8 pgs. Est. Time: 0 min			

FIGURE 12
Stripboard schedule example

Our finance plans in the past have tended to look more like this:

UK tax credit (20 percent less commission = 17 percent)—£39,000

Private equity—£50,000

Crowdfunding campaign—£11,000

Tax incentive scheme (SEIS), but more recently private equity—£130,000

TOTAL—£230,000

GAP finance, if needed, is the last hope really because it can end up being very expensive due to the amount of interest or return they want to see on their investment. Because it's the final bit of your money to fill the "gap," they're last in and first out usually. So before going down that route we'd always try to get a post-production deal, if needed, first. A pre-sales deal, or minimum guarantee, is very hard to get without some major bankable name, which is more unlikely on such a small budget. We've always avoided BFI or other regional funding (soft money) because there's not enough soft money for the thousands of applications and funding keeps getting cut, so we've never spent the months it takes to even apply in the first place.

In the United States, it's a much simpler model. Not to say that it's simple, it's just very much seen as a business, especially compared to in the United Kingdom. Therefore the projects are expected to be able to recoup their money, and investors treat it more seriously and are therefore more willing to enter into that market in the first place. In the United Kingdom, it's still seen as a bit of a hobby by a lot of people and not to be trusted with large amounts of money even though arts and entertainment is now the second biggest industry in the country. Hopefully perceptions will change soon.

FINANCING FILMS: FAKING IT AND MAKING IT 75

"The American way, because they don't have any of these things over there (soft money), you go out, you hustle, you find your investors, you structure it in a sales, commercial, kind of way to finance it and then, if it's a success loads of people will beat a path to your door, you'll have all the agencies chasing you and you'll probably be given a ten million dollar film next. The path is just so steep. Filmmakers and companies over here (UK), need to take more of a leaf out of the American book; you stand on your own two feet, and you're as good as your last film. And I think the market is coming around to that way of thinking, especially with the death of EIS, the old film schemes that sail close to the wind, which was just more money that anybody needed for a film that should have been made for a third of the budget. So the old years of making films for film sake are gone, so how do you make one now because you can't rely on an EIS pot of five million; you've got to be smart and co-produce with someone that brings in more soft money, and bring in as much value from the market as possible, like pre-sales and MG, which means you need a film that you can pre-sell a film and get an MG for, which is probably going to be more commercially focussed than was getting made previously."

—*Phil McKenzie, Goldfinch*

Steven Adams on the US model:
"What we have is tax incentives, the most attractive is number one Georgia, Louisiana number two and then New York and Massachusetts stand out in my mind. The reality in the US is that, yes you can apply for grants and support from various foundations, especially if you have a special topic, when I did 'Huge meeting Story' with Spike Lee we got support from the Ford foundation and Rockefeller Foundation, on the condition that because they were both educational grants our obligation was to come up with a curriculum that would educate people on the topic on film and hold town hall meetings. You have to work for your money.

Who's the potential audience, why will they want to see your film and what's the way that I can maximise that, and then work backward from there. You can finance in a few ways, if you can access talent then you can go to a sales agent of distributor who, if they're reliable, they can give you a minimum guarantee or a pre-sale, and if that's bankable then you can have that

financed through a bank. Cash flowing the pre-sale, it's got to be a reliable company that's vetted by the institution that says, ok we'll give you the amount with their percentage, 15% usually. Banks won't be interested in loans that are below $5 million, it's not worth it for them because of overheads, or resulting in very little profit for them. So you get a couple of independent companies that can hit that sweet spot under $5 mil-$250,000."

WHERE TO FIND INVESTMENT FOR YOUR FILM

Here we'll briefly explain the different areas that you can approach to find investment for your film, including what you'll need and how you can get it.

- **The UK Tax Credit.** This is a tax rebate that is 25 percent of the budget, which is awarded to a film that has spent money in the United Kingdom. The film has to qualify as a British film by completing the culture test. This test is a series of questions that establishes what the film is about: if it's about a British subject matter, if it's set in Britain, if the characters are British, or who in the team is British, so the heads of department, crew, and cast. Or your film has to qualify as a co-production.

 It must have a minimum spend of 10 percent of its core expenditure in the United Kingdom and a maximum of 80 percent of its total core expenditure or if its lower, the total amount of actual UK expenditure.

 In other words, if you are spending 100 percent of your £230,000 in the United Kingdom and you pass the culture test, then all your budget is qualifying spend. You can claim 25 percent of 80 percent of that back, equaling £46,000, or 20 percent of £230,000, equaling £46,000.

 You have to wait until you've made your film to then submit all your accounts to Her Majesty's Revenue and Customs (HMRC) and then get your rebate. It's a fairly quick process but it does mean that in order to use that money as part of your budget to begin with, you need to find someone to cashflow or bankroll it. There are many companies

that offer to cashflow tax credits and most will require a commission fee of anywhere between 1.5 and 3 percent, so make sure you minus that amount from your calculations, otherwise you might end up missing a few thousand from your total.

In order to claim your tax credit, you will have to have set up a company that is responsible for the principal photography, post-production, and completion of the film and that falls within the UK corporation tax net. This company will then apply to HMRC, with the production accounts, for the rebate which is usually processed within six weeks.

The United States doesn't have a countrywide rebate scheme, but many states have their own individual ones as an incentive to go and film there, which means bringing money into the region. They all have different application processes but they're easy enough to find out; as with all things, we think it's easiest just to get in touch and ask for help from the off, rather than blindly filling in forms, getting something wrong months down the line, and getting yourself in a mess. On the whole though, as these incentives are cash based it means you'll probably get your cash a lot faster than we do in the United Kingdom.

"You have to finance in advance of them being made by a combination of: Tax credits, these can be from various countries, UK 20%, and European countries, Greece 30%, Romania 30–40% you need your tax credits."

—*Gareth Jones*

- **Pre-sale deals** are when you have a sales company attached to a film and they have the rights to go out to the distribution market on behalf of the film and pre-sell it. They might do deals with territories, countries, or areas of the world and/or companies, like Netflix, that might pre-buy your film based on who is directing it and who is in it. It's a gamble because they haven't seen the film yet, so for a small independent film with a lesser-known cast and a first-time director

the likelihood of pre-selling your film is slim. If you're Tarantino with his latest offering starring Michelle Williams and Brad Pitt, your sales company will be far more likely to get pretty sizable pre-sales. (And we'd definitely watch that movie.)

"It always comes back to if the script's good, if the director's good, if you get good cast, you can get good sales and reverse that into the finance plan. It should be simple in theory, but as we all know it's very rarely simple! . . . Sales companies are coming on earlier now so they can help with the packing so they've got more of a hand in what it's looking like, which is another key point, if they are helping to control that they know they can deliver that to the buyers a bit better as well. So, it's definitely changing and we've seen a lot more projects come through to us with pre-sales attached or MGs that are going to be back by pre-sales as well."

—*Phil McKenzie*

The amount able to be raised through pre-sales will be somewhat dependent on the cast that you manage to attach to your film. An "attachment" is an official letter signed by the actor's agent and/or the actor expressing their interest in playing a certain role in your film. It does not mean a contract that they are 100 percent going to be in your film, nor are they "attached" if they've simply agreed to read your script.

If you get a sales company attached to your film before you've made it, they might do some "sales estimates" for you. Instead of them actually going out and trying to sell something for you, they'll look at the screenplay, the genre, the cast that's attached, and the director's track record and give you a list of estimated figures that they would hope to sell your film for in all territories around the world. These sales estimates can come in handy because you can then go to some potential private investors and show them the figures; if they look promising, the investors might be more inclined to invest in your film, especially if someone other than yourself is implying that they might see their money back.

It is also important, however, to take these sales estimates with an enormous pinch of salt. They are by no means a guarantee that that is what the sales company will sell your film for, so don't be disappointed when the figures are wildly below what they've estimated. This is also why it is now increasingly difficult to get useful sales estimates, because films are selling for way less than they did fifteen or twenty years ago.

"Most films get nowhere near their estimates, sales estimates are basically an academic exercise and if you look at a range of companies the estimates they come up with are based on a percentage per territory which is an accepted way of calculating estimates, but it's not very meaningful because at the end of the day films sell in different territories in different ways. But it's the accepted way and professional investment companies like to have sales estimates from a recognised sales company.

Pre-sales and MGs are difficult to obtain. MGs are what you receive when a film is sold, a pre-sale is an MG you receive before a film is made. So they're not dead but they're difficult and you can only really get a pre-sell from a film with a director who is trusted and an actor or actors with name value."

—*Gareth Jones*

- **Soft money.** Trying to get money out of the BFI can feel like trying to draw blood from a stone. It's not fun and it's bloody hard work, but it's worth it if you can manage it because of the many doors it opens. There's a certain stamp of approval that comes with BFI funding that can help you access other forms of money. Other companies might be more inclined to invest when they see you have BFI backing, and the bigger film festivals love a BFI film. It can also open doors for distributing your film as well. The downside is that it can take a long time to get the actual funding. We know friends who are still waiting to make their first feature film with BFI funding in the time that we've made and distributed two of our feature films. Will their film be better for it? Quite possibly. Will more people see it? Maybe. Do we want to one day

soon crack the stone and get BFI funding for one for our own films? Absolutely. But would we still be in the industry if we'd had to wait six years to make our first film? Probably not.

"The development funding from any of the public broadcasters, or BFI or Creative Scotland is essentially for script, and if they like the script they'll give you money for recces and preparation of a schedule and a budget, casting and probably an overhead for the producer and production company. After you've had endless script meetings and notes, you get into stage two. It's slow, super slow.

They hang back from actually committing until the finance is almost fully closed. If you've had development money, there's a good chance you'll get production funding, and then you've got to come up with some non-public funding, because under European/state aid rules a film should not be financed with 100% public funding. You need to have a sales agent attached (for soft money), but they can waive that. And you're also supposed to have UK distribution but they do also waive that in some circumstances."

—*Margaret Matheson*

You have to apply for funding from the BFI through an online form. This consists of a series of questions about your company, the team making the film, and the screenplay itself. They also request supporting material like director's and producers' previous work, the director's vison for this particular project, mood boards or reels, biographies, cast attached or at the least ideas of who you want to approach, possible locations, when you want to film, any challenges you might face, how you intend to overcome those, the schedule, and the budget, finance plan, and recoupment schedule. (This is a list of parties who are investing in your film and where they are expecting to sit in the waterfall of recoupment when the film is sold and money starts to come back in. We'll go into further detail about this is later.)

As we've never been through the BFI or soft money funding process, we spoke to Hong Kou whose first and second feature films, *Lilting* and *Monsoon*, were soft money funded through the Film London Microwave scheme and the BFI and BBC.

There are other pots of regional funding in the UK; Screen Scotland, Film Cymru Wales and Northern Ireland all have appealing production and development funds accessible depending on who is in your team and how experienced they are. You might have to attach a producer from the local area in order to qualify for the fund.

- **Crowdfunding.** This is when you try to find people with money to spare and who fancy the idea of helping you make your film a reality. Some films have been made solely by crowdfunding campaigns, which is kind of extraordinary; massive congratulations to anyone who has achieved this. Nothing about film financing is easy, but crowdfunding we find particularly hard. You have to get people fired up enough about your project from the start and get it seen and noticed on the platform that's hosting it. It takes a huge amount of time. Just go to a crowdfunding site and you'll see the thousands of different campaigns running all the time. Getting yours to stand out is tough. Aside from that, most of our friends have projects of their own that they're trying to make and what you're really doing is just asking people for their cash. The donors don't get any financial gain from giving over their cash, just a warm feeling that they've helped a struggling artist and maybe a signed poster if that struggling artist remembers to get them signed by the actors at the end of the shoot, which nine times out of ten they don't because they're standing in disbelief at the wrap party, that they've made the movie, not even thinking about getting posters signed.

 You might have guessed that we've never had much luck with crowdfunding. We've run a campaign for all three of our films and probably

raised a couple of thousand pounds each time. It helps for sure as it's "free" money in the sense that you don't need to pay it back, but it definitely doesn't come free of effort, time, and responsibility. The best campaigns that people we know have run have offered non-tangible rewards to their backers, like links to the film and video blogs. We've made the mistake of offering DVDs and realized that it'll be months, even years, before we have a DVD to send to our backers. We still feel guilty that a lady in America is waiting for her eco pack of *The Isle* wildflower seeds, notepad, pen, water flask, signed poster, signed DVD, and signed t-shirt, all of which will probably cost more to send to her than she actually gave us in the first place. But we stick by our promises—Sally, if you're reading this, we hope you've got them safely!

"Be careful with your awards, we used a lot of prints and signed photos. Still did tangible items, and we also did screenings so a company would sponsor the event, the screening for £4,000, the premiere and on the mic, we thank the sponsor. It's advertising for something they believe in, so if it's a vegan cheese or a supplement. . . . Anything that you can think of that isn't something you have to physically make, are the best rewards, but it's about being clever with it."

—*Giles Alderson*

"Crowd funding is harder than a lot of people thought it would be, it's a lot of work but the work that is demanded is actually great work for a filmmaker, because it makes you do all the things we're talking about, it makes you find an audience, it makes you focus on who you'd want to see your project, and if it succeeds it gives you quantifiable numbers and it builds audiences. That is something that is very attractive to a distributor, you've got a group of people who have invested in the film who want to see the film happen and that's a great place to start when you start to build a campaign. You built an image of this film on social media and built a community and it's authentic and organic and interested and invested in the subject."

—*Steven Adams*

You need to update people and keep them engaged with your campaign. But you're doing that anyway on social media, because you have to (we'll get to that later, but you need your film to have a presence and a following online in order to help sell it afterward). So any exciting updates and information that you might share with your crowdfunding backers can easily be found by following you on Twitter. Having said that, if you do successfully engage with your backers, they will support your film and be a massive help once it's completed. We've had some amazing crowdfund backers from all over the world who have followed *The Isle* through its journey, coming to see it at the cinema and helping to promote it online by reposting and retweeting. It means a lot, and building a community around your film can really help; it keeps you pushing forward and ensures that you deliver and actually make your film.

Two of our very good friends have had wonderfully successful crowdfunding campaigns: Giles Alderson made seventy-five thousand pounds for his documentary on veganism, and Chris Dane ran a campaign that enabled him to fully fund his online web series "Ren," building a massive following to boot.

"£75,000 but we targeted the right people and we aimed high, we weren't asking for £10, great to get that from friends and family but how many people are going to do that, you'll be lucky to get £1000. So we targeted big people with big money and that they'd said they might invest in the film anyway. We did it in three ways, we targeted people who were vegans, animal lovers and environment. We did three weeks and we were clever with our strategy. Every tweet that went out, and email that when out was specifically targeted and we had certain people that were putting in at certain times, we'd set that up a bit so we knew we'd have a boost at certain times in the campaign that could at least get people to say quick put in, it's the fear of missing out thing. We made it by 3 minutes. . . . It was all or nothing. It would have been £74,000 that disappeared. If it was a minute to go and I

had to put in a hundred quid to get us over then I would have done that but we didn't need to. But it was down to the wire. We were really clever about how we did the whole campaign, we planned it way in advance, six months to a year. Getting your team ready and your tribe who will at least retweet your message and that's enough. We'd write out full messages, asking people to tweet it out for us. With a picture and a link. It was a mission, we did it, but I don't think I'd want to do it again. I'd rather just go to an investor. . . . We got done on tax. A lot of people don't think about the tax implications when you do a crowd funder, they just think oh we'll sort it later, or we'll forget about it. Inland revenue are trying to clamp down on it. When you have a large amount they come knocking! . . . Because they've (your investors) paid for the DVD, even if you haven't made it yet, you still have to pay the tax on every DVD sale. Be very careful and aware how you run the company because VAT is 20% that goes. And the platform takes 5%, so technically you can lose 25% of what you've raised."

—*Giles Alderson*

- **Private Equity.** There are a few angles that you can approach for this. You can target friends and family; they might support you by giving you a thousand pounds, maybe more. That's a substantial amount of money, and we've always put that amount into the film as an investment instead of into crowdfunding. That way we don't lose any of the money through the crowdfunding platform's percentage fee that they take, and it means that our backers might one day see some sort of a financial return—fingers crossed! This is the tricky part about private equity: you can't publicly advertise for investment, so you have to either know someone who might consider investing in your film or know someone who might know someone.

 There's also the option of investing your own money in your own film. This, like any investment, should only be done if you can afford to lose the money. People always say, don't invest your own money in your film—this is for a very good reason: you may never see that money again

or at least for the next five years. But if you're working as an ad director and have just been paid a whopping big paycheck for a car advertisement you shot in South Africa, and you really want to make your film, why not put a few thousand of that paycheck into it? That scenario is the stuff of dreams for most of us and nowhere near reality; instead we have a credit card or three. Most of our short films were financed via credit card—we are not condoning these actions, nor are we advising them. We're just saying that's what we've done.

If you, your family, friends, or acquaintances do decide to invest in your film, they will want to know where they sit in the recoupment schedule. This is a document that combines all the investment parties and what terms they have agreed to. You want to look after your private equity investors and make sure that they don't sit at the bottom of the recoupment schedule. For example, taking the UK finance plan from before:

UK tax credit (20 percent less commission = 17 percent)—£39,000
This has been cash flowed by a company who will be paid back when the tax rebate is issued, and they will have had their commission, so we don't need to worry about that.

Crowdfunding campaign—£11,000
This is money that does not need to be returned, so we don't need to worry about that either.

Leaving you with:
Private equity—£50,000
Tax incentive scheme (SEIS)—£130,000

The investors in the SEIS scheme want to see their money returned, as do your private equity investors. There might be some expenses that need to come out of first money in. This could be either sales company expenses and/or press and marketing expenses.

Your recoupment schedule might look something like this:

First monies in capped at up to £20,000 for sales, prints, and advertising expenses.

Subsequent gross profits split 50/50 between private equity investors and SEIS investors until 100 percent return on original investment has been received.

(You might want to add a corridor, or bonus for your private equity investors, so that they see an additional 2 percent on top of their investment at this first stage. You'd have to get it agreed by all parties, but the SEIS investors get the bonus of their tax deduction, which we'll explain in the next section.)

All remaining net profits are split 50/50 between the production company (that's you) and the investors: 25 percent to private equity investors and 25 percent to SEIS investors.

That's a very basic recoupment schedule, but hopefully you get the idea.

"Private investors are often people who have money they can afford to lose, because if they can't afford to lose it, then they shouldn't be doing it really. Because film is a very risky venture for anyone, particularly individual investors. . . . What you need to do is try and create a nexus between the film you're making and the kind of investors you might be looking for. Are there people in real life who are related to the subject matter who might find it a positive thing to invest in films. Also individual investors tend to be attracted by the glamour of the film business, that's why they're doing it. So in any financing package you have to put together a list of perks, these include people being able to visit the set of the film, meet the actors, go to premieres, go to pre-release screenings, something they can invite their friends to because the reason they're doing it is so they can tell their mates that they're involved in film . . . they're less concerned with sales estimates because they'll be less experienced in that. They're interested in the subject

matter of the film and who's in it. But they'll still want to know where they would sit in the recoupment order."

—*Gareth Jones*

- **Tax Incentive Schemes.** There are hundreds of articles that will explain this much better than we will, and it's pretty dry and very much UK focused, so we won't spend long on it. In 1994, the UK government set up the Enterprise Investment Scheme (EIS) to encourage growth and investment in smaller companies. If you invest in a qualifying company, up to one million pounds per year per individual, you can get 30 percent off your income tax bill. (You can only get the full relief if you're in the 45 percent bracket, which means that you need to earn over £150,000 per year.) In other words, if you invest ten thousand pounds you get three thousand pounds off your tax bill. There are other benefits to the scheme, like no capital gains tax, no inheritance tax on the shares, and the ability to offset any losses—you just have to keep the shares for a minimum of three years and you can't have a larger stake than 30 percent of the company.

 In 2012, the government set up a sister scheme called the Seed Enterprise Investment Scheme (SEIS). This was designed to help investment into even smaller companies. The tax relief is 50 percent instead of 30 percent, but with a limit of one hundred thousand pounds per year per individual investment. So, invest ten thousand pounds and you get five thousand pounds off your tax bill.

 Both schemes work very well for films. You have to set up a company for your UK tax credit, so setting up a special purpose vehicle for SEIS or EIS shares in that company is relatively straightforward. A film through development, production, completion, and selling will take up to three years easily, so your investors will hold the shares for that amount of time anyway. You can set up an EIS or SEIS yourself;

a lot of film funding companies are all based on EIS and SEIS finance. They have a group of investors who are wanting to invest in an SEIS or EIS company, and your film can be one of them. In fact, a lot of these companies have been extremely clever by setting up qualifying special purpose vehicles that contain a number of projects, that way spreading the risk for their investors. Instead of just investing in one small independent film that might not make any money back, they will combine a few projects to create a company that holds a low-risk, medium-risk, and high-risk project. One will almost certainly make some money, one might, and one probably won't.

However, since March 2018, it got a little trickier, HMRC introduced the Risk to Capital condition, which means that the company has to have the long-term objective to grow and develop, and the investment must carry "significant risk." This is deliberately vague so that HMRC has the power to look at each individual application and ascertain whether it is high risk enough. Yes, investing in film is incredibly risky but using the schemes to invest in a singular film project is no longer possible because it is by no means long term. Once that single film is completed, that's it. Getting EIS funding to make films is still possible if the company can prove that it is actively developing a number of projects and will continue to do so; it's a long-term objective. That's why and how there is still some EIS finance available, for now anyway.

- **GAP Finance.** This is when you have a hole in your finances and in order for all the pieces to fit together, you need to fill that hole. GAP finance will be last in and first out usually. You might have 90 percent of your budget promised to you, but you might not have it in the bank yet and other finance parties might not release the money they've promised until you can prove you are 100 percent financed. You really want to make your film and you are so close to eventually being able to,

it's just that last 10 percent. You're desperate, and you need it quickly before it all falls apart and the money promised to you from elsewhere disappears to fund another project and then you have to start all over again at square one. In steps the GAP money. This can either be a loan from a bank or company that is made against the as-yet unsold rights or territories based on sales estimates, or it can take the form of a bridging loan which will carry high interest rates and which you'll want to pay back as soon as you've secured all the finance and it's in the bank.

- **Post-Production Deals.** This is when a post-production house might invest in your film if you agree to the post-production of the film being done at their facilities. They will then charge you for the work that they carry out, thus making back their investment and extra. So it really means that you're spending money to get money. Your post-production budget might be fifty thousand pounds, and you can keep the costs down because you're going to independent freelancers to do your grade and edit. They don't have the overheads that a large company has, so they cost less. However, if you go to a post-house, they might say you need to up your post budget to one hundred thousand pounds. They will invest twenty-five thousand pounds, so that's great news, but in order to get that twenty-five thousand pounds, you've had to add fifty thousand pounds to your overall budget. That's not to say that it's not worth doing. It can be a massive help getting that twenty-five thousand pounds; it might be the missing piece of your finance and preferable to a bridging loan because you get all the upside of fantastic facilities for your post-production: amazing edit and grade suites, automated dialogue recording booths which you might have to end up hiring anyway, 5:1 sound mixing that you'll need if you're releasing theatrically. There are all sorts of bonuses added to the overall production value of your film, and upping your budget will give you more back in tax credit later on.

"It has all just changed (in the UK), but you just need to borrow a bit more from the American model; you find an equity investor, find some tax credit and then you build the rest through sales, and if you can't find your equity investor then you co-pro it, or do some sort of clever post-facilities deal that will help you close that gap, or you reduce your budget. Tighten your belts a little bit. It's been negative for a while but I think we're definitely on the upward slope now. In business you have to be positive, you have to go for the opportunities, and not say 'oh, it wasn't as good as it was four years ago, remember when we used to just make a poster and sell it for a million dollars around the world.'"

—*Phil McKenzie*

"Your business model by nature has to make sense from a financial point of view, because you can't take money without showing how you're going to do an ROI (Return on investment), but if you're smart and you're taking money from someone then you should be able to demonstrate on paper how you're going to get it back, the smart thing to do is to work with the distributor aiming for the right talent, or the right combination of talent, doesn't have to be a star, that combination that adds up to enough. . . . There's always a tendency for filmmakers to be secretive about their budgets, but if you can really give someone something amazing for nothing, it's a virtue. If you can show that you can give someone great return investment at that rate you're a better risk for more money. I personally think it's a virtue not something to be ashamed about because if you can make a full feature for very little money that people love, then you can say get me 2 million now."

—*Steven Adams*

All three of our films have been financed slightly differently, mainly because each time the budget has crept up. *Miss in Her Teens* was so low budget ("no budget") that it was all funded through private equity, two extremely generous individuals, and angel investors (aka Tori's mom and dad). Our next film, *Two Down*, was a little higher in budget, double in fact, but still not a lot. This was raised by a combination of crowdfunding and again private equity. Our angel investors came back in, along with

more family and friends this time. Thank goodness, as there's no way we would have been able to do it without them. We also persuaded actor and writer Stephen Fry, theatre-producing legend Anthony Pye-Jeary, and Sir Derek Jacobi to invest. We had to send them all our short films and the trailer for *Miss in Her Teens*, which was not yet finished, as proof of our work, along with a document laying out the synopsis of the film, attached cast, the top sheet budget breakdown, and the recoupment schedule.

These investor packs are really helpful and necessary when you're approaching people to put their money into your film. You want to appear as professional, organized, and most importantly as capable as you can—like you know what you're doing even if you don't! A slick-looking pack containing information about your film can really help to secure finance. Don't make it too long or too wordy. Keep it clear, concise, and professional. Include pictures of the cast, a mood board, and a brief description of the director's vision; also include some examples of other films that yours might be similar to and how well they did in the market. And don't choose things like *Lock, Stock and Two Smoking Barrels* if it's a UK gangster film—that was an insane success and was released many years ago. Choose something that was at a similar budget level, that was released recently, did reasonably well, and had a similar cast in it.

"At the screenplay stage, ask who you're writing it for, who will go and see this film, who will turn up to the cinema to see this film, who will watch it at home. Have an audience in your mind. Also, financiers and investors are impressed if you have some kind of marketing idea. Another thing to work through is comparisons films, what film is it like, or do you hope to be in the same area as, comparables. Buyers and home entertainment are very big on comps, even if those comps maybe somewhat vague they can still make a difference. And in an investment brochure, but don't use great big films, avoid the extremes."

—*Gareth Jones*

Getting the budget for *The Isle* was a little more complicated. As we explained earlier, we met with Great Point Media after Laura Macara had seen a screening of *Two Down* at the BFI. We initially went in to pitch our drag heist comedy, but they were looking for something more genre focused, so we offered *The Isle* to them. They read the script and liked it, had a few notes understandably, and once we'd worked on the script, we went back in to discuss the possible finance they might offer.

Gareth Jones was working with us as a co-producer and advised us that we couldn't go in empty-handed and expect them to finance the entire film; that's a big ask and it's important to show that you as a producer are working to find investment from elsewhere and that other people believe in your script as well. We had managed to secure nearly a quarter of the budget in private equity and had a crowdfunding campaign that had brought in a couple more thousand, but there was still a big gap to fill. Great Point Media said that they would usually completely fund a project but had reached the limit on that particular SEIS fund for that financial year and that they would be able to cash flow the tax credit for us and provide us with just over half the finance through SEIS. This meant we had almost all of the budget but needed a little bit more, and Great Point wanted us to confirm that we had all the finance in place by the end of day. We had a mad Friday afternoon running around Soho to different people trying to find a way, the cheapest way, of getting our missing money. We talked to post-production houses about doing deals with them, but they wanted more for the post than was in our budget. In the end we managed to get an amazing quote that reduced our post budget by a third, thus saving us money, so we didn't need to raise quite so much. The final piece we managed to get from private equity at the very, as in a few minutes to spare, last moment.

Raising the money for any film is hard and can take a long time. On the whole it helps to have as many parts of the puzzle in place first: a finished script that's in a pretty good state, key heads of department at-

tached with a good track record of producing and making the type of film you want to make, key cast attached who have some level of experience and notoriety, a budget and schedule breakdown of the script, a finance plan, and a recoupment schedule. This all goes into a pack or deck that you can then show potential investors. But like so many other aspects to independent filmmaking, every project, every film is different and will come together in a different way. There's no one way of doing it. All you can do is work hard, keep at it, think outside the box, and stay open to opportunities that might arise from the most unlikely places when you least expect them. Oh, and if you would like to invest in a Fizz and Ginger film, please contact info@fizzandgingerinvestment.com.

"You have to be optimistic, you have to believe in your film, but you also have to know that most films don't get made. They just don't. Doesn't matter how good they are and every meeting you go in to, cheerful and convinced that this financier, developer, distributor, whoever it is that you're seeing is going to save your life, is going to love the project and put money in, but you discover that nobody has the ability to sign the cheque. Nobody you meet can do it, you don't know where they are . . . any filmmaker who is a real filmmaker only wants their film to make money because it allows them to make another film. Not because they want a Rolls Royce, not because they want to live somewhere very rich, because that's not going to happen anyway. It's the way you keep score to be able to say, I'm now enough of a filmmaker, like Ken Loach or Mike Leigh, with my own regular financiers, my own compadre of people who know how to raise money. That's the dream!"

—*Stephen Fry*

From speaking to many people on this subject, the continual controversial issue that comes up is about where and how public money is being spent for the development of the British film industry. Should it be trying to see a greater return on its investments? Or is that exactly the purpose of public money, to support those films that would otherwise not be made,

regardless of their commercial value—it's about their artistic value? We can't really finish this finance chapter without bringing up the elephant in the room. Time and time again people who we've interviewed have expressed the feeling that the soft money governing bodies remains a pretty closed shop, with a "it's about who you know attitude." Whether that's to the detriment of the industry as a whole is questionable—at the end of the day someone has to make the decisions and who's to say if anything is truly fair in any business. We strive for equality and fairness within the entertainment industry, and it seems that there is a unanimous thread of thought which suggests that we're still some way from that.

"Almost everything they do is motivated by the laudable desire to achieve what they call diversity, all of which we applaud and agree with but one of the ways of going about it is to have talent networks. . . . There are various schemes, national schemes and regional schemes, all linked by networks and there are endless sessions with people telling them how to do it. . . . I think that in the end talented writers and directors have just got to beat their way up through the concrete, and preferably not be told how to do it, because it'll spoil what they're trying to do, so there's a massive amount of homogenisation going on, with the best of intentions, but very little self-awareness. . . . It's about how you support people to be artists and the fact is if you collect a 100 people on the basis that they're all worth developing as artists, you may perhaps be trying to create artists out of people who don't really have what it takes. . . . I don't mean to say you can't help to develop, but a novelist working alone either comes up with something that stands up and is of interest or not. It doesn't matter who you are, it must be distinctive, and that's what we should be doing in film, on the independent creative side, but in the context of an audience."

—*Margaret Matheson*

"Having BFI on there, having Creative England gives it a stamp of approval of a long line of interesting festival films, from good filmmakers, but certain

sales companies will know immediately the kind of film it is. . . . There will always be a space for interesting, artistic filmmaking that is more, pushing the boundaries, weird and wonderful, but we've all got to eat and pay our mortgages, and it is a business."

—*Phil McKenzie*

"Everything you do is scrutinised and questioned. Our conclusion was that maybe that was their way of preparing us for the private sector, the bigger industry. And to be honest, having made a second I oddly feel like I'm able to put a lot more of what I want in because *Lilting* punched above its weight a bit, they trust I can make a feature . . . (on *Monsoon*) the BFI and BBC were very kind and allowed me to have my personality in it. I have to say I've really loved the experience of working with the BFI and BBC."

—*Hong Khaou*

"One thing I've seen since doing the film is the politics in the industry within the funding. And what films are going to get hype . . . if someone chooses someone to champion, they are going to hype it up to the tenth degree no matter what. . . . Producers who find it easier to get funding than others, I've done so much research into who gets funding and why they get funding and then you realise that it's just because they're pally with this set. . . . No one's willing to back you in the UK until you've already done it. It's ridiculous. . . . You know it's happening, they're tweeting about films ages in advance, you know the steps and I've seen how they manoeuvre in order to push certain films. Anything they back, and if you're not it's an uphill battle, you don't stand a chance unless you're connected in some way. It's a little club."

—*Aki Omoshaybi*

"It was demonstrable that in the era of British Screen when there was far less hands-on they were recouping on average at least 50% of their investment, but, last time I looked, the BFI was nowhere near 50%."

—*Margaret Matheson*

4

Pre-Production: Tackling the Traffic Lights

YOU'VE BEEN GREENLIT!

You've slaved away on all the hugely exciting (?!) finance side of things for potentially years while putting your film together, and you've got the go-ahead to make your movie. At this point, you've probably already got your lead cast together as they might have been part of your finance plan, which is great. You now just have another thousand things to put in place before you start filming.

"First day of pre-production, we'd had the green light from the money people. . . . Richard sat me down and said the money's gone we're not making the film. That was my first day of making the film, to be told that we're not making the film."

—Ian McKellen

We're going to write about what, in an ideal world, would be a good way of preparing for a feature, but bear in mind that time costs money and you might not have all that much of it. We've certainly never had enough time on our own films, and it's only been while working on other

projects with larger budgets that we've sometimes had the luxury to do a bit more of it. But we've never managed to get everything prepped before we've started shooting, and so we end up spending the beginning part of production catching up with things that should have been done in prep. The more we work with different people, the more we find that this is very much the norm for most indie films.

At the end of the day, you need to do your best for whatever project you're working on. No matter what some people say, or what some books try to convince you of, there is no one way to make a film—there never has been. There are lots of things that have to be done of course, and there are things that *should* be done, but if you stick religiously to a particular template you could end up spending a fortune. So read on, but don't be put off if you're working on a tiny budget film that could never afford this much prep time.

Having said that, if you don't have much money for the whole thing, you as a filmmaker should be prepping by yourself, or with your team of writer and producer, for as long before as possible. I, Matthew, like to storyboard things to within an inch of their life so I know I have planned every second of the film visually: camera moves, potential edits, even lens choice. That's not to say it all happens, but what it does is make sure that I know every aspect of the story inside out and what character and storyline beats we absolutely must hit to make the film work. So, if things go wrong on the day, and things always go wrong no matter how much prep you do, you're mentally prepared to be able to adapt and come up with new ideas with the story or character beat at the heart of the moment.

"If you wrote a book you'd write several drafts, and an outline, that's why you storyboard before making a film. If you've never done it before you are spending hundreds of hundreds of thousands of pounds in a really short timeframe. So, if you did a prototype before you do the actual, isn't that the best way to do it? . . . When I got lumped with being a producer, I looked up

'producer' and it said 'to produce' great! Filmmaking itself is not just the shoot, there's a massive amount of work before you even get to the shoot."

—*Kirsty Bell*

With *The Isle* we only had three weeks from being officially greenlit to our first day on set. This is a ridiculously short amount of pre-production time, and it was because of two reasons. When we had pitched the idea to Great Point Media, we had told them that Conleth Hill and Alex Hassell were attached to be in it, which meant that their finance was somewhat dependent on us casting both actors. Conleth Hill was about to film *Game of Thrones* and Alex Hassell had to film *Suburbicon* with George Clooney. This gave us a window of three weeks to prep the film and then four weeks to shoot it. After that both actors would be unavailable, in Conleth's case for several months. If we hadn't struck while the iron was hot, and taken the investment from Great Point Media, by the time Conleth was available again, the money may not have been.

It was all kinds of ridiculous to prep a feature film set in the 1800s and in an extremely remote and challenging location in just three weeks, but it shows it can be done if you focus on the right things. We absolutely wouldn't choose to do that again, but it did prove to us that you can create a movie you can genuinely be very proud of by serving the story, as long as you remember that the story is the most important thing.

To start with even though you may have been promised the money to make the film, or at least the production part as sometimes the post-production money has to be found after you've filmed, make sure you have enough for at least the pre-production in the bank account (which you've set up especially for the project). This is purely so you know you can pay whoever you have on the payroll for the time in pre-production. There are too many horror stories from people we know and work with who have been working for weeks, sometimes months, on a film only to

be told the finance has fallen through and no one is getting paid. You don't want to have that kind of reputation in the film world, because it's a lot smaller than you'd think!

So, on most indie budgeted movies, at least in the United Kingdom, you'll tend to have four weeks of hard prep where all of the major players involved in the film are on board and working away on something. The major players being your key personnel/heads of department, such as Director of Photography (DOP)/Cinematographer, Production Designer, Art Director, Costume Designer, Makeup Designer, Line-Producer (if you're not doing that yourself like we always have), and if you're like us the Composer and Editor (the last two won't be getting paid yet, but we like to start those creative talks from as early on as possible).

We've usually worked with people that we started out with on the short films and then slowly added to that pile when people were recommended to us over the years and after we've gotten acquainted with their work at festivals and such. It's only recently that we've had to look outside that pool for the two features we worked on in 2018 for other people; we've used film crew websites when we wanted to give the directors choices to find the people they felt most compatible with.

This does take time, and this is when soft prep comes in handy as you can have a couple of people (it's usually us) searching for heads of department who are available and willing and then sending their info over to the director and setting up meetings to see if they're on the same page. This is also the time, in our experience, when you're going through all the financial contracts and obligations with the investors, whoever they may be, as it'll be different for all of them and better to be doing that before the proper prep time when you're focusing on the creative aspects of the film.

As a director you should also be working on the script side as well as chatting with the heads of department. As I, Matthew, mentioned, I storyboard everything to help with the shot-lists at this point, knowing that things may change but to give a blueprint and something from which everyone can

work. Storyboards look like cartoons in a box that will represent the ratio size you'll be filming with, and again this will probably change depending on the kind of project you're working on. I like to use scope (2.39:1), which is very wide but quite narrow in height for that old-school cinematic look, but as screens get smaller we're being encouraged to think about how people are viewing it—I say if it helps with the feel of the story, fight for what you think is right. Every shot is drawn in whatever you think is best for that moment: mid-shot, close-up, etc. Every time I want to show a specific camera movement, I'll draw that and add an edit point that I think might work. Everyone has to work out what is best for them, and some people don't even do them. I like to be very specific with my visual storytelling so will plot this all out, all while chatting to the DOP and often the editor, but some people will just make a shot-list and have it as a more organic experience with the DOP choosing more shots and movements. Each to their own.

The shot-list is exactly what it sounds like. For each scene the crew, especially your DOP and first AD, need to know how many shots you're planning and what they are. This is incredibly simple, and I find it easier to have done the storyboards first to inform what the shot-list will be. The storyboards can also be useful to show actors who might not know sometimes the language that is used on a film set so you can show them how things will look and what movements you want from them with respect to where the camera will be.

This soft prep time is also a good opportunity to set up things like websites and social media accounts for the movie if you haven't already done so. You'll know most of your cast by now, at least the leads, so can start building your audience and take them on the whole ride. People like seeing how it all comes together so share the joys of pre-production!

When you get to the proper hard prep, however much time you can afford for that, you and your team have a heck of a lot to work through. It's mostly fun stuff though, especially as you see it all come together and watch it take shape. A production book (also known as the bible) is a very

handy thing to have. It's a shared document (we've used Dropbox for this) with your production team which will have pretty much everything to do with the cast and crew, location info, facilities companies, accommodation, and anything else you think might be helpful for your team to know.

In the United States, you have to submit SAG-AFTRA (the Screen Actors Guild - American Federation of Television and Radio Artists) paperwork for the production, but in the United Kingdom we're just happy if something is actually happening—over here, you only have to worry about that if you're using American cast. In the United Kingdom, you can choose if you're working with Equity contracts and fees, and that will dictate your budget somewhat. Most actors understand that a low-budget indie film, unfortunately, won't always be able to pay those rates, but it's always worth raising that bit of extra money to make sure people are getting paid at least a decent wage. They'll feel respected and will work hard for you; we've often had everyone on the same rate so people feel no one is being short-changed and then offered percentages of the film, which comes out of the Fizz and Ginger Films' pot of money.

As we always say there's no one way to do this, and half the fun is working out what is the best way for you. It might not always be the proper way in some people's eyes, but if you come in on budget and on time, and people love the movies, what more do you need?

Having said that, there are certain things that just need to happen for your film to start and then to function in a way that makes the best use of time so you're not flapping around to fix things when you should be being brilliant and creative and having fun. Let's have a look at what you should be doing at this point.

"What I didn't like about producing was having to employ people, I didn't trust my own judgement to whether this person was the right actor to play that part, or whether that person was going to be the right technician, or whether I could trust this person if they said they had money. I didn't know anything

about that at all. So I didn't feel comfortable about that. But I suppose why I wouldn't want to do it again was because it took about two years and I didn't do much else for those two years. If you're an actor that's a long time not to be working. Even if the pay-off is that you get to make a very good film."

—Ian McKellen

LOCATIONS

As you know, we've often worked around locations and they've informed our script as it's a great way of getting the most out of your money and giving you great production value. You'll have your main story points that have to be hit, but often you can write around locations you know you can get hold of, which will not just serve the purpose but give it that extra bit of visual excellence.

In *Two Down*, we based the entire film around a mile square area knowing that, with twenty-two locations, we'd spend more time moving between them than filming unless we were clever. We're not saying you have to do exactly this, and the bigger the budget the more freedom you'll have, but no matter the budget we'd always rather spend our time filming than traveling around because the script says "a red brick walled courtyard" when it's not essential to the narrative or visual storytelling. Or if there *is* a specific reason, figure out if the point can be made with a different visual—one that's not so bloody far away!

STUDIOS AND SET BUILDS

We've never really used studios much, and we have only ever done minor set builds within an actual location. I think this is partly because locations are often cheaper if you're clever about how you use them, and you can often find places to film several scenes in the same area, or even building. But in addition, because we trained as actors, we like the authenticity a location can often bring. When we worked on a horror in 2018 that wasn't

ours, there were some scenes that just had to be in studios for various safety reasons and the director liked the control as in essence it's a blank canvas—you can see the appeal.

If you've got the money, then studios can make a lot of sense. They're usually large empty rooms that are sound- and light-proofed so you can dictate exactly what your lighting states are without having to battle nature. There will be rooms, or at least space for your costume and makeup teams to set up, and you can leave lights and equipment set up without any worry overnight, whereas some locations may require you to pack it away or have overnight security, which can be expensive.

If you can't afford official studios, there are always large spaces, such as warehouses, rehearsal rooms, or photographic studios, that could be used to build sets in, which we've done too. They'll be much cheaper, but you may have sound and light issues. Automated dialogue recording may be a cheaper option than a real movie studio.

You also won't have the owners of a location turning up unexpectedly wondering what you're going to break next.

INSURANCE

That brings us rather neatly to insurance. You have to get it, simple as that. No matter how small your budget, and even if it's just a short film shot over two days in your friend's café, you need to be covered.

Crew will ask, actors' agents will ask, and equipment rental places won't let you go off with their lovely, very expensive equipment without it.

Shop around and see what kind of quotes people can give you. There doesn't seem to be any set prices, at least in the United Kingdom, as to how much it costs. Tell the truth though about exactly what you're doing and when. You need to be covered for what you're shooting and make sure it is for all the dates, including picking up and dropping off equipment and props and costumes, which sometimes will take a week after you've wrapped from shooting.

There's also a kind of insurance called Errors and Omissions, which for features you'll absolutely need; distributors won't take on your movie unless you have it. On *Miss in Her Teens* we didn't have a clue about this so didn't have it, but thankfully we had a very nice Canadian sales company take pity on us and helped sort it out!

In a nutshell Errors and Omissions makes sure that you have the rights to everything to do with the film, including all the contracts for everyone involved, script rights, music, and anything else they can think of. That's not us being flippant; we've since discovered that different sales or distribution folk sometimes require wildly different things to be included so when they give you the deliverables list, read it thoroughly. The Chain of Title, which is basically all the legal contracts to say that you have the rights to be handing it over, will differ from company to company.

People in the United States tend to be more cautious and ask for things that don't exist in the United Kingdom, so you'll have to be prepared to add clauses to the insurance policy if you've already done it, or you can wait and when you get distribution base it around that. We'll go into it more later, but you must be aware that you're going to have to splash yet more cash further down the line, so try and save some for those little surprises.

PERMITS

More dull yet vital things: permits for the places you're going to film. Some people do go guerrilla and just turn up in places and film, hoping they won't get stopped halfway through a scene and have to run off. A part of that sounds fun, and maybe for shorts that could work as you're probably on such a tight timetable you can't hang around for long. We'd rather know we could spend the time setting up what we need to and make sure we get exactly what we want without having to rush just because of a permit. They usually don't cost much if you don't leave it to the last minute, and it also means your insurance will be valid if anything goes wrong!

You're spending all this time on a project, so it'd be a bit bonkers to rush through a scene just because you don't have a bit of paper to wave at the local busybodies and police. But we're not here to tell you what to do! We're just letting you know how we do things and you can decide for yourself!

CREW IT UP

There are different parts of getting your crew. You have to find your heads of department/key personnel, and it's so vital that you're all on the same page and work well together. If you have been collecting people through your networking and festival travels way before you get to this point, it'll really help. You'll be spending a long time with these people in probably quite intense situations, so you want to be around people who are excellent at their job and that you won't want to push off a cliff after two weeks.

After you've found them, they will probably bring in people to work on their own team. We'd absolutely advise you to let them do this as they'll know how they work, and they also want to work with people they know so as to make the long, hard days bearable.

If they're stuck and all their people are busy, then you'll have to help find some. This is why it's good to have a pot of all sorts of people you have collected. Failing that, we'd advise asking fellow filmmakers for suggestions first, and then looking at crew search websites last. This is purely because people you know are more likely to be honest about crew they've worked with and can also vouch for them, whereas people on those search sites can sometimes lie about experience (we're sure most don't but we had a few problems on one particular project we helped out on so are a little wary now).

Saying that, a lot of the people we still work with came from our first short film back in 2009, and we advertised for a lot of them, so you never know. And I think that was partly us all growing together and none of us really knowing what we were doing at the time anyway!

FIGURE 13
The Isle cast and crew

One thing we'll say is that even if people come highly recommended, go and have a chat yourself and explain the project. On most low-budget movies, crew often have to wear more than one hat, or at least muck in at points where they strictly shouldn't have to. Most are fine with this, but some just aren't, which is fair enough, but you need to know that before you start filming. *The Isle* needed everyone, cast included, to understand there were no roads, just two-hundred-year-old rough paths and tiny boats to get from location to location, so if something needed moving we all had to help drag it there (see figure 13).

"It was a great experience shooting with people who are so close to me, it felt like a family affair, it was very tight and without that it could have been a lot more tricky. And if the crew hadn't got on as well as they did it would have been a very different experience.

A few extra hands would have been nice, but then again with the logistics of the island that wasn't possible there're wouldn't have been enough beds!"

—*Louis Devereux, independent documentary filmmaker and producer, and associate producer on* The Isle

PRODUCTION DESIGN

When all this rollicking paperwork fun is happening, there are still some creative things going on, so don't worry. A production designer can mean different things on different budgets. In an ideal world, they're designing the film alongside the director and DOP, which includes the look of the sets, costume, and makeup. Then they'll work with the art director, costume designer, and makeup designer to bring all their designs and expertise into the same vision so everyone is on the same page.

On *Two Down*, we had one person, Gini, do production/art design (so all the prop buying too) and costume design and buying. This was not a small job for her, especially as it had a 1970s vibe, but it worked brilliantly and meant we could actually afford to do it, and as we had a lot of time to prep it meant being able to spend the time to get it right (see figure 14).

For *The Isle*, with our three weeks of prepping the entire thing, that would never have worked. So, we had the full team thankfully or we would never have got it done and certainly not to the excellent standard they all accomplished. This was an example of working out where our precious modest budget would be best spent. Having a team work on this rather than a couple of people meant it was actually achievable in the time we had (see figures 15, 16, and 17).

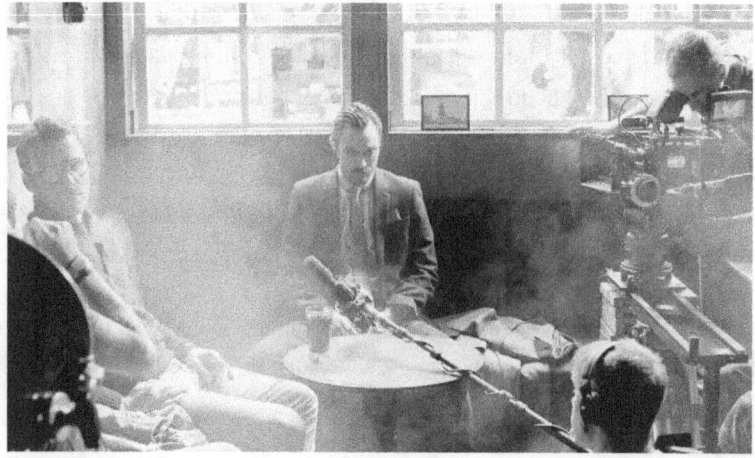

FIGURE 14
Two Down with actors Alex Hassell and Nick Rhys

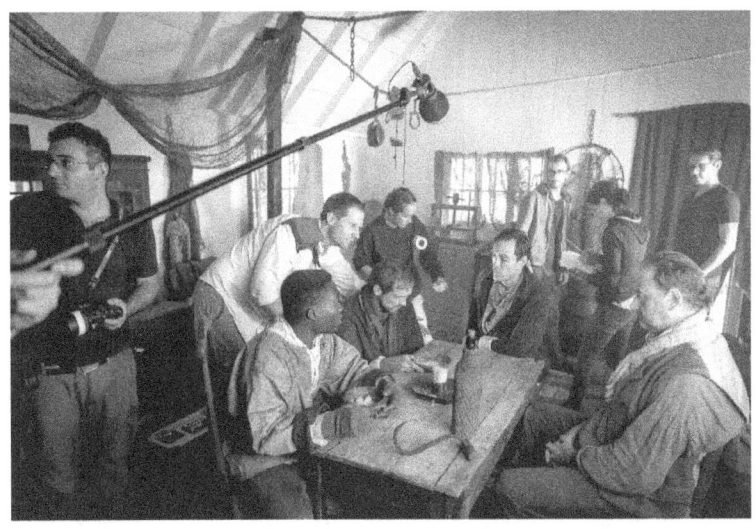
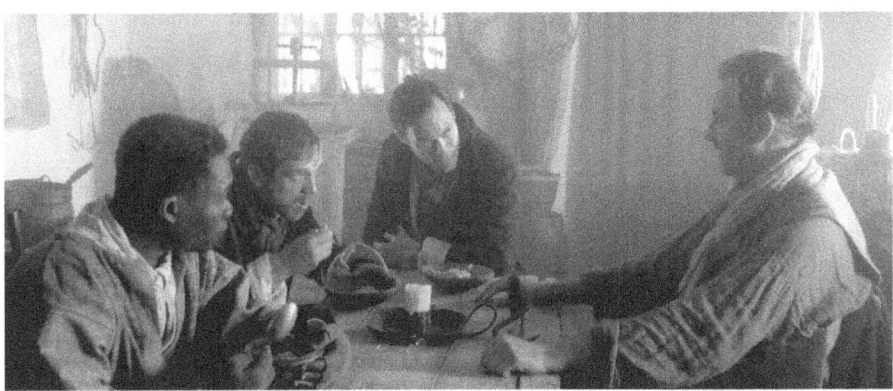

FIGURES 15, 16, AND 17
The Isle production design and screen shots

COSTUME

We tend to make life hard for ourselves and seem to always make period movies, which means expensive costumes!

From a storytelling point of view, we feel that it's more fun to get subtle subliminal story points into historical costumes rather than modern ones as you have license to play more. Done well, the costumes also make it look like you had a bigger budget, therefore adding to the production value, which distributors like.

Miss in Her Teens was a miniscule budget, but the setting and costumes made it look like our budget was a hundred times more than it was. After we'd signed the contract, we told the sales company the true cost and they couldn't believe it; they thought we'd spent about a million pounds, whereas we'd spent about the same amount as a big budget movie would on coffee cups. We still think this was largely down to the costumes (see figures 18 and 19).

But obviously if your movie is specifically set now, you can save money by having your costume designer looking in thrift/charity shops or buy various new items, keeping the labels for the ones that aren't used to take back. In fact we know some people, for items that are just worn once, to just hide the labels when they're being worn on set and take them back to get a refund so they can hand the money back to the production. We'll leave you to decide if you want/need to do that!

You can always ask the actors to bring in a few things too, which in theory you should officially rent from them, but it works out cheaper than buying or going to a rental house, and saves time in running around getting things. Watch out for actors forgetting things though. Great that their coat will fit them properly and be lived in, giving the costume an authentic look, but you can guarantee they'll forget to wear that coat the day you're shooting all the exteriors.

One thing to keep an eye on is the need for duplicates. You won't always need them for every costume, but you have to think about where it's set and what might be happening weather wise. *The Isle* really taught us the importance of having backup clothes and specific duplicates for

PRE-PRODUCTION: TACKLING THE TRAFFIC LIGHTS 111

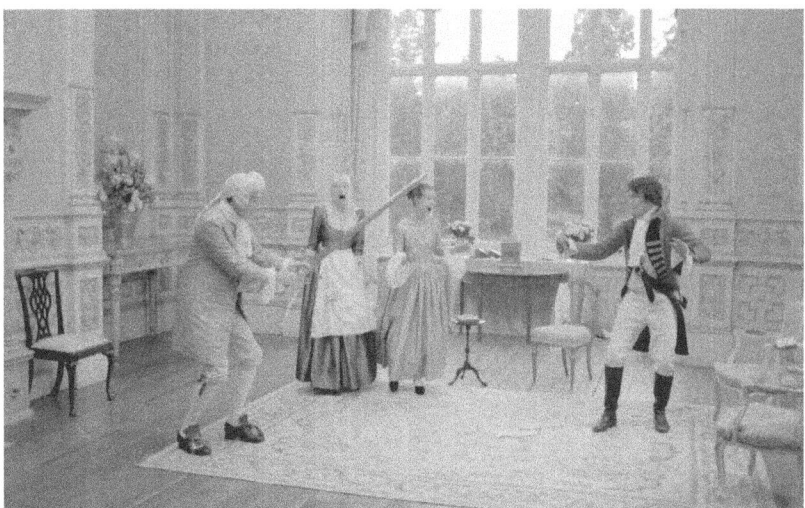

FIGURES 18 AND 19
Miss in Her Teens costumes used from the theatre company

certain scenes. It's set on a remote Scottish island and with that comes very changeable weather, so we had a lot of actors walking around in very wet clothes, and not just from being in leaking boats and drownings. Melanie, the costume designer, had tried to get as many as she could but with only three weeks of prep time for something set in 1846, it meant that we often didn't have copies when we would have liked so sometimes

had to rethink, or adapt a shot, to accommodate it. It was just lack of time, but it was a good lesson for us.

All these costume decisions, like props and set, have to go by the director, production designer, and DOP to be signed off, so having group Dropbox folders means no one gets left out of any of the important conversations even if they're off somewhere else sourcing things for the shoot.

EQUIPMENT LISTS

Once the director and DOP have gone through all the scenes and worked out, as best they can at this stage, what the shots will be, the DOP and his gaffer will send over a really long wish list. Remember that this is a wish list, and even if they know the budget, they'll still add a load of things they know you probably won't be able to get. Don't despair—this is all part of the process; when you asked for things for your birthday as a kid, you knew you were never going to get it all!

You can now send this list off to different rental houses to see what quotes they come back with. The numbers that come back will be frightening, but this is also part of the game. You then go back to the houses and tell them what you can afford and then the negotiations begin. Some may not move at all, especially if they don't know you; reputation goes a long way in the movie industry and if you're new then you need to build it up. Your DOP may also have good relationships with houses so ask them too.

If it's not going well and the list is just too silly and long, go back to the DOP and ask what they could take off. There may be a bit of a battle, but, you guessed it, all part of the fun. Between you, the rental guys, and your DOP, you'll work out what you can realistically afford and actually need to do the story justice. (And we can guarantee that not all of the equipment will be used anyway, but keep that between you and us.)

AGENTS

It's likely you've got your main cast sorted at this point, and by sorted I mean they've agreed to do it and convinced their agent that even though

it's not a huge amount of money it's a great part and it's only four weeks of filming.

This means you now have to draw up a CAN (Casting Advice Notice) for the agents (in the United States, you might call it a deal memo), which is a short, almost mini contract that needs to be signed before the actor can work with you. It outlines the basics of whatever you're offering, dates, pay, accommodation . . . whatever it is you're tempting them with.

Later on, you'll have to do a much longer contract based on the deal memo, but you have to get past this hurdle first. And it can be a real hurdle depending on the agent. They're trying to do their best for their client and be able to go back to the actor and say "I've got you this, this and this," which is fair enough, so don't panic when they start demanding that their actor has their own private green room, which if you have five actors in one scene is just going to be silly, and very few actors actually want this or have ever asked for it.

The trick is to just work with actors who are nice and understand how much hard work an indie movie can be and know that you've probably been slaving away at it for years; if they start making outrageous demands that take money away from things that should be on the screen so they can have a daily supply of Cuban hand-rolled cigars, they're probably the wrong actor. We trained as actors, so we're allowed to say that. (Half the time the demands aren't coming from the actor at all but the agent, and the poor actor doesn't have a clue, as we've discovered. We've had to call up an actor and ask if she really wanted whatever silly thing it was, and she said, "No, of course I don't!")

CASTING

We also want to touch on casting, as even though you probably have the main cast (or you might not if you've managed to get the money based on you and the script, which is great!), there will probably be other parts to cast.

We've been lucky because working as actors we knew a lot of people we could call on, especially from the theatre stuff we did, so we knew how

they worked and could get easy access to them without going through their agents (until the contract part anyway).

Apart from that, though, we like to keep an eye out for interesting actors and keep a note of who we like so we'll go along to theatre, drama school plays for younger actors, and even short films (sacrilege we know) to look people up if we like them and add them to the pot.

We'd usually say if you can find a way of connecting with them without going directly through the agent, it can help your cause to be able to get them interested in the material, so they can let the agent know they're happy to start the conversation. The agent might not be thrilled about doing it this way, but on the other hand they'll get their 10 percent whichever way the work came about.

We tend not to audition people if we've seen them in things before (that might change, you never know), but we insist on meeting up and having a chat. We can see they can act from previous work and showreels, so the most important aspect for us is that we'll have a nice time working with them (see figures 20 and 21). Filmmaking is not an easy job, and

FIGURE 20
Actors Graham Butler, Fisayo Akinade, and Emma King on *The Isle*

FIGURE 21
Working with a great cast on *Two Down*

you often have to wait years in between each one, so if it's not fun why on earth do it (in our humble opinion)?

"As you know, you're asked questions all the time in pre-production and it's also true of the actors as well, you're asked about what sort of actor, what sort of look and you can easily confuse yourself. You have to keep reminding yourself what sort of story you want to tell, because you can get over glamorised by suddenly hearing a very famous person wants to be in it, or a certain part doesn't matter, but of course every frame matters in film and you never know at the time what the great scenes are going to be or what beats are going to carry weight. Sometimes it's just the way someone puts the coffee cup in the saucer, and it rings through the film because they've made a decision and you know it just by the way they've done that. . . . It was Stephen Campbell-Moore's first film and he came to audition, or the meeting I should say, and I'd only ever been in those things from an actor's point of view. I remember David Tennant and James McAvoy both said to me that they were convinced that they hadn't got the part because they basically only had to open their mouths in the audition for me to go, 'great, thank you that's lovely, thank you very much.' Because they were just perfect, I mean I saw

them after about three days of seeing actors for those parts and they were so good that I didn't need them to do any more. Whereas when someone comes and you're not quite sure you ask them to do it lots of different ways. They were in and out so quickly they thought, 'oh well I fucked that up!' But you are desperate, every actor that comes in, you want them to be the one, you're sitting there thinking this film depends on the right people."

—*Stephen Fry*

CATERING

Food is one of the most important things to get right on a film. Amazingly, this seems to be the last thing on a lot of indie producers' list to sort out and because of that usually ends up being expensive and mediocre or cheap and horrific, which quickly turns the crew against the production.

Specific film catering is a really tricky thing to get right, though, as you have a lot of very different people, some of whom are on their feet twelve hours a day, so they need substantial amounts of energy-giving food, preferably healthy (but there will always be people who get sick of the healthy stuff!), and countless allergies.

The go-to of so many indie producers is pizza. We love pizza, but not every day. It's not going to keep your crew alive, and neither are sandwiches for every lunch. You may be thinking, well yes, obviously, but that's because you're a smart cookie. In my (Matthew), acting days, I was in about twelve indie features and most of them served me sandwiches and pizza every day and my energy levels were non-existent by the end.

What did we do then? On *Miss in Her Teens*, we had Tori's dad making us homecooked meals every day and had friends help out with meals too (people love being involved in films, and they get a credit in the film too; something to dine out on for years!). The cast and crew probably only amounted to twenty people, so it was pretty easy to manage and it made a huge difference to morale for a start. We were lucky though as we filmed in one location, a big country house, and had a kitchen nearby.

On *Two Down*, we had twenty-two locations and were constantly on the move, but we were always within a small area based around a North London town so we made deals with all the local restaurants to create special meals for us which we just went and picked up. Every day we had a completely different kind of food to keep us from getting bored, and we could make sure they were always full of healthy but tasty energy!

As we progressed and things got bigger, so did the number of allergies and food preferences that we had to deal with. A good way to keep a track is to send out a survey to the cast and crew (there are free websites that let you set up your own survey with whatever questions you like), where you can ask about all sorts of things like home address, next of kin, and the all-important allergies and food preferences question. Then everyone can go into a database and you can hand it to whoever is sorting out the food.

For *The Isle*, we would be miles from everywhere but have a large kitchen at our disposal. We looked at hiring a proper caterer to come and stay but they were going to cost an absolute fortune and what they were proposing for food, bear in mind they were "professional film caterers," just sounded bland and horrific. We'd be stuck on an island with some very grumpy people if we'd done that. So we asked Tori's father again! He's a very good cook who understands that you need to take the location and kind of shoot into consideration to inform you what should be served to the crew.

This was a much bigger undertaking than *Miss in Her Teens*, so we were a little worried at first just about the sheer amount of work involved, but we needn't have been. Chris also brought on his friend Keith who had just retired from NATO, of all places, to come and help (he didn't know what was about to hit him, but we think he enjoyed it!). The cast and crew were delighted as Chris took far more care about what he was giving them, and their multiple allergies, than most movie caterers ever did (see figure 22).

FIGURE 22
Actor Dickon Tyrell with Keith Ritchie and Chris Hart (long-suffering caterers on *The Isle*)

We're not saying you need to bully your parents into cooking for you, but the idea is to think outside the box rather than just getting the normal caterer to turn up and serve expensive but mediocre food. One of the films we were asked to work on, with a much bigger budget than *The Isle*, had different professional caterers at each location and most of them were more than a little disappointing to say the least. By week three, a lot of us had swapped lunch for coffee and biscuits. This is quite a long section on food! That's because it's so important and so often not treated as such. It's very simple though: if your cast and crew are happy, the film will run far smoother than if they're not, and on a movie set the key to happiness is decent food.

REHEARSALS

While all the jolly prep is happening, it would be a great idea to get the director and actors to do some rehearsals if you can all be in the same place at

the same time, which is not always possible as actors may be on other jobs, unless you have agreed to get them in and pay them a week or two before.

It's not just a great way of connecting if you're not that familiar with them, but you'll save so much time when it comes to the shoot as you'll know exactly what everyone will be doing so you can have planned exactly where the shots will be and hopefully what's going to work and what's not. We've had rehearsals and then had the DOP come in and watch, while we're still in prep, to get an idea of how the scene will feel. This was especially helpful on *Miss in Her Teens* and *Two Down* when we had a lot to shoot in very small amounts of time.

It also means you can have all the conversations with actors about exactly what the lines mean and about what they're thinking of changing. Now this is a tricky subject; most actors like to change things in the text. Sometimes it is for the best as they're bringing a fresh perspective, but only if they're thinking of the piece as a whole and where their character fits into it. Otherwise, it can sometimes be better for that scene or that moment or that particular actor, but may throw something off further down the line, perhaps in a scene that they're not even in; it might just be tempo or something bigger, but you have to keep an eye on it.

Coming from the acting side we know it's very tempting to try and change things we don't like, or think might be better for the character, but we also have to bear in mind a few things. The writer may have been working on it for years, and us as actors may have only seen it a couple of weeks ago and haven't fully realized that the change, however small, might harm rather than enhance. Also, the finance company, or private investors or whoever, has given you the money based on that script and may have a thing or two to say about changes.

This happened on *The Isle* where quite a lot of dialogue had been taken out by the actors, sometimes by saying that they could act it rather than say it; that makes complete sense as it's a visual medium and at the time in situ it seemed to work. Edited together, the finance company thought

that certain scenes had lost their clarity and we had to be clever to bring it back to a standard they would allow, including having the actors do some automated dialogue recording of the original lines when their character was off-screen. Not an ideal situation as it sometimes took something away from a moment as we had to show something else we didn't want to, but it was a valuable lesson for us.

We're not saying all changes are bad, but just remember that as the filmmaker you're responsible for the entire story and vibe and should think very carefully about changes. We had more time for rehearsals for *Miss in Her Teens* and *Two Down*, so we had room to look at the changes that were being suggested to see if they would work.

For *The Isle*, we had very little time at all so I, Matthew, just met up with the actors and chatted through the script with them and then in the evenings we'd go through every scene with the actors to discuss what was going to happen. We didn't have as many rehearsals as I would have liked at all, which meant that we had to do it on set and I would run it like a theatre rehearsal, which at first annoyed some of the crew as they had to stand outside while we played about, but when they saw that it meant we could do most things in one or two takes they realized the advantage of doing it like that. I would sit there with Pete the DOP and as we rehearsed I would move around finding angles so Pete and I could work out the best ones, and if my funny little stick-person storyboards would work (see figure 23).

It's a good idea for you as a filmmaker to read some acting books or, better still, see if you can go to some acting classes to understand the process so you know how actors approach things. There are too many directors who have spent three years at film school but have no idea how to talk to an actor to get the best out of them. And actors will spend years at drama school but are never really taught about the film side of things so don't know how it all works or what you're asking of them, which means you need to be able to communicate it in a way they'll understand. This

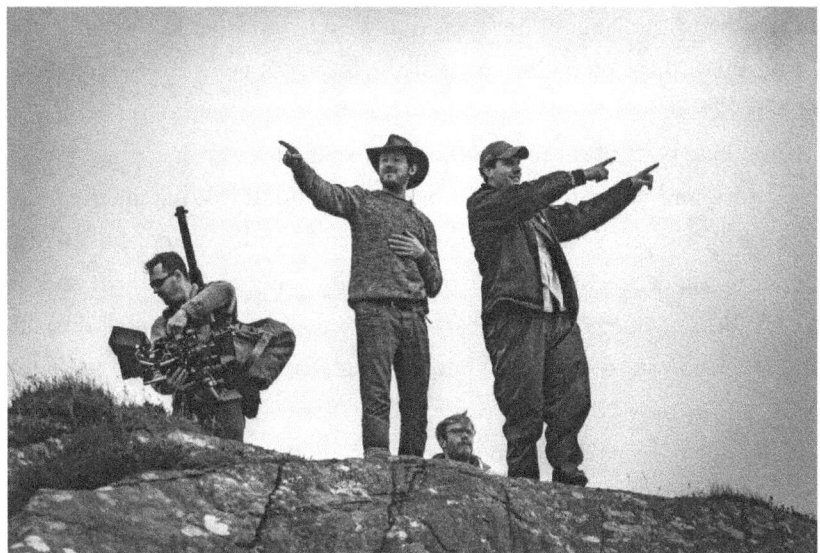

FIGURE 23
Rehearsing with DOP Pete Wallington

sounds simple, but so many directors out there haven't a clue and are all about the camera moves and shots.

"I think directors should do all the other disciplines. Go and be in your mate's film and act in it, oh this is what it feels like when the camera is pointing at you and the lights are on you and they're going come on hit your mark and say your lines. It's a big thing, it's huge, especially for new actors. Directors often don't know how to talk to actors. You have to be able to understand what they're doing. They all have different processes."

—*Giles Alderson*

RECCES

We're talking about location recces with the team, your key personnel/ heads of department. If you've been clever and found your ideal locations while you were writing the script or, if you didn't write it, while you were

beginning to think about how you would do it and what in the script can be adapted, these recces are to see if the locations work from a logistical point of view.

Are there spaces for vans, rooms for makeup and costume, green rooms for actors, and places to keep equipment safe and dry? What are the noise levels like? Does it suit things visually? And if you have a crew of twenty or thirty wandering around, are they actually going to fit in the space?

Of course, your heads of department are there to advise on all this; it's not down to you to work it all out, although that's what we had to do for most of our movies so don't panic. The gaffer will see if the electricity is enough for what you want to do, and also that it's safe; your production designer will be looking to see what needs to change to fit in with the design and how much furniture and props need to be brought in; the DOP and gaffer will chat about where can lights go and how much space there is for lights, as well as how much room there will be for camera movement and what the restrictions will be.

After all this, they may say it's not workable at all so you'll have to think again. You can of course avoid that if you've had this hat on while you were originally looking, as much as you can anyway, by asking about the electrics, for example, to see if it's what is needed for the lights.

On *Real*, Aki Omoshaybi's debut feature, locations were falling through, sometimes hours before we were meant to shoot in them—a lot of things that had been promised as favors disappeared once it was actually up and running. That's where adapting comes in handy if you know exactly what are the most important story points that need to be hit, rather than just a cool location. We were lucky on *Real* though, for the locations we lost last minute and then had to run around like loons trying to find somewhere else, the new locations worked out perfectly and were better than the originals a lot of the time, so it's not always bad news, sometimes a new location can be a happy accident (see figure 24)!

FIGURE 24
Pippa Bennet-Warner and Aki Omoshaybi in *Real*. DWGH Photography

ACCOMMODATION

We won't bang on too much about accommodation as there's not really too much to it.

For an indie film, of course you need to think about saving money, but as with the food you need to make sure your cast and crew get a good night's sleep.

Hotels, although easy from a pick-up and drop-off angle as you have everyone in only a couple of places, are usually not the cheapest way of doing things. Some let you haggle a bit but not much, and most of the people you get to speak to aren't in a position to do the haggling anyway. We've always tried to find local bed-and-breakfasts or even self-catering cottages, where sometimes, especially out of season, you can talk about discounts if there are lots of you.

Sometimes a bed-and-breakfast owner will suggest friends they have that take lodgers, and never underestimate how excited some people get by having film-folk to stay! Use that excitement to plead "indie moviemaker" and give them a thanks in the credits if you can get a discount. It won't always work, but it often does. In an ideal world, you wouldn't have people too scattered around though, as you run more of a risk of people being late in the morning.

This is obviously not a worry if you're filming near where most of you live, in which case you'll save a ton as people will be able to go home at night.

BE GREEN

The film industry can be a horrific place of waste. The sheer number of things designed for a film shoot that are not great for the environment is appalling. Things are getting better, people are becoming more aware, and there are now lighting companies (not many yet) who specialize in lights that are far more eco-friendly.

As a lot of these companies are currently in the minority and trying to stake their place in the industry; they're usually willing to accommodate the indie filmmaker, especially if you're actively trying to create a green shoot.

Water is the stuff of life, especially on a busy set; the amount of plastic bottles that a crew can get through is staggering (and half the time when the day ends you'll see dozens of half-drunk bottles, which drives us insane), so we always provide people with their own water bottle. On *The Isle*, we also gave them their own hot drink cup too as we'd be moving around the island so much and couldn't bring china mugs to rocky cliffs and refused to use those horrible polystyrene things that never decompose. On *Real*, where the budget was much smaller, we asked people to bring refillable cups and bottles as most people have their own these days, and if someone didn't we'd splash out and get one for them; anything to stop

people using plastic bottles! There are still a lot of crew people who are just used to the waste and complain about us trying to change things, but they're just going to have to suck it up I'm afraid.

On our own films, we don't like giving out paper call sheets or even sides (the scenes you'll be shooting on that particular day) and will send everything via email. Some old-school people don't like that either, but most people only glance at the call sheet and then leave it somewhere a minute later.

There will be more and more ways of not using wasteful products in the industry soon, so just keep thinking of ideas where you can help the cause. It'll save you a lot of money too, if you want to think about it like that.

LOGISTICS

As you've been finalizing all your locations and worked out where people can park and found maps of how they get there, where the nearest toilets are, and which hospital to rush people to when they chop their finger off trying to attach a water container to a costume trailer (Matthew, 2018)—all this info needs to get to your crew.

If you've got someone as your production manager, they'll sort this out and everyone will get that info along with the next day's call sheet the evening before. Having someone who just looks after the logistics is money well spent, we have to say.

When you're filming, or producing, there's just too much to think about to remember the little, but massively vital, things that will keep things flowing nicely. It's often a thankless task as they're the person people go to when things go wrong, and they are badgered by actors when they don't know what's going on with their transport, so be careful when choosing this person as they could be your shoot's savior. On indie movies, they often double up as a location manager too, so they quite literally hold the keys to your shoot going well.

Along with the call sheet a Movement Order needs to be created for each day, at least each filming location, with all the above fun information included. It can be nice and simple with little maps showing all the relevant things.

CALL SHEET

The call sheet, a new one of which will be sent to everyone on the cast and crew who is involved in the next day's shooting, will be made up by the AD team, along with the production team, and sent out at the end of the day's filming.

An example can be found in figure 25, but in essence it gives you all the numbers of the people you might need to contact, what scenes are being shot and in what order, which of the cast are needed for which scenes, when cast and crew are called for the day, and the times for breakfast, lunch, and wrap. It looks like a jumble of nonsense if you haven't seen one before, but it's very easy to understand and massively essential that you understand it no matter what your role on the shoot is, including acting.

Saying that though, people will still ask what's going on all day long, and that's the same for the Movement Order. Just part of the fun of set life, I guess!

WHO DOES WHAT?

This might seem fairly obvious, and in most cases with your crew it is. When it comes to elements that might overlap, however, it's good to work through every single thing that happens in the script to make sure someone is on it. Too often the conversation between, say, the production designer and the costume department happens where each thought the other was sorting it out. Or when makeup and special effects makeup overlap. Or special effects and production design. There are lots of things that can fit into both camps and a lot of the time people assume it's the

DATE	CALLSHEET #1 of 24	DIRECTOR:
LOCATION		PRODUCER:
ADDRESS	**UNIT CALL: 1000**	Breakfast: 0930 (30mins) Blocking: 1000
SEE MAP	CREW PICKUP – FROM HOTEL: 0900	Lunch: 1530 (1hr) Est. Cam Wrap: 2100

	Current Script: Pink Revision - 24/04/18.		Current Schedule: v8, 30/04/18 – 2 WEEKS ONLY.	
TECH PARKING	MAKE-UP/COSTUME Split on Location.	CATERING	CREW & CAST PARKING	WEATHER A few showers in the afternoon. Rise: 0534 Hi: 12° Set: 2023 Lo: 7°

Producer:	Line Producer: Tori Butler-Hart	1st AD:
Producer:	Production Manager: Matt	2nd AD:
Exec. Producers	Production Co-Ordinator: I	3rd AD:

PRODUCTION NOTES
NO PHONE USE ON SET AT ANY TIME.
We are shooting on someone else's property for 2 weeks, please be respectful and behave yourself.
No smoking on the property at any time, there is a designated smoking area so please use it.

ROUGH SCHEDULE

SC	I/E	SD	SET/SYNOPSIS	PGS	CAST	NOTES
18	EXT	D2	**OXFORD HOUSE – FRONT** Sun lowering behind the house.	1/8	-	-
			SD CHANGE – TO D3			
			SHOOTING AS ONE			
38	EXT	D3	**OXFORD HOUSE – FRONT** IZZY rushes toward the garage.	1/8	1	-
39	INT	D3	**OXFORD HOUSE – GARAGE** IZZY searches the drawers and finds surveillance cameras.	1/8	1	-
			SD CHANGE – TO D4			
43	EXT	D4	**OXFORD HOUSE – GARAGE** The house in the morning.	1/8	1	-
44	INT	D4	**OXFORD HOUSE – GARAGE** IZZY is asleep in front of the laptop, she wakes from the sun hitting her face.	1/8	1	-
49A	INT	D4	**OXFORD HOUSE – GARAGE** IZZY & ETHAN watch the screens, it's clear Izzy was alone in the music room.	2 5/8	1, 2	-
54A	INT	D4	**OXFORD HOUSE – GARAGE** IZZY watches the screens, she sees that Richard is a scam artist.	4/8	1	-
53	EXT	D4	**OXFORD HOUSE – GARAGE** IZZY tries to call Ethan.	1/8	1	-
			MOVE OUTSIDE – CHANGE TO N3			
42A	INT	N3	**OXFORD HOUSE – GARAGE** Izzy watches the surveillance screen, she sees a dark figure.	3/8	1	-
41	EXT	N3	**OXFORD HOUSE** The house at night, the lights go off, we see the garage light is on.	1/8	-	-
			TOTAL	4 3/8		

CAST

ID	CHARACTER	ARTISTE	Notes	P/UP	CALL	COS	HMU	BLK	SET	SWF
1	IZZY		X	0930	0950	1010	1050 DF	1030	1130	SW
2	ETHAN		X	1340	1400	1630	1400 ES	1500	1650	SW

SUPPORTING ARTISTS / VEHICLES / ANIMALS

ID	ROLE	ARTISTE	PICK UP	CALL	COS	HMU	BLK	SET
X	X	X	X	X	X	X	X	X

REQUIREMENTS

REMARKS	- Please NO STILL PHOTOGRAPHY or VIDEO'S to be taken on set, unless prescribed. If prescribed, always include #TheUnfamiliar. - ALL CREW MUST CONFIRM WITH ELECTRIC BEFORE USING ANY ELECTRICAL APPLIANCES – If you don't have to, then don't.
ACTION VEHICLES	-
ART DEPARTMENT	
ASSISTANT DIRECTORS	-

FIGURE 25
Call sheet example

other department's responsibility, so having production meetings to go through every little thing could save a lot of arguments, therefore time, therefore money, on set.

And keep them up throughout the shoot to make sure nothing is left out. We had them every night on *The Isle* as things on the island were constantly changing so the schedule kept moving around and there were so many unpredictable moving parts.

RELEASE FORMS

These are simply little contracts for locations to say that you have permission to use the building.

These forms need to have all the details of the production, contact details of the producers, a location manager if you have one (or whoever is wearing that hat at the time; it's often us), any details of the deal including dates, and times of start and finish, and how much they're going to get paid.

Also work out the details for when—sorry I mean if—things get broken and who's responsibility it is to sort out. You'll be paying for it but sometimes it's best if you sort it out so you know you're getting a good rate for the work. You'll be able to claim it back on your insurance, but you'll have to pay up first.

On that note, make sure that everything is photographed in the place you're filming if it's a location. Especially anything that's already broken so they can't try and blame previously smashed things on your crew.

Make sure they and you sign it and you both have copies.

You'll need a different release form for supporting artists (extras/background/atmosphere), with a quick description of what they're doing, the date, and scene number.

And it's good to have some blank release forms on location just in case someone walks into frame if you're filming out in public and they haven't noticed the film crew and a dozen people waving at them to stop but you like the take and it works.

This is all just to cover you legally if they turn around and say they didn't give permission to use their likeness when your movie suddenly starts making loads of money. Better safe than sorry.

EMERGENCY SERVICES

If you're out in public and shooting a scene that might get people concerned, like a bike theft or a heated argument, let the police know you'll be in the area that day and what you're doing. Once again, sometimes people seem to miss the camera and crew and call the emergency services for all sorts of reasons.

It just means you won't get interrupted as police cars race into your shot.

YOU'RE READY . . .

There are so many things to get ready for in even the simplest-looking movie, and actually those simple ones are even worse because it can lull some people into a false sense of security that the shoot will be as simple as the script. Every film is a massive jigsaw puzzle and the only way to get through it is one piece at a time and to be prepared as possible.

You just have to be absolutely meticulous when going through the script, breaking everything down into lovely long lists for each scene and what it will take to make that happen. Most of pre-production is common sense, but it also takes practice; the more movies you make, the more adept you'll be at remembering what needs to be ordered or talked about weeks before it happens, rather than minutes before.

This chapter has hopefully given you insight into what is needed so that you get an idea of the depth that you need to be thinking about, and also to add your own elements depending on what the film requires and how big your budget and crew is. The bigger the film and more money you have, the more there will be to do. If you start using costume and makeup trailers and dining buses, there's a whole other set of problems that go along with that. And at the end of the day, you can prep all you

like but there will always, *always*, no matter the budget and months of prep you do, be things that go wrong. But sometimes those happy accidents are what make filmmaking fun.

"Jeremy Irons said, 'how's your film coming along?' And I said, 'I think it's going alright, although I won't believe it's actually happening until I'm in the car on the way to the first day of shooting.' And he said 'No, when you're in the car on the way back from the first day of shooting.'"

—*Stephen Fry*

5

Production: From Country Houses to Sinking Ships

We often say that the production part of making a film is by far the most fun but unfortunately takes the least amount of time. Making a film is hard work, and you've spent probably hundreds, if not thousands, of hours working toward this point: all the drafts and rewrites of the script, finding the money to actually make the film, and getting your team together in the pre-production stages. With a bit of luck, most of your shoot is organized, planned, and prepared before you start filming.

There's never enough time in the pre-production period, and there's always inevitably last-minute things that need to be sorted out and they will continue to show up throughout the shoot: signed casting advice notices from cast that you're still waiting on and that won't probably be returned to you until the second week of the shoot, or maybe one of your sparks has been offered work on an advertisement three days into filming and because he's going to be paid more for those two days than you're paying him for the entire shoot, you agree he can take the job, which means you need to find a daily to replace him for those two days.

The lead up to, and throughout, principal photography is never easy; there are a 101 things to think about. The production team is working on the logistics and basically looking after everyone while you're filming, so

the creatives and rest of the crew can focus on making the film the best they can. For us, as producers, writers, director, and often one of the lead actors, it is the craziest time—we don't stop. We've never finished a shoot and not felt utterly exhausted and destroyed, but it's an incredible feeling and the reason that we want to keep making more and more. The pride that you feel on the first day of the shoot, when everyone is gathered together to make your film, it's a feeling that's kind of unbeatable.

We've made numerous shorts and three features as well as co-produced one and line produced another, and all five features were very different shoot experiences and teams. But what we always hope to instill whenever we work on something is a sense of fun and comradery. Although there is a hierarchy built within the workings of a crew, where people's job roles sit above other roles, we've never encouraged that kind of vibe on our sets. Yes, there needs to be respect, but respect for every single person working on your set. They are all talented, they are all uniquely gifted, and they are all working toward making your film the best that they possibly can. Because you can't make a film on your own, it's not just your film, it belongs to your crew, your cast, everyone. And that sense of being a part of a team is what makes filmmaking so fun. As an actor, you can kind of miss out a little on the team feeling; you get picked up, you get plonked in your dressing room, you're in makeup, you're on set, you're wrapped, and you get dropped home. So, for both of us coming from acting backgrounds, suddenly being privy to all the other stuff that goes on behind camera and off-set was incredibly humbling, exciting, and enlightening.

Because we tend to work with budgets that are crazily low for what we're trying to achieve, we often end up doing ten people's jobs—it's not perhaps advisable to do this, but despite being control freaks, it is often necessary. For example, we will never have the budget to have drivers as well as runners and in turn, we never have enough runners. So what ends up happening, because we don't want to exhaust our camera crew by asking them to drive a van which isn't their job anyway (and often people

aren't comfortable driving big vans full of expensive camera and lighting equipment, understandably), we end up driving the vans. That means that we'll go to the van hire and pick up two big vans, then drive in tandem to the hire houses, pick up the camera equipment that has all been checked that morning or the day before by our DOP and his team, and pack up the van. Then we go to the lighting rental house and pick up the lighting kit that has all been checked by the gaffer. This is on day one of the shoot, the pick up and get-in day. And to be honest we really don't mind; it's what we've always done and now it's just part of the fun and excitement of starting a new film. Often the rental houses are at places like Pinewood Studios and driving around there will never get old, no matter how many of these size budget films we do.

We might also help the production design team. So, if they're under-crewed, which often they are because we don't have the budget for enough art assistants, one of us might spend the days before picking up camera equipment driving around to all the prop houses, collecting set and props with our production designer. We've often had to go and collect costumes and makeup kit—these might be from elsewhere in London or from somewhere a couple of hours drive outside the city. All of these departments have a lot of kit; they need to have a lot of kit because they want to be prepared for any eventuality and it all needs to safely find its way to wherever you're setting up base. And if you're doing it yourself, you know you're going to take care of it!

Get-in days: Once we've spent a few days driving around picking stuff up, and the art department is busy getting into the first location and the camera crew is rearranging their van or checking all their kit again and the lighting department is sitting on the lighting van smoking because there's nothing for them to do until the art department clears the space and they can light it, we are usually going to the supermarket to get food to feed everyone, or helping in the kitchen because it's my (Tori) Dad doing the catering and he's already in a total mess and hours behind.

We'll also be sitting down with the first AD and going through the call sheet for the first day's shoot. We'll be checking that cast have been picked up from the station and taken to their hotel; if they haven't, we figure out where the runner that's supposed to be doing that is or why the actor missed the train that they were specifically told to get. We'll be helping set up the makeup and costume rooms, finding extension leads and mirrors and more lights and more chairs that are the right height, and setting up the green room to resemble something that an actor might want to sit in, instead of a bare empty holding cell. Setting up the production office, which usually does end up looking like a bare empty holding cell, but with a printer, endless stacks of paper, and all kinds of potentially useful stationary you'll probably never use. And then there's "craft." The table set up with the hot water, tea, coffee, water, biscuits, crisps, snack bars, cereal bars, chocolate, fruit, mini cheeses, and the like, because for some unknown reason as soon as a crew steps on set, they are desperate for fluids, will drop down dead if they don't receive a strong black coffee within five minutes of arrival, and are ravenous because they haven't eaten for days. In some cases, this is true—they might be starving and the best way to keep your crew happy is to pay them on time and feed them well.

"I've always liked being in a group, I don't like being the boss. I guess what you need as a producer is what you two have got, which is; a very easy comfortable manner with other people, interested in other people, confident about yourself, optimistic, wanting to get something done, all those are great, great attributes . . . there are people in the industry who are tyrants but make masterpieces. In the end I would much prefer to make a film with you than Alfred Hitchcock because I would have been in a Hitchcock film, but I would have made a film with you. Other people may love being bullied and pushed around."

—Ian McKellen

When we filmed *Miss in Her Teens*, we had seven days to shoot it. This seems insane, but because we had already performed the play many times and had spent time rehearsing the scenes in London before we went to film it, we actually managed to fit it in to just a week reasonably easily. Our locations were all set around a large country house. This country house was Wroxton Abbey in Oxfordshire. It's actually owned by an American university, Fairleigh Dickinson University in New Jersey. They have students from America come over for a semester to study British history, politics, art, literature, etc. The reason we chose to shoot the film there was because we could get access to it: Tori's mother, Wendy, is an art historian and teaches British art there. Over the summer months, the college is empty. We could be there for nine days, accommodate everyone in the student rooms, and it's very close to Wendy and Chris's house, so Chris could do the catering in his own kitchen. Friends of Tori's parents helped out and were importantly also our supporting artists.

Because the screenplay had stuck very closely to the play, the locations remained contained; we set most of the action inside Biddy Bellair's chambers, a large elaborate room in the abbey that had beautiful wooden floorboards, gold fabric wallpaper, and a grand piano, all in keeping with the date of the play or near enough. We furnished the room with a portrait, chairs, and a table, all from the correct period, and added details with props and flowers.

The other main scenes were in the grounds of the abbey and the local village. As a lot of it was shot outside, we didn't need a lot of set changes or dressing. We filmed in the knot garden, which was beautiful and overlooked a huge lake, which all added production value to the film (see figure 26). It was already there, and we didn't need to do anything to it; we just adapted the script to work with what we had easy access to. We filmed another scene in a wooded part of the grounds and by an old gate which led out to a beautiful old little cottage covered with climbing roses. It was all quintessentially British, and it was a lovely backdrop for another scene.

FIGURE 26
The lake at Wroxton Abbey in *Miss in Her Teens*

The most complicated set-up was for our main opening scene, which was meant to be in a marketplace. This is when the hero of the film, The Captain, has returned from war with his manservant Puff, and is there to reclaim the love of his life, Miss Biddy Bellair. We needed the market to seem full of life and like there were more people living there than just our cast. This is when we depended on the kindness of friends and family to get dressed up and hang about the market. We had little stalls set up, a few chickens clucking about, and a horse from the local farmer that we borrowed to walk across camera to help bring some life into the first shot of the scene. We also enlisted the help of Tori's old drama teacher and some of her students who lived local to the area, who all jumped at the chance of dressing up and being in a feature film for the day. There was somewhat of an age gap between the female students and the rest of our extras who were mainly Tori's dad's friends, convinced to take part by

the promise of a few beers and a decent lunch. When we watch it now, we wish that we'd had a few more bodies and a bit more set to really sell it. It looks pretty good for the non-existent budget we had, but it's by no means the bustling market we'd imagined. We had to use elements in the post-production side to make it seem fuller with sound effects, which really helps actually.

That's something that we've learned: managing expectations on the budget that you have available. This is an interesting point that comes up time and time again. The director will want something because that's how they've envisaged the scene or they've changed their mind about how they want to shoot it. They're allowed to do that! For example, they want a huge mirror at the end of a long hallway to give the illusion that the hallway continues. This came up in the pre-production conversations with the production designer and art director and said mirror is there ready for the shoot. But the director has a flash of inspiration, "Wouldn't it be great if the cricket ball could fly through the open window and smash the mirror?" Ok, well production design doesn't have the budget to buy at least five big sheets of sugar glass to make that happen. You ask the line producer, "Is there more money that the art department can have in order to make this shot happen?" The line producer says no.

There's two ways to look at this. First, as the director, manage your expectation of what can be achieved on the budget that you have. This might mean that you need to rethink things and be prepared to make compromises. However, make sure that those compromises aren't to the detriment of your film. In the words of Stephen Fry, "Everything on film matters because you can't go back and change it." So, if that shot really, really matters, then fight for it. But how can you do that without annoying the rest of your heads of department? As a director, spend some time with your producers and your line producer and know your budget better; know where the money is being spent and why. What areas could you potentially rethink and offer an alternative that could save some money? And

this goes for the producers and the line producer as well. Yes, you have to deliver on budget so don't let your director get away with changing their mind every other day; manage their expectations but instead of just saying no, find ways to compromise so that the important story beat is still being served, and not the ego of people involved.

"I wish I had a seat at the producer's table, because when you're making a film as a writer/director you put so much into the film, every day of prep and shoot and even afterward, you're so front, centre and inside of it, you represent the film so much and you think about the different ways of doing it, and then I think there's another conversation that happens with producers that I don't feel like I'm there for and it can probably affect what I do as a director. . . . Why are we putting this money here, why can't we put this money here instead? When you're directing and you're doing a scene and you're thinking a million things, and you maybe have an hour to finish and you think well maybe if I condense this, you're doing a million calculations in your head to help you get what you need to on the day. And sometimes, the line producer or the production manager or even the producer will come and say 'look I'm not sure you can do this, think about the money,' if I'm also thinking about the money I'd probably find ways of being smarter with it and anticipating the problems that occur. Sometimes a producer comes on and says, 'look this is what you have' and not through any fault of theirs, but if I'd been party to that and aware from early days I could have almost anticipated it, and then I could say 'what about this or this, try it this way.'"

—*Hong Khaou*

Another important lesson is to remain open to the unexpected. The opening shot of *Miss in Her Teens*, or at least it was at that point the opening shot when it was running only sixty minutes, was of the two characters The Captain and Puff returning from Flanders. From my parents living in the area and walking the dogs around the surrounding fields, we knew that there was an obelisk at the top of the hill behind the abbey. It was an interesting feature to include and it added to the overall historical feeling

FIGURE 27
Poppy field in *Miss in Her Teens*

of the movie. We'd done a recce and knew it was possible to get the kit, crew, and cast up there quite easily, but it was only by chance when we went up there to film the scene weeks later that we discovered the field was covered in poppies (see figure 27). This beautiful splash of red makes for a stunning opening shot, and the fact that the poppies were there, linking the image to war, was one of those happy accidents that happens on set sometimes: unforeseen circumstances have led you there and it works out for the best. There's a lot to be said for trusting and going with it when making independent films, and those moments are very often some of the best parts of a lot of films.

A wonderful example was on a film we co-produced called *Real*. We shot the entire film in twelve days and had booked the beach scenes on a particular day due to actor availability and when we could get the permits to shoot on the beach. Needless to say, being in the United Kingdom in late September on that one day we absolutely had to shoot the scene, it absolutely poured with rain. In the script it was meant to be glorious sunshine. It's one of our favorite scenes in the film, because it's not perfect.

They turn up to the beach and sit in the car as the rain hammers down on the windscreen and then they make the decision and get out and make a run for cover, just so the little boy can see the sea and run on the sand for the first time in his life. It's a really beautiful scene because it's the start of a new relationship between the two characters; somehow, if it had been sunny, it would have been too perfect. Nothing else in their lives is perfect, and so why would their first date be? Instead, they push on with resilience and good humor; it's kind of the perfect analogy for the whole film and wouldn't have been there if we'd had the luxury of more days to shoot and reschedule.

It was a year before we went back and filmed the extra ten minutes of *Miss in Her Teens* so it would officially be feature film length. We didn't need to use the abbey this time and managed to shoot the additional five scenes over a weekend. People came down for just a day, or if they needed to stay we housed them at friends' or at the local pub. The new opening scene of war was filmed in the field in front of my parents' house, and the obliging farmer yet again allowing us to use his horse. This time we needed to hire army uniforms for The Captain and Puff, and a cannon because nothing says war like a cannon! To add atmosphere, we got some smoke grenades and filled the scene with supposed gunfire smoke, selling it afterward with sound effects. Other than that, we had a scene of a picnic by a lake (the lake that's in the grounds of the abbey) and a couple of tiny inserts that were more pick-ups than anything.

The final scene we added was of a wedding between Biddy and her Captain, which we filmed outside the village church. A lovely happy ending, with all the cast gathered together and wishing them well. Biddy's wedding dress was one that Tori's mum found in a local charity shop and although it was more Victorian in style, we discovered that if Tori wore it backward, it actually looked in keeping with the period of the film! The night before shooting the wedding scene we were busy sewing embellishments onto people's costumes. We couldn't afford to

hire all new costumes for everyone, especially just for one scene, but what we could do was mix things up, add a hat here and there and some extra ribbons and lace.

It was an interesting exercise going back and filming the beginning and end a year later. Not only had our cast developed and learned more as actors working on camera, but Matt as a director and us as filmmakers had developed. Being more adventurous with shot choices and movement of the camera gives the scenes a greater feeling of artistic maturity. We learned all sorts of things from making *Miss in Her Teens*: to be brave with your script and to not be afraid to alter it if it better suits your location and the facilities at your disposal. This is particularly true when you're adapting a play or a novel into a screenplay; don't be too precious—it's a very different medium to theatre and books and needs to be treated as such. We learned that we have to be creative with our shots and allow them to tell the story, not just the characters, which is what we were used to with theatre; visual storytelling is an art form and it's precise and needs to have a lot of time and effort spent thinking about, especially on a modest budget. Above all, we learned how to be resourceful. To beg, borrow, and steal. Look at what you have, what is given to you, and what is already there, and make it work for your vision. To film around, and think outside, of the box.

To be honest, we didn't have a clue what we were doing when we filmed *Miss in Her Teens*, and only a bit more of a clue when we'd finished, but it was the beginning of us starting to understand more, and it fired us up to go and learn. Our camera crew was a huge help, although small in number; our DOP Pete Wallington, our editor and sound recordist William Honeyball, his brother and our first AD Ben Honeyball, our boom op Martin, and our gaffer Igor. The five of them were brilliant and knew far more than we did, having all worked on features before.

The whole experience was nothing like any shoot or set we've been on or ever will again. Probably the best way to describe it was like filming a

play on location, because that's exactly what it was! The shots were often reasonably wide and lengthy with not many takes and mostly handheld, partly for speed, as setting up would be much quicker; partly because there could be up to five characters in one scene, all in one room, so it made it easier for Pete to move around them all and cover everyone in the limited time we had; and partly to help reduce the theatricality of it. If we had had a series of locked off shots, it would have felt very like a fourth wall in the theatre, the audience viewing from outside, removed from the action. These historical films are often much more static, so we also wanted to have a different feel and make people experience that period rather than just observing. By shooting handheld, it gave the viewer a greater sense of being involved in the unfolding action and worked well when characters like Puff and Biddy broke the fourth wall and spoke directly to camera, as they did in the original play script with cheeky asides to the audience.

Two Down was a very different experience. We wanted it to have an elevated almost theatrical feel, a lot of the shots being locked off, or very slowly tracking. A majority of the film is very contained: three characters in one room, thinking and discussing, plotting and planning. For a thriller, there's very little action until the end of the film. Matt was hugely influenced by films of the 1960s and 1970s, especially movies like *The Conversation* starring Gene Hackman and directed by Francis Ford Coppola, and the whole look, feel, and pacing of *Two Down* reflects that.

As we mentioned in the scriptwriting section, we'd written *Two Down* with locations in mind and so it meant that when it got to the production stage it was very contained and quick to get to and from all the locations. We kept costs down by using our flat as the unit base and filmed it in two weeks. It was quick, it was sometimes rushed, and it was way bigger than *Miss in Her Teens*.

In the first week, we shot something like twenty different locations. We filmed the revealing final scene in a big old church with the actress Felicity Montague (*Alan Partridge*) (see figure 28), a flashback scene in a pub

FIGURE 28
Church in *Two Down* with actress Felicity Montague

with Matthew Cottle (*Citizen Khan*), and two flashback scenes in another pub with our leads Alex Hassell and Nick Rhys. We filmed establishing scenes of John Thomas walking to work, the opening scene with him in a coffee shop (this we had to shoot once it had closed in the evening but the scene was set in the morning so we had to create a daytime look at night aka "shooting night for day") and the "hit" scene when he gets shot in an alleyway (see figure 29). We filmed a hidden drug deal behind a block of council flats, a hit scene in a hotel room, and a scene from his time at war which we shot very closely in our back garden and threw cat litter across his face, slowing it down so it looked like an explosion with debris flying across camera (surprisingly it really works!). We filmed poor old Psycho Jones in his horribly dated apartment and him being executed. We went down to Limehouse and filmed for a day with Conleth Hill (from *Game of Thrones*) and got all five of his scenes in the can. And we filmed all of Sam and Rhona's scenes in a café as they wait to hear from John.

FIGURE 29
Coffee shop in *Two Down* shooting "night for day"

It was crazy and stressful with lots of logistics and movement to think about. An actor didn't turn up for a scene, so Matt had to play the role of the waiter, which he ended up cutting himself out of in the final edit anyway. Other actors turned up three hours late, or they got so into the scene that they ended up punching a hole in the hotel wall and costing four hundred pounds in repairs. We didn't even have a proper designated costume designer; our production designer Gini Godwin did the costumes and art direction with the help of Sofia Stocco, so actors playing smaller roles were asked to bring their own clothes and inevitably things were forgotten.

We had fight scenes to coordinate, which we'd been working on for a few weeks beforehand. Matt had always been interested in Wing Chung, and we asked his teacher if he would mind teaching us some fight moves and choreographing our fight scenes for us. It was fantastic; some of us had never had to do any filmed fight scenes for characters and so it was

a totally new experience and discipline to learn. Matt choreographed and directed the smaller fights in the alleyway, and then the big fight sequence at the end of the film was properly learned and rehearsed over the course of several fight sessions. Our teacher even brought his Sifu (master of martial arts) along to help teach us, which was a massive privilege.

In the second week of filming, we moved to our flat location. Having had such a crazy first week moving all over the place, we could at last keep all the equipment in one place and leave it there without having to keep packing and repacking. Unfortunately, as incredible as the flat was in respect to look and feel, it wasn't great for filming in. It had wooden floors and the guy who lived below it worked from home, so was constantly complaining about the noise as fifteen people walked about moving things in between takes. The owners would also come home very promptly at the end of each day and we had to be wrapped and ready to evacuate as soon as our time was up.

As so often on low-budget films, those extra few minutes of goodwill that you can squeeze out of your crew at the end of the day wasn't available to us so the only day we were able to go over time was on the final shoot day, which was a night shoot. They'd agreed to stay at friends' and leave us to it. That was the day we were shooting the final scenes, in some ways the most important scenes, the climax to the whole film. It builds to a big fight scene between Sophie and Rhona, Sam and John have their final stand-off, and John speaks his final words. We also had to shoot Rhona and Sam in the car driving to the flat. We went massively over time, and this was down to numerous factors.

First, the day before, one of our runners was meant to take a van and pick up additional lighting that we needed for the night shoot. He forgot to do this. It was a very clear moment in my memory when I, Tori, was meant to be concentrating on the scene I was acting in, and in the middle of a take my producer hat went on as I looked across the room and saw the runner talking to one of the camera crew. I thought he'd been incredibly

quick, so I asked him, "Are you back already?" "Yeah," he said, "I've got the van." "And the lights?" When I saw his face drop, I knew we would have no lights for the night shoot. It was too late to call the hire company as they were closed for the weekend. We had an empty van and no lights.

This meant that when it got to the night shoot, we were working with very few proper lights and using the light from the streetlamps to help us. This made DOP Andy Alderslade's job much harder and slower. And although we'd rehearsed and rehearsed the fight scene in the studio, when it came to being on location the space that we had was much smaller than we thought, so we ended up having to rework a lot of the moves. As time ticked on, poor Andy felt more tired and more ill. He was exhausted; it was the end of a very intense and packed shoot. All of the final scenes were handheld, and he started to really suffer. Unfortunately, we couldn't stop filming—this was our last day, we had no more time in the location, we couldn't afford to extend the shoot, and all the kit had to go back on Monday.

Andy battled through, and the results are amazing. He could have handed over the camera to one of his team, but he didn't want to. In a lot of ways, that's understandable—it was some pretty tricky stuff that we were shooting, with a lot of logistics to work around, a lot of movement, and they were the final shots of the film, the last images that the viewer walks away with in the forefront of their minds. Perhaps if he had handed over the camera it might have helped to speed things along a bit, but that's part of the compromise of filming. Those last few hours of filming *Two Down* were hard and slow, very slow.

There was also the fact that we were shooting the fight in the hallway and stairwell outside the door of our chum from the flat below. He was not out on the town that Saturday night; no, he was at home working to finish a deadline on a sound edit, so was locked away in his flat hearing everything. This meant by the time we got to filming the bulk of the fight scene it was 2 a.m. and we had to film the entire scene in near silence, which is very hard when you're trying to sell hits by vocalizing the hurts.

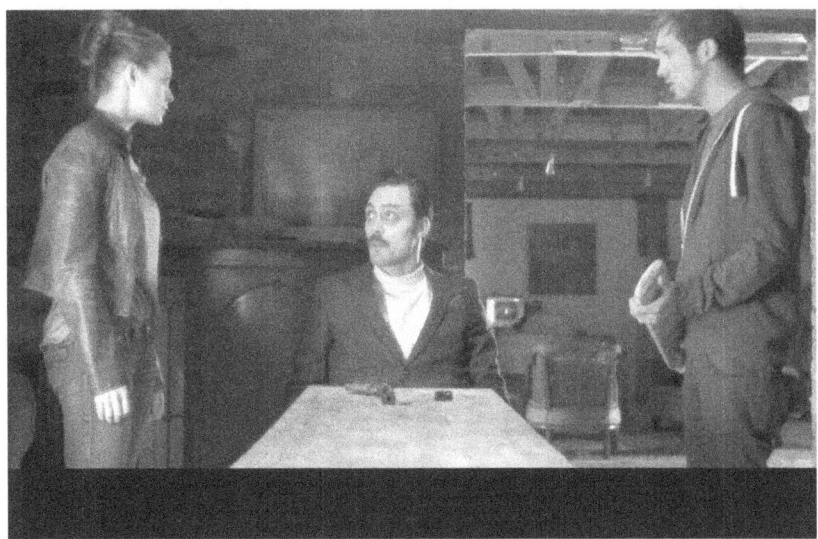

FIGURE 30
Filming the final scenes of Two Down

By the time we wrapped on *Two Down* it was 4 a.m.; we'd started the day at 12 p.m. the previous afternoon. It was a sixteen-hour day, and everyone was utterly and completed exhausted; it was the quickest and quietest wrap drinks we've ever had (see figure 30)!

That's not to say that we didn't have fun on *Two Down*; it was a great experience, a lot of friendships and working partnerships were formed, and it was the beginning of working with a lot of people who we've continued to collaborate with. Our first AD James worked with us again on *Real*, the film we co-produced in 2018. We've worked with Andy on another couple of shorts. We've continued to work with both Gini and Sofia, who after that shoot started working together on many projects. Will and Ben from *Miss in Her Teens* joined us again, and we continue to work with them on as much as possible. And we met Louis, who was one of our sparks on *Two Down* and then became our associate producer on *The Isle*, introducing us to the beautiful location of Eileen Shona and taking on the role of being our incredible production and location manager.

From a filmmaking point of view, though, it was a great learning curve for us, and for Matt specifically as a director. Because we wanted it to have that 1970s vibe, I, Matt, had to start thinking about how we would put this across, not just with music, but with the visuals that I chose as a director. It was on *Two Down* that I started to realize the power and importance of visual storytelling. I watched all the films that I had grown up with to see what the style was in those days and what made certain images and scenes stick in my mind for years after I saw them. It was the beauty of subtle, subconscious visuals that started a whole new way of thinking for me. In *The Conversation*, I remember a scene when Gene Hackman is walking down a spiral staircase as his life is unraveling, and the way it was shot helped you realize what mental state he was in without the actor having to explain anything to us. As a trained actor, these ideas were mind blowing, to realize how many other factors in a film are telling the story alongside you and that you don't need to do everything; as a director, a whole new world opened up to me. I started to notice what specific camera angles and moves would do to a scene as well as a performance and how you can plot this in at the pre-production stage when you're storyboarding to see what will tell the story purely from a visual point of view.

Another big part of the learning curve was also the transition from actor to director. Yes, I'd directed *Miss in Her Teens*, but because I was also acting, and we'd been asked to make it, it felt more that we were all part of the project and I just happened to be directing. On *Two Down*, this was really the first time that I felt like I was there as a movie director and that different mindset was a little tricky to adjust to at first. I fairly quickly learned to enjoy the stress and fatigue of constantly problem solving and being the center of the community that is created when you're making a film, but to be absolutely on it at all times and not really part of any one group took a little getting used to. You move from one department to another checking in, making adjustments, and

FIGURE 31
Matt on set directing *The Isle*

then moving on again, always very much the boss, and being treated as such, and therefore expected to be on top of everything. It really hit home how prepared you need to be as a director on all aspects of your film and allowing your vision to shape your answers when you're being asked fifty questions at the same time (see figure 31).

"From being an actor to then being behind the camera as a director and producer, I found the atmosphere really different. Being in charge, maybe it was my insecurities, but I remember walking into the room and people would look around at me, expecting. Fitting in where normally as an actor I'd slot in and chat, but on set I didn't feel like I was myself properly. The stress and having so many roles and I had some of the actors staying with me, still the director but also looking after people and hosting. All I wanted to do was get some rest and zone out."

—*Aki Omoshaybi*

"You are the captain of the ship, you steer it, and you have to know every single detail about every single thing from the colours of the books on the shelf, to what they're looking at, how they're looking at it, where the camera is, to the lighting. You have to know everything, every single thing and when you're speaking to people in a different language in the studio system, it was a massive wow moment, and a 'you have to step up a gear Giles because you can't get lost in this.'

I learnt that you have to make a decision . . . you're 100% within your right to ten minutes later, ten seconds later, to say I've changed my mind. But as long as you make a decision. No one wants you to say, 'I'm not sure, I don't know, um, what do you think?' No one wants to see a wishy-washy director."

—*Giles Alderson*

It makes sense: film is a visual medium, and that fact should be a big driving factor of your story and should be taken into account when you're writing the script. We used to rely on text too much, and although *Two Down* is quite text heavy, it's the visuals that are supporting the story that bring the text to life. And that's through the visuals of the actors too: they can't just sit there and emote hoping it will tell the story, film just doesn't work like that.

"The director is always hoping that something is going to happen in front of the camera, unique and unexpected, real, happening then and there and the camera has captured it. You need to be let in though as an actor. And you need to absolutely trust the director. When I'm filming and I have a difficult scene, I long for it to be over. The most blissful thing you can hear as an actor from a director is perfect, moving on. When Peter Jackson says it's perfect, you know it's perfect from his point of view. When he says you're done, you're done and you know you can totally trust him."

—*Ian McKellen*

That was a tough shoot, and especially for me, Tori, to be an actor and a producer on. Because I was playing one of the lead characters, Sophie,

while producing and line producing and production managing, it all became too much; there were definitely more than a few tears shed. Now, when I watch *Two Down*, I feel like my performance suffered because of it. There's only so many jobs and roles one person can fill, and despite the desire and necessity to keep costs down, there comes the point when you have to figure out when to draw the line and ensure being spread out isn't to the detriment of the final film.

What I've learned is that you can do all the pre-production stages—the contracts, the casting, the dealing with agents and the organizing, the booking of locations and crew and accommodation and the travel, and everything else that goes before principal photography starts—and while you're doing all this you need to carve out time to work on your character and learn your lines and rehearse. But as soon as the shoot begins, if you're playing a lead and producing, you need to make sure that you have a team behind you that are on it, all over it, and under it, that you trust completely and that you can hand over to. I need to learn to hand over more, we both do, Matt as a director needs to leave the producing hat on the table when he's directing. I'm a control freak so find it very hard to relinquish responsibility and delegate, and that's probably one of the biggest things we learned on *Two Down*: the importance of working as a team, trusting in that team, and knowing when to hand over the reins.

"As a director you have to trust that other people are working as hard as you behind the scenes and that sometimes you won't know about those issues that go on, because you shouldn't know about them as a director. Having only produced a film, knowing when you've shielded the director from certain things, but when you're doing both you know about all those things and it can potentially distract you from doing what you really need to focus on, getting the movie from A to B."

—*Giles Alderson*

We're writing this in the same year that *The Isle* has been released in cinemas in the States and the United Kingdom, and then on to all the usual digital platforms and DVD, which means it's been about two years since we completed it, which is the reality behind the timings of getting indie movies out into the world. But it also means that we've learned a lot about the craft of filmmaking since then with the amazing gift of hindsight of looking at *The Isle* from a different perspective. The idea behind *The Isle* was that we wanted to explore making a genre film but in our own way. It's essentially a supernatural folk thriller that could be viewed at first glance as a horror, but we prefer the more subtle ghost stories than lots of jumps-scares, gore, and screaming (just a personal thing, every film is a miracle!).

This was partly so I, Matt, could focus on the visuals more than I had with *Two Down*. To be able to depict that sort of story, a slow-burn chiller, relied hugely on my skills to be able to tell the tale with the camera as much as with the script, more so in many ways. What we'd learned, and are definitely still learning, is that it's as much about the spaces in between the lines as it is the actual dialogue. Those spaces are where the visual storytelling happens for the actors, and the less dialogue there is the more they have to be able to tell their character's arc, that of the scene and overall story.

"When you're feeling very harassed and someone from wardrobe comes up to you with three hats in their hand and says, 'which hats?' Don't just go, 'oh it doesn't really matter, that'll be fine.' Because if you choose the yellow hat then in the cutting room you'll be thinking, 'that fucking hat is so distracting,' or you'll think 'why didn't I choose a yellow hat, so that I can pick her out of the crowd and it would have just been so distinctive.' Everything matters, everything. Every colour, every choice you make, in the cutting room you can't go back. In the theatre you can say tomorrow we'll try it with the yellow hat."

—*Stephen Fry*

Every moment on film is hugely important—every detail in every frame needs to be there for a reason; pushing the story or the characters on, adding to the layers, building the world, playing with pace and rhythm, and drip feeding the audience information. That requires a lot of precision on the part of the director. In the kind of movie I wanted to make, it was even more important as the balance between it being an intriguing slow-burn chiller and it being just too slow was tricky. I wanted to gently bring in this idea that the island was watching and was by the end very much part of the story, but that meant spending a lot of time on, and with, the visuals of the island itself. It's a gamble as it only really works if you have the patience to sit through all ninety-six minutes of it, but the audience that I wanted ended up loving it.

And that's a big part of movie-making: knowing who you want your audience to be. It's no good saying "it's for everyone"; no film is. There will be horror fans who love the fast-paced gore kind of movie that will hate *The Isle*, and that's okay—it was never intended for them—but to know exactly who you're making it for will help you craft the film when you're actually on set. This is what I had to keep in my head as we filmed yet another swaying tree, "Why am I making this film? Who is it for?" It's paid off because all the critics said very much the same thing: "Thank god there are still filmmakers creating these kind of films." But if I hadn't started, and I was just starting, to learn about how precise the visuals had to be, and not to rely on the text as much, then I don't think it would have turned out as well. I would have fallen back on what I thought it should be based on other movies, and that would have taken us off into a very forgettable mediocre route I think.

"Try to do things smarter and keep costs down. Create projects with an audience in mind. Some people will say 'oh, it's for a certain audience,' but when you really break the film down it's really not. What is going to drive a consumer to purchase your film or leave their house to go and see it at the

cinema. Go on iTunes and see what's on there, what's on the front page, what's charting. See how those films were put together and released—was it theatrically released for instance. Most importantly ask why does your film exist? What is its purpose? It's a very brutal way of saying it but you've got to know who your film is for and if there's a primary inbuilt audience for it. If it's a doc about rock and roll in 60's London, tap into those groups early. First time filmmakers thinking they know better than anyone else and not considering these factors is a huge issue!"

—*Mike Chapman, Blue Finch Distribution*

Something else I've learned since *Two Down* was that the only reality that matters when you're in the process of making a film is the reality that is being seen on the monitor, what the camera is actually capturing. I had a monitor for *Two Down*, of course, but because I'd rehearsed it like a play I almost watched it with different eyes, sometimes remembering the feel of the scene when we'd rehearsed it rather than watching to see if those feelings were actually coming across visually (see figure 32). On the whole they were, but with hindsight came the understanding that what you see in the room and what the monitor really shows are two very different things. I suppose because I trained as an actor, I thought that if the actors are in the moment and feeling it, that is what would come across, but it almost doesn't matter if they're feeling it, as long as on the screen that's what's coming across. And it's not just the responsibility of the actor for that, in fact it's a lot less their responsibility than I used to think—they can only tell so much of the story in this medium. It's up to us as filmmakers to be precise with what lenses we choose and why: why the camera is moving at that exact moment and how it's moving, and from what direction, or why it's static and from that angle. It all adds up to this strange, layered reality, which has little to do with what you're seeing in real life on the day when you're shooting. So a word to directors: keep your eyes glued to that monitor and even if an actor is bawling their eyes out over the emotional memory of their dead pet, if it's not reading on the screen as you need it to, it doesn't work.

PRODUCTION: FROM COUNTRY HOUSES TO SINKING SHIPS 155

FIGURE 32
Keeping an eye on the monitor

"One little trick I do is ask the DP to turn over quietly before I say 'turn over,' especially with kids it makes a huge difference because you'll nab a moment of them practising their moment without them 'acting' it, they'll just be going over it in their head. . . . Ignore other actors telling you it's your moment, it's your big moment. Don't worry about what it says in the script. It's so much better that you're trying not to cry, it looks better that you hold it in. As long as the audience believes in the performance, that's what's important."

—*Giles Alderson*

"It's surprising how infrequently on a film set somebody, a director, will confide in you and says this is what we're doing now. The problem is the director might not know what he wants and he won't know until he's got it all assembled. I'll try and give the director as much information about the character as I can in that moment and he'll then decide what to use. . . . I've long thought actors should direct and equally I think a director should act."

—*Ian McKellen*

On the practical side *The Isle* was a different ball game all together to *Two Down*. The principal photography was split into two main locations: a farmhouse in Suffolk and Eilean Shona, a tiny, beautiful but very remote island off the west coast of Scotland. We started the shoot in Suffolk in the middle September. It was glorious weather, and everyone was in good spirits. Costume and makeup were set up in one of the outbuildings of the farmhouse where there were power sockets and lots of light. The "production office" was in the small living room at the end of the house, as much away from everything as we could get, although because we were in the middle of the Suffolk countryside, the internet was erratic to say the least. Although that was handy in a way as it was harder to send dailies to the finance company who wanted to keep an eye on us!

The farmhouse was livable but basic, and a couple of brave crew members offered to stay in the house, along with all the equipment, which was a blessing and a saving, otherwise we would have had to consider getting overnight security. In addition, we had five cottages in nearby villages that housed the cast and rest of the crew. It wasn't ideal to have people dotted about—some had slightly longer drives to set than others, and it's usually a good idea to know where everyone is when you're away from home—but each cottage had a kitchen and so breakfast was all done before arriving on set.

We spent ten days in Suffolk: two days of get-in, seven days filming, and one day get-out. With the beginning of a shoot always comes a mixed bag of emotions. The crew are having to start to gel and figuring out how to work with each other, actors are coming and going, some meeting for the first time, and there's a feeling of nervous anticipation. But we were lucky because we'd worked with a lot of the crew before, as well as a lot of the actors and so *The Isle* was almost like a reunion for a lot of us, which meant that although we'd had very little prep, a lot of us had a shorthand in how we all worked together, which is probably how we managed to achieve what we did. They were a fantastic group of people who were

extremely talented, hardworking, and humble. It makes the whole process much more enjoyable and smoother if you're working with good people who have left their egos at the door. It's not an easy process, making a film, and you might have spent three years putting it all together so the last thing you want is people bringing a downer on the whole experience—it's very hard to do good work with that going on. It might seem like a small point, but it's far more important than you'd imagine. It's really why people work with the same team over and again: they can trust them to do the job and let everyone else enjoy doing theirs too.

As an actor, it can be a good idea to learn everyone's names on the crew and offer to help out if you can (they'll usually say no, but that's not the point!), not only because people will enjoy working with you but if you're easy to get on with then that message will trickle back to the producers and the powers that be. An actor who is friendly, helpful, and interested will always be at the top of our list to work with again.

You can also learn so much about your craft by being interested and asking questions. Ask the DOP if they have a moment to talk about lens choices and framing space. If it's your scene and they're setting up, and the director or DOP asks you to take a step to the right, trust them but ask if you can see the frame by coming around to the other side of the camera and looking at the monitor. You'll see what they're talking about, and you'll begin to learn more about your craft. We never stop learning, actor, writer, director, or producer, so use your time on set to the best of your advantage, take everything in and learn from it.

"It's a shock when you realise in life, like I'm doing now, you don't look at the other person when you're talking, it's very, very difficult to look directly at someone, it means I need to know exactly what's going to happen. I stop looking at you when I'm thinking. Now that's what you must do on film. On stage, no don't do that, it's all about the eye contact. But most human beings don't look at each other when they're talking, it's very uncomfortable. They can listen and look, that's easy. My note to young actors, act as much as

you can in front of your phones and watch other people act. That's easy, you don't have to pay a fortune to see other people act, you just turn on the television, there they all are acting away; politicians, news readers, the weatherman, everyone's acting on television. You can stop the frame and watch it back again, you can learn so much by observing and sitting on the bus looking at people."

—Ian McKellen

Of course, things went wrong on *The Isle*: there were accidents that happened and scenes that didn't work out as planned, which was inevitable with such a small amount of time to shoot. Another downside to having limited prep time is that you therefore have very little time to rehearse scenes before the day, but there's nothing you can do about it so you have to rethink and plan accordingly. As long as character and story beats aren't lost because of whatever it is, you'll be fine.

Getting timings were tricky for some of the more chilling moments, especially as we wanted to do everything in-camera. We'd wanted the ghost of Persephone to appear behind Gosling as he was trying but failing to light a candle; every time he tried to strike a match, she would be a little closer to him until he finally got the candle lit and she was too close for comfort. Unfortunately, when we got to the scene, the matches wouldn't go out when they were meant to, meaning there were no scary dark moments for her to creep closer. In the end Matt had to change it in the moment, with no time to break and reset and work out how to make the matches work, so we had it that Gosling lights the candle and as the room slowly illuminates, she is revealed standing in the corner behind him. It's not a bad moment and it's definitely on the subtle side, but on a bigger budget you might well have the time to spend hours getting that shot exactly how your director has envisioned it. But when you don't have the time and you have to move on to the next scene, as a director you have to be able to think quickly and outside the box, hopefully not too much to the detriment of any of the important story beats. In the end it works

really well as in the cinema you can slowly hear different sections of the audience get it, and maybe it worked out better than the original plan, which might have been a bit clichéd.

We learned on *The Isle* and subsequent projects about the importance of allowing time for scenes that, even though they may seem simple on the page, if there's any kind of effect or tricks to be done, it will probably take three if not four times as long to shoot, no matter how prepared you are.

At the end of our week in Suffolk, we had the mammoth task of relocating to Scotland. We had one day to get out of the location. All the set had to be packed up—some of it was being returned to the rental houses because we were finished with it and were trying to save money by using actual things found on the island, and some had to be taken up to Scotland. All the costumes and makeup had to be packed up and put into the production design van, along with the camera kit and severely reduced lighting kit, which was doing the epic drive up to Eilean Shona. They took a break in Glasgow and arrived the following day at the island.

Meanwhile, we had to take the other van back to London, return all the set, props, and the lighting which would have just been too impractical for the island, before flying up to Glasgow the next day. Our DOP Pete, first AD Dom, and editor Will came up earlier as well, so we could get there ahead and begin to set up and work out the practicalities. At Glasgow Matt drove Pete, Dom, and Will to the island, while Tori collected a small van that we used for catering and traveled with her dad and his friend Keith (who had just retired from NATO and fancied something different!), who were doing all the cooking for the shoot. They collected additional kit from rental companies up in Glasgow and the all-important food supplies before following on to the island.

This all took way longer than expected, and by the time Tori reached the island it was getting dark and a force nine gale was heading toward the island. All the food supplies needed to be unloaded and put onto the boat to take us across to the island, but by that time it was too dangerous and everything had to be left locked in the van until morning. The speed

boat just about made it across to pick us up, by this point the waves were very high and the crossing was choppy to say the least.

All the rest of the crew and most of the cast were flying up the following day and being driven in a minibus from the airport. The weather was so bad that night we worried that we'd even be able to get the rest of the film shot if it stayed like it for the next two weeks. But Louis knew the island well and knew that it had the ability to be torrential rain and gale force winds one day and beautiful sunshine the next. We frantically sent messages to the rest of the team to remind them to bring their wellies and waterproofs, as well as sun cream and swimming costumes.

Everyone stayed in two houses: the big main house that had ten bedrooms and the smaller farmhouse that had four. This dictated how many crew we could have: the cast was ten, which meant there was room for twenty crew. We had some extra people join us for the two weeks we were in Scotland, and some who didn't join after the first section of shooting because of the physical demands that filming on the island involved. Everyone was warned beforehand that it would be tough: there are no roads on the island, so all transportation to locations was by foot or on quad bike. Costumes and set had to be ferried via quad and trailer or carried by whoever was willing; it was very much the kind of shoot that needed people to go above and beyond to get the project done. Because of this we tried to keep locations as close to the main house as possible; however, the farmhouse that we used for the exteriors was still a ten-minute walk and Fingal's house was a twenty-minute walk. So, if anything was forgotten back at the main house, it was a forty-minute round trip, which could really eat into filming time. This meant that when we finally arrived at the location, we had to be precise and certain that what we were shooting was exactly what was needed. This meant as a director I, Matt, had to know exactly what would be needed for every frame of that scene; my badly drawn but rather exact storyboards were very much needed so Pete could interpret what was needed for each shot and we could work sparingly, not shooting things that we knew we just didn't need (see figures 33 and 34).

FIGURES 33 AND 34
Hard-to-access locations

It means not just shooting "coverage" and hoping that you have the right footage to be able to create the film when you get into the edit. It's making bold decisions with the storyboard, which is really the first time you'll make the film, which is why I think it's imperative to always storyboard so you know what you'll need and what you won't so you're not wasting time. That's not to say you have to stick to it like it's gospel; there should always be room when you're finally on set to make it better than you imagined, but the boards keep you on track and within the vision that you've created and also sold to the investors.

Getting back to the practicalities, though, it was amazing to have everything under one roof. The kitchen was there for catering to use; every breakfast, lunch, and dinner was onsite. The makeup was set up in the living room, a quiet space away from everything, and costume had a space in the huge hall that they could spread out in and create little dressing rooms in. There was a large dining room with an enormous table that everyone ate around together. And there was an office, with semi-working WiFi that production could use. Every evening after dinner the heads of department would gather in the office to discuss the following day's shoot, and it was only with these meetings that we got through the shooting. One of the hardest elements of the shoot was working in and near the water. Because we had beach scenes to shoot, we had to check when the tide would be out and therefore had a beach to actually shoot on. We'd been given a chart, which later we discovered was a year out of date, so each time the chart said the tide would be out we'd all pile into the speedboats and drive around the island to the other side where the beach was meant to be. Needless to say, when we got there, there was no beach to film on (see figure 35). This happened a couple of times because of weather, so we had to do some very last-minute shifting around of our shooting schedule, or find new locations and adapt what we'd spent hours planning. Luckily, we had everyone there on the island for most of the shoot, so we could change what we wanted to shoot very last minute if we had to, although we only had Conleth Hill (see figure 36) for the first week, before we had

FIGURE 35
Some of cast and crew after a day's shoot

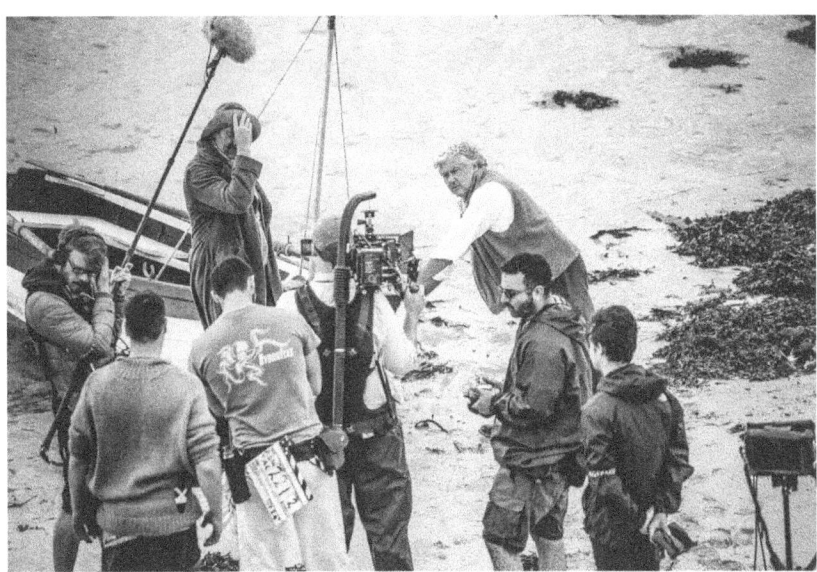

FIGURE 36
Actor Conleth Hill filming the final scene of *The Isle*

to shave his head and send Lord Varys on his way to film the penultimate series of *Game of Thrones*.

The other main challenge was shooting with the boats and filming in the water. We had two boats; the first a little lifeboat that the three sailors are in at the beginning of the film. This one we'd been kindly lent by a local gentleman who had filed his teeth down to fine points and requested that we pay him with a bottle of mead. (For anyone not living in 1543, it's a liqueur made from honey.) Unfortunately, the boat had a leak in it, so Fisayo Akinade, the actor playing Ferris, actually had to bail water out of the boat for real, which added to the authenticity, to keep it afloat.

The other boat we used for Fingal's little fishing boat was the one we use in the final scene when Alex Hassell is rowing out to sea and supposed safety. This was a very small boat and once Alex, Pete the DOP, the focus puller Mo, Matt the director, and Will the sound recordist were all in it, the boat was sinking dangerously low to wave level, and the boat was quickly being whisked off backward with the tide (see figure 37). With

FIGURE 37
Alex, Pete, Mo, Matt, and Will all in the boat

Will out, it was still pretty unbalanced and by this time the wind had started to pick up—the waves were getting higher and Alex was heading out toward the Atlantic. We had the camera speedboat there on standby ready to rescue them if they got into trouble, but there were certainly health and safety alarm bells ringing for a lot of the water stuff. I think because we had such little time to prep, if we'd actually stopped and thought about what we were about to do, we may never have done it!

All of the water scenes we filmed on location in and around the loch—no water studio was used because we didn't have the budget or the time. This includes all the stuff at night—we were out there in the dark shooting on the water—and even the underwater shots that open the film (see figure 38). As the producers, we were apprehensive about asking the crew

FIGURE 38
Night shoot on the water

to swim underwater in the freezing loch. They all had wetsuits but only had to wade in up to their waists. We needed some drowning sailors, so it ended up being Louis, Tori, and Mel, our costume designer, who was a very strong swimmer and used to swimming outdoors in cold water. It was cold. Very cold. A few crazy folk would take a morning swim in the loch each day before call time, led of course by Louis who opted out of even wearing a wetsuit.

Like a lot of shoots, if you're filming outside weather can always be one of your biggest challenges and filming in Scotland was particularly demanding for that reason. It would be glorious sunshine for a few minutes and then grey clouds and rain the next, so getting the light balance right from shot to shot within a scene was incredibly tricky. Having said that we were pretty lucky with the rain on the whole, apart from the final night of the shoot.

Unfortunately, we'd scheduled the last scene to be the death scene of Lorna in the woods. It was meant to be shot at dusk, just as the light was fading, but it was absolutely chucking it down and we had to call it as the camera and crew were beginning to sink. There was no way we could shoot the scene: it involved Lorna lying down on the ground, which was impossible—she would have ended up covered in mud and her costume ruined for any additional takes. So our final night which was meant to be a wrap party was instead a wrap for a majority of the cast and only half of the crew. A core team still had to get up at 5:30 a.m. to be on set ready to shoot at dawn instead of dusk the following morning, our get-out day. This of course had the knock-on effect of delaying the get-out by a few hours.

As we mentioned before, we very rarely have the budget for enough drivers and runners, and on *The Isle* it was no different. After about a month with maybe two days off (they weren't days off—you never get proper days off while filming low-budget independent films because there's always stuff to do, fix, and sort out), we had the delightful job of

driving the equipment van back to London from Scotland. This drive took almost an entire day because as we were just passing Leeds our tire blew, and we were marooned at the side of the motorway for hours in the middle of the morning before a truck big enough to tow us was available. Even then, they could only take us to a service station a couple of hours south. After that we had to wait, shift trucks, and then be delivered to my parents' house south of Birmingham. Definitely not the most ideal way to finish the shoot, but better it was us than one of the crew. Important lesson for a producer: you need to be prepared to take one for your team!

"Talking to you has excited me again, it's a magical world. It's insane that one should love it because there's so much pain involved, so much disappointment. You have to be prepared for immense compromise, as you know as a filmmaker in the wider sense, getting the money and the casting, getting the time you need to make it, but also in the principal photography a lot of compromises are made. And a lot of those compromises can be beneficial . . . you think oh god it's raining or when we did the tech recce there was no noise and now there is and now we've got to do something else, the something else can often be the saving of the film."

—*Stephen Fry*

"I think what I've learnt is everything is a compromise, you start off with the big ambition of this is what I want it to look like and then you come to talk it through and it ends up being not really like that but you can sort of get away with it. And then you get on set and you're ready to shoot that bit and it's been raining all day and you've got no time, costume's late and an actor's ill and suddenly now you haven't got the time to shoot the scene how you wanted to so you compromise again. Or the lights coming in from the window are funny so you have to compromise your shots again. Then you get into the edit and you realise that the continuity was wrong on this and that and so you compromise again, so from your original dream you're often constantly compromising."

—*Giles Alderson*

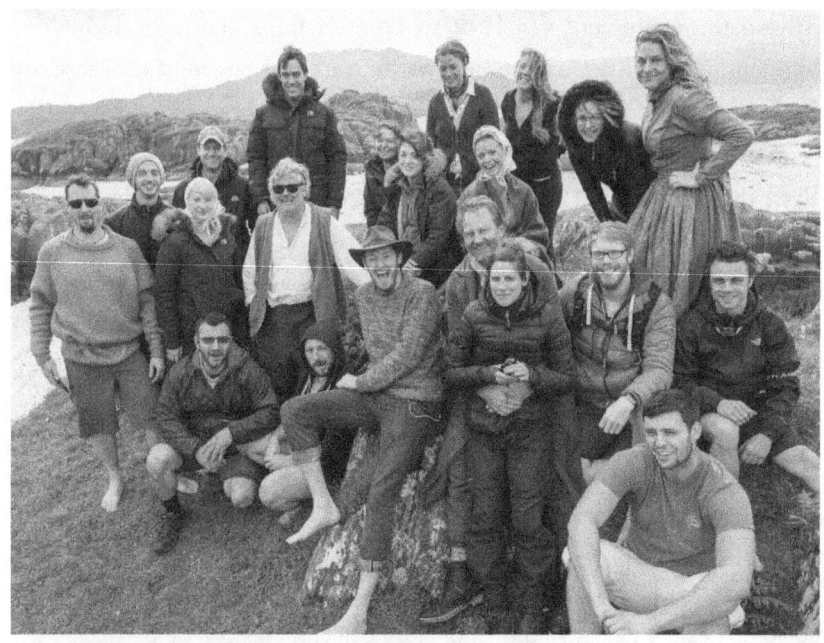
FIGURE 40
Some of the amazing cast and crew on *The Isle*

Despite the harsh conditions, we still bump into crew who say *The Isle* was their favorite shoot (see figure 40). I think it's because we try and run the set remembering how important each and every one of them are, and we treat them accordingly. It can't just be an ego trip for the filmmakers or a money-making venture for the investors; it should feel like an experience that no one will forget, that they are proud to have worked on and that they feel that they have equal ownership over. I honestly think you can tell when you're watching a film what kind of experience it was for the people making it, and ultimately that's going to have an effect on the audience. So if you want to make a good movie, be good to the people making it!

6

Post (It) Notes

"As you know, the extraordinary thing about films is, well I got this from John Schlesinger, I asked him what should I bear in mind most when directing and he said 'oh well, pre-production; the casting, not just of actors but your heads of department, your production designer, your cinematographer, even your prop buyer, the pre-production is the most important part. But of course when you're on the floor shooting, that's the most important part. And of course the most important part of filming is post.' And he's right!"

—*Stephen Fry*

We want to start this chapter by saying that, as we've learned with each film, our feelings toward certain aspects within the filmmaking process have changed along the way. But as this book is all about finding your own way and that there is no one way to do anything, forgive us if it sounds like we're flip-flopping between ideas! As we're writing this I, Matt, have recently been thinking about what exactly my preferred way of working is, and although I feel very solid now in what I think should be done and how, it doesn't mean I've finally cracked it. So, strap in for what might be a bumpy ride.

What exactly does post-production entail, and why do the entire crew squirm if a director ever dares to say, "We'll fix it in post"?

Everyone always says that the production part, the actual filming of your movie, is the easiest bit. And no matter how hard it may feel when you're out in the North Atlantic Ocean at four in the morning with a sinking boat, it's still not the hardest part.

The post side of filmmaking can be pretty tough, trying to wrangle all the strands of your story together and see what has worked and what hasn't. But it's also one of the most fun elements of creating your movie. What we'll chat about in this chapter is how this part of the filmmaking process has changed for each of our films each time, as we've learned more and, since finishing *The Isle*, how we feel differently again about how certain things should be approached for the next time around.

So you've got your template of what the film could be in your script, and then you have this huge pile of visual and audio files (we're slightly assuming that as an indie filmmaker you're probably not shooting on film, unless the process is a lot cheaper by the time this book comes out), which is another sort of blueprint as to what the film *could* be, but you can now go and bring together all the elements from each of the departments and start to add layers to your story. Some people like to really play and create something entirely different to the original script, and this is one of the main elements where we keep changing our mind as to what is best. We always say at the script stage that if you can move scenes around you haven't got the character and story beats right, or that they're not strong enough and we now feel, on the whole, the same way about editing.

However, with the editing you can purposefully play around with the timeline if you want to; you can watch it in reverse almost if, after filming, you think that your thriller could do with starting at the end and working backward. It's often with the fresh eyes of an editor that a whole new way of looking at it can happen, even if like us you like to have them around on set to talk about things as you film.

But we're getting a little ahead of ourselves. Post-production can be the most important stage where you really need to take your time, which is hard because a lot of filmmakers are desperate to get their movie out into the world, or you might also have deadlines for festivals or the finance team (although they'd rather you have a good movie than rush it in most cases), but you might also be racing to get it done before the money runs out, which we totally understand.

When we say this is your chance to add new layers of storytelling on top of the script and the visuals you've shot so far, we're not just talking about editing but the soundtrack and sound design. Some filmmakers like to stick rigidly to the vision they had, but it can be helpful to be able to let go sometimes and listen to other people's opinions as we can get so bogged down by what we've been imagining for so many years that we can't see any other way of doing it. And if those people understand what you're trying to achieve as a whole, then they will be adding to the story even if it's a slightly different way of telling it to what you've been dreaming for so long. Time to let the egos go (at least a little bit because if you listen to everyone and do what they all suggest it'll be a right old muddle!).

Just remember that the story is the most important thing and you're there to serve it; you'll know when to say yes and when to politely but firmly say, back off, pal.

"The editing was quite painless, the only thing was we pre-sold and they (were) involved in the edit, so they also fed in with notes and I felt they came with a whole other agenda which I didn't want. . . . I felt like we should have just made the film we wanted to make and this is the film, because you pre-bought it. There was a note which we couldn't really address because we didn't shoot enough, we had no more material, it is what it is!"

—*Hong Khaou*

Two very different examples of what post-production can do to a film are the original *Blade Runner* and *Annie Hall*. There are seven different

versions of *Blade Runner* out there; the first released in 1982 after sitting around for some time, and it was only in 2007 that Ridley Scott was allowed to release a version that he had total creative control over. And they're all very different tellings of the same story. *Annie Hall* was scripted chronologically at first, and it was only in the edit that they had the idea to start playing around with the timeline, which was considered one of its masterstrokes and still hailed as filmmaking genius. And it was never the original plan.

We like to let our editor Will Honeyball take the footage away, make a first assembly, which is exactly what we shot in the order of the script to see if we have everything we want. It's very possible that you'll realize you've missed something vital, and after you've stopped berating yourself for not realizing after all that prep, you need to start thinking how you can creatively make that work to your advantage.

"Rebecca really connected with the script. . . . I said do a first pass, do what you want because I'm interested to see what you do. . . . From there then we went back. We sat down about four times on different weekends, I'd give her notes she'd do an edit then we'd go from there. It was getting to a point where something wasn't clicking, so I sat down and went through every single rush and wrote down to the second where I wanted it cut. The notes were so precise, it might have been a bit too much but I just knew we didn't have much time."

—*Aki Omoshaybi*

Stephen Fry says be careful with your choices when you're filming even down to the color of a hat because once it's filmed you can't go back. Very true. This is where post-production can come in, though. A lot of people see it as the time to fix things that went wrong; that's that classic "we'll fix it in post" line that sends shivers down the backs of crew on set. Others use it as the time when they start thinking about crafting the story of

their film and how it should look and feel. This applies to documentaries as well as fictional narratives, perhaps more so. At least this is what Louis Devereux found when he came to editing his first feature doc *The Rift*.

"I wish I'd had a better idea, or at least earlier on in the filming process realised where the story was going to go, because it was a real struggle in the edit. I wish I'd spent longer reviewing the footage in between the shoots, and hired an assistant editor from the beginning who could have complied the highlights from each trip when I got back and I could have had a bit longer to think creatively about how I was going to shoot the next trip.

Because I basically didn't review anything until we'd finished and then it felt really daunting. Making a film is such a big task that breaking it down into bite size chunks, daily tasks rather than six months tasks.

I wish I hadn't tried to edit it myself for six months because it really disillusioned me from the process. Being director, producing, part of it and editing it, I went around in circles for too long. It was impossible to remove myself and be an outside eye. A really important lesson; never be too attached to how hard a shot was to get, if the shot is not worth the final cut. Being part of the shooting process can really fog your mind in the edit."

—*Louis Devereux*

Neither of these options are what we tend to do at Fizz and Ginger, partly because both are too risky and too expensive, and I, Matt, like working out exactly what we're doing before we start, which is also how we keep budgets so low and deliver big ideas. But everyone has their own way (this is the issue that I tend to shift around with!). If you're relying on making things work either in the edit or with visual effects, I'd say that you probably haven't spent enough time prepping in the first place. I know you might not have had lots of pre-production time, but as a director or producer you have to put the time in creatively so that you can think your way through a problem when it occurs during production rather than hoping that something will be able to rescue you in post.

Yes, things go wrong on set all the time, no matter the budget, but if you know your story and important character beats, you should be prepared enough mentally to be able to work out a solution on set. If you and your excellent team can't, after lots of thought and hard work, well, shit happens, and at least you now have the post to try and rectify it, but that should be a last resort.

Another way of looking at the post-production process is as a time to work on what kind of film it's going to be. To us this is a terrifying way of doing things for an indie filmmaker. For a start, it's a very expensive way of doing it, not just on set as it means you're just shooting huge amounts of "coverage" (filming every single angle under the sun numerous times so you don't need to make a decision there and then), but also you'll spend so much time in the edit first trawling through the footage to see what works and what doesn't, and then concocting your story arc and those of the characters almost from scratch. It means you can do whatever you want with the film afterward, change the whole story and performances, but also tells us that you don't really have a vision for the project, which is kind of crazy because most indie movies take between three to five years to get made from being written to getting out there so you need a heck of a lot of passion to see it through!

We spoke to first-time director Caspar Seale-Jones (son of legendary composer Trevor Jones) about his feature *To Tokyo*, and this is how he started shooting while he was in Japan, but he quickly realized that he was constantly on the back foot and really struggled to keep control of what he was shooting and why. So he paused, went back to the drawing board, quite literally, and storyboarded the rest of the film and says he'll always plan everything out precisely from now on.

Modern blockbusters tend to go for coverage, but that's usually because the money people demand it. If there's every imaginable angle of the whole scene dozens of times, it means that if the studio loses faith in the director, which we all know happens fairly often, they can take it away

from them and create the film they want from all those options. That's the extreme version of fixing it in post!

So, let's stick with indie for now. I think of post-production as crafting and weaving more nuances into the story; in an ideal world, this needs to have been thought about when you were writing the script and in pre-production with your team to find ways of adding production value to your shoot. This all contributes to having a solid vision from the start when you're tapping away at 2 a.m. on that script. Spend the time thinking about if you really need visual effects in it or if it can be done in-camera, as cheap visual effects can make the film look unpolished even if the rest doesn't, which would be a shame. The same can be said for the sound design; sound can make or break a film but often people don't realize the importance of it until it's bad, and that goes for far too many filmmakers who don't think about it until it's too late. With sound design, including music, we like to start thinking about possibilities from very early on. The composer will of course have their own stamp of brilliance to put on it, but we find as filmmakers that to have suitable music playing when we're writing can inform the script, so when you get to the score part you've already been thinking about it for years.

"You know if a film hasn't been properly put together, usually from the sound before anything else. It's incredibly difficult to create a seamless and beautiful soundscape. It takes real professionalism and knowhow and you have to pay for that. And the score, the foley, everything."

—*Stephen Fry*

It's at script level that we started to think about the template of an edit, which we then talk to the editor about when we're filming. It means we're ahead of things in post and enter into it with a clear idea of what our film is going to look like. And this can inform you about what camera you're going to use, which in turn informs what your technical

workflow is going to be at this stage, so you can start conversations about the end at the beginning, which means you don't have any nasty surprises that you can't afford.

Now, we can sit here and glibly tell you to know exactly what to do at the end before you've even started, but we didn't know this either when we made our first shorts or even our first feature. A lot of the books we read when talking about post tell you to prep by talking to your chosen post-house. On *Miss in Her Teens*, we certainly didn't have the money to work with a post-production facility and, to be honest, we wouldn't have known what to do with one. I, Matt, had been very specific about what I wanted to shoot because when I read through the script I imagined the thing as if it was playing on a big cinema screen in my mind, so I knew what the story needed when it came to actually shooting something. This meant the conversation of getting coverage rather than very specific shots never came up, and because we had a tiny amount of time to shoot quite an extravagant eighteenth-century farce, this worked out well all round and our tiny crew was very happy. Some of the scenes had a lot of characters in and to shoot it in a coverage way would have meant shooting for at least twice as long as we had.

On the flip side, I have since learned that you do at least need to give yourself a "get out of jail free" option to help you get around shots or takes that don't work from a performance point of view. In the edit, if you have other options you can jump around, enabling you to navigate yourself out of trouble. I've never been a huge fan of lots of closeups, but having them is helpful to get around parts of a performance that haven't worked. Another shot to get is the scene from behind; as in, if two people are walking down a street shoot them from behind so you can't see their mouths moving. If you get to the edit and realize that you need to change the dialogue for some reason in automated dialogue recording (or looping), you can cut to this shot and no one will ever know!

"When I'm shooting I'm thinking about the edit all the time. What my reverse is and how do I get out of it. An insert is a huge thing that we forgot to do all the time, but so valuable. It's vital to tell the story, or help build the tension, like a pause or a breath. You need those moments to play with pace. You need cut outs. Otherwise you've got this great 'one-er,' everyone's over the moon, but you get to the edit and it's too slow, it's boring, the continuity's wrong, boom was in shot. Just getting a reaction shot to get out of something and you only learn that by editing."

—*Giles Alderson*

Miss in Her Teens was the first time that we started to properly understand the importance of replacing the sound that we had recorded on the day; I'm not talking about the dialogue at this point, but every rustle of a Georgian gown, every swish of a sword as it's drawn from a scabbard, every footstep and creak of a chair. The actual real noise just didn't sound right so we set about, with no post house behind us, doing the whole Foley (re-recording sounds to match up with the visuals), between us and our editor. This is not a quick process without a studio! But we saw the importance of doing it, and once we started putting it all together could see how much of a difference it made. Often the noises that you've recorded on the day just don't sound right; they might feel like they're in the wrong perspective for where we would expect the noise to come from even if it's being made by the actual object, or we just need to make more of it, and that often means creating a whole new sound out of something entirely differently.

As an audience, we've come around to the idea that if a gun is picked up it makes a little metallic sound. In real life that doesn't happen, but if someone in a film picks one up and it doesn't make that sound, it subconsciously feels odd! It's just one of those film conventions that we've created and now have to stick to, so audiences aren't pulled out from the story. (I'm not saying go back to the days of the 1980s when guns made the

most ridiculous of noises, but somewhere in between that and real life!) And it makes sense I suppose; films are not reality, even the gritty realism of a socio-political drama is often elevated for us because that's what we go to see films for: entertainment of some form.

As the budgets have increased on our own films (as opposed to other people's films we've worked on), we've continued to do the Foley because we take the sound as seriously as the picture, and this is now part of deciding early on what sounds we want to focus on. I'll skip *Two Down* from that point of view, although it was a nightmare doing the Foley as we were doing it in our house in North London so had to wait until midnight to start recording anything to avoid helicopters, planes, sirens, or crying children going to the park, which meant it took far longer than it should have. For *The Isle*, we packed ourselves off to the countryside, just three of us, and spent a few days in more sedate surroundings and got the bulk of it done in a couple of days. This time Will the editor had sourced a lot of sounds from a sound library as we weren't going for realism, and there were things that we just couldn't recreate with Foley. In fact, we stripped all the sound away so we could be very specific with what the audience heard. We didn't want any wildlife sounds at all because it was a "dead isle," but we wanted the wind to be a major factor of the soundscape as that was what usually preceded the siren's song. We also wanted to make the island seem even more cut-off than it was, and having the wind blowing at specific points helped to create the feeling of isolation.

Automated dialogue recording is usually used when a line hasn't been recorded well enough, maybe because of noises on the day that you couldn't control like a plane or the wind, which means you have to bring the actor into a studio to watch the scenes back and re-record them. That's if something went wrong. It's also used when you want to change a performance. Sometimes what you think you got on set just doesn't work when it's in context after being cut together; you need to fine-tune it. There's also the option of changing the entire performance if you feel

that you and the actor had pitched it in such a way that doesn't serve the story in the way you wanted, or that you've since worked out what would be better for the movie, especially if you've moved things around in the edit and various points or beats have changed. Some directors like doing this just as part of the process, to be able to watch it all once it's put together and seeing what can be done to make it even better. We've never gone that far, but each to their own. Although we did have to replace an actor's voice on one film and used a different actor entirely for the whole performance. This was for various reasons, and it was a very difficult decision to make, but in the end it elevated the entire film.

Music is its own amazing world of storytelling, but you should really be thinking about it at the same time as when you're planning and talking about the sound design at the beginning of the process. People often treat them as completely separate entities, which is crazy. You need to have the two in sync so you know what is telling certain elements of the story at what point, or if both need to be, or when one complements the other without overriding it. And although music can transport a movie from good to great, you shouldn't really rely on it to rescue scenes, which we hear a lot from people. We'd advise you to start the process of talking to the composer right from the beginning so they can be part of the conversations from the ground up. With *The Isle*, we were listening to certain kinds of music while we were writing the script and would send over early drafts to the composer, Tom Kane. We would never say that anything should be exactly like another piece of music at all, but it was so that all of us started thinking about the time period and style of the score, and very much the overall feeling of what we were trying to achieve with the film.

The music that we'd been sending over to the composer, I, Matt, listened to while we were filming too, to help me imagine scenes and how the music would affect them, and when we needed certain things to help with the storytelling. I always think of the rhythm of the film as we're shooting, and to have an idea of where we would be going with the score

really helps with that. As we were filming, we would also send images over to Tom so he could start to see what we were building, as well as art from the period rather than films as references, which is often what people tend to do. This way it's much more the life and soul of the film rather than influences from movies already made. *The Isle* is very specifically reliant on the music because of the siren's song playing such a large part in the film, so it was very important for everyone on the creative team to understand its importance and what impact it would have on the visuals. Although we never imagined Tom and Eivor (the Faroese singer who helped compose the song and sung it) would come up with something so beautiful that utterly captured the mood so well.

Saying all this though, about planning the sound design and score as early as possible, and with each in mind of the other, when we got to the final sound mix when you get to play with levels and amazing cinema 5.1 surround sound speakers, we realized there is only so much planning you can do, and that you're still crafting even when you get into the mixing suite. It's a whole other art form in itself, and it's then that you can really see the effect single noises make, and if it's at the wrong time or the wrong level, the scene can feel off. A lot of people really don't spend enough time on this side of the post-production, and it's such a shame. Maybe the film will end up good, but with more time and thought put into this side you can elevate your movie above just "good." Not that we're saying *The Isle* is a masterpiece at all, but the sound design really does something extra to it, and for such a modest budget, helps take it to the next level. So it's worth studying the sound and score of your favorite films to see what it is that is working and why.

"I started to look at any film I'd been in and looked at who did post, like sound design. And looked at the assistants and I thought it's not going to be so much about the money for them, it's going to be about the credits, so that's how I started operating and that's how I got the sound designer on board."

—*Aki Omoshaybi*

Back with the visuals now and to color-correcting and grading your footage. This is where you can play with the look of your footage and fix anything that doesn't match for whatever reason. I know that's very vague, but that's because you can do pretty much anything you want with it at this stage. You tend to start by making sure that all the shots work with each other in a scene; for example, if one actor's close up was quite bright because the sun was blaring, but then by the time you got around to the reverse shot of the other actor the sun was quickly fading (this happened in *The Isle* quite a lot because sunset would last just a few minutes so you had to be quick if you were filming at that time of day), then you could correct the darker shot and brighten it to match the other (though we ended up darkening the original shots as I think it worked better for the story in the end and was much easier to match up technically!).

I love the grading part of the process as you get to be really subtle with what the audience is taking in subconsciously; more than just by lightening or darkening a scene, you can bring in visual clues or highlight an element that you may not realize is there, but adds to the texture of a scene. I'll keep using *The Isle* as an example because we played a lot with what we'd shot, which was always the idea right from the start, but I never realized to what extent you could add things to influence the audience on that level. We'd found these red berries, which turned out to be the only red plants growing on the island, and we placed them in certain scenes to warn of danger or when something bad had happened. In the grade we'd highlight them very slightly so they would pop out more than in real life. We picked out blues from people's costumes when we wanted to bring the sea into people's minds. These were very subtle, but it all adds to the feel of it; no one is ever going to consciously notice that we've done that, and that's the point.

For the more obvious grading parts we used it in conjunction with the visual effects that had already been done by this point. There are scenes when sea mists roll in, storm clouds dominate the sky, and women's eyes turn sea-blue when they're possessed (see figures 41 and 42). We used

FIGURES 41 AND 42
Lathe and Persephone's visual effect blue eyes

practical effects (or real clouds), then ramped them up with visual effects and then finished them off with grading to make sure they were just right, and that they popped on the screen when we wanted. We even made the sea at the beginning of the film ever so slightly red, indicating bad things to come but we got a quality control report back from someone for the distributors and they thought we'd made a mistake, so sometimes maybe it doesn't pay to be too clever!

On *Two Down*, we graded the entire film to give it a 1970s feel. With our grader we created a LUT; this is a color template that you then ap-

ply to each shot, so that a scene or an entire film has a unified color and tone. For *Two Down*, we wanted a yellowy, orange look that film stock in the 1970s gave to most films. We of course corrected things, but this was much more of a bigger, overall blanket change to the footage we shot. Grading is not always for subtleties but can be for big color statements that change the entire look and feel of the film. Interestingly, by doing that, a lot of the longer takes and scenes all done in one shot suddenly made sense, because they felt at home as part of a 1970s film in look as well as pace (see figure 43).

In post-production, depending on where you get your money from, it's possible that you're going to have to do some kind of test screenings. We were lucky with our first two movies that the exec producers were happy for us to get on with things, but for *The Isle* we not only had to keep sending the film off during editing to the execs for notes (which

FIGURE 43
Grading *Two Down*

is absolutely fair enough—they've given you the money), but do a test screening too. This was after all the post-production had been done, and we'd convinced them not to come until we could add all the sound design and music as we knew what a huge portion of the film that was, and they kindly agreed. And it was the right choice; things that they were unsure of when we were editing it were now clear because the sound told so much of the story, and they mercifully signed off, which was lucky as we'd run out of money. It really showed us the power of sound and grading, as well as how it affects an audience.

When it comes to technical programs that people use for editing and such, again I'd say there's not a lot of point in us talking about them as the film world and what is used is forever changing. I have preferred editing software, but it's not currently considered "industry standard"; there's no point talking about what is, as it'll probably change in the next year. And at the end of the day the editor, sound designer, and colorist will all have their ways of working; it's just up to you or your post-production supervisor to make sure that they can all work well together not just from a creative perspective but the technical workflow as well.

What I will talk about is what "deliverables" are needed for your film when it's finally finished and you have to hand it over to the sales company. Now, I'm going to warn you: there's almost no way of making this part interesting, because although it is one of the most important aspects of the entire process if you want people to actually be able to watch your film, it basically includes months of sitting at a computer. Deliverables are the pages and pages of legal documents that a sales company will require you to have, including the proof that you hold the full rights to your film. They are also the physical elements of what they need to show a distributor to be able to sell it to them, who will in turn deliver those to the companies actually screening your work, be that in a cinema or digital platform. Those are the more creative bits and we usually start with them,

purely because they're more fun, but you could save yourself so much time and effort if you think about the paper deliverables from the beginning and collect them as you go through the process. It may also help get you out of any legal bother later down the line if people start being silly about who owns the rights to your film, perhaps if they've helped edit your script, for example.

Deliverables also need to be factored into your budget or timeline right from the beginning, which we didn't do for the first film—we realized the hard way why you need to do this. You'll be given a list of what you need to get together, but if you can get ahead of it you won't be chasing people around after the event trying to work things out.

"They should be shown the pile of docs that is the chain of title . . . and what constitutes each part and whose job it is for each of those constituent parts . . . and then compare it to the deliverables list that you have to do and I don't think there's many producers that know much about either of those things. And that's how films can lose money and they don't need to because if an educated producer looks at those constituent parts they're actually quite easy. It's a complex exercise but it's not complicated. You can do your paper deliverables now, you don't have to wait until you've finished your film."

—*Kirsty Bell*

Every sales company, in our experience, will ask for slightly different things, and I think that's because the distributors that they tend to deal with all have different items they ask for. It certainly seemed far more complicated in the case of *The Isle*, compared to *Two Down*, anyway. What I'm saying is we'll give you a list of things that we know you'll absolutely need, but be aware that you may be handed an even longer list of very specific things; different countries also seem to require variants, and we needed to create some documents that we'd never heard of for *The Isle* even after doing two other films. I'll try to be concise.

Here are most of the physical ones you're going to need:

- A DCP—You'll have your film on a normal hard drive which any computer can read, but a DCP—Digital Cinema Package—is the whole film on an encrypted hard drive, which can only be played in cinemas. If you're using a post house, you should get at least one from them, hopefully two. They may only offer to make one; they can be expensive to make, so you need to go and get a copy made pretty quickly. For *The Isle*, the finance people took the original so we made sure the post house made one for us too, just in case, which was wise because when it came to being released if we'd wanted to get hold of it to make copies for the cinema, the holding company that they used were going to charge us to get access to it. It is possible to find freelance people who will create a DCP for you, and they tend to be cheaper than a post house. You just need to make sure they know the right technical requirements for the country that you'll be screening in.
- Trailer—You know what this is. They'll want this on a hard drive in different sizes, and maybe even different lengths for different occasions. They may also want a DCP of the trailer to screen it at cinemas.
- Electronic Press Kit—These are the little films that will help sell your film to an audience later on, or could end up online for free ahead of a release to give people a taste of what the film is. It consists of clips from the film, interviews with the actors (often in costume) and director on set, and behind-the-scenes footage of the making of the movie. Even if you can't afford someone to come and film these bits, try and remember to find some time to do it yourself, or get a producer to do a couple of days of filming behind the scenes and grab some quick interviews with people.
- Closed Captions—These days movies need to have all the dialogue as text on digital files so they can be placed on top of the film if needed.

It's required by law in the United States (though not in the United Kingdom, but I imagine it's only a matter of time before we follow suit).

- Combined Continuity and Spotting List—There doesn't seem to be any one way that this needs to be done, so have a look and see what template works for you. We made ours up and no one's ever complained. You can pay people to do this, of course, but you know us by now: if we can save money we will. It basically breaks down every moment in the film and gives you the timecode of it; every time there's a line you need to list the time code, what the line is, who says it, and what action might accompany it. It takes a long time to do, but you'll really know your film by the end of it!
- QC Report—This is a quality control breakdown that will have to be done by a proper company; it's usually sorted out by the post house if you're using one, which will go through the entire film looking for technical problems—flickering in a shot, some dodgy grading, even anachronisms in the props if it's a period piece, and continuity of the actors. All these problems will be given marks as to how much of an issue it is. If you clock up too many marks, a distributor might not take the film on even if they like the actual movie.
- Audio Stems—You very likely need all the individual audio stems separately on digital files; that's dialogue, Foley, music, effects, all the elements.
- Digital Stills—Aim for one hundred stills that were taken on set as well as choreographed scenes with the actors specifically for publicity. You often see on posters and in movie magazines shots that you know are not from the film, and this is what they're after. They don't want screen-grabs from the film, and some publications will refuse to print or publish a story or review without proper photographs. Make sure you remember this when you're filming and carve out some time with your actors to do this, as well as behind-the-scenes photos with key people like the director and producers (see figures 44 to 47).

FIGURE 44
Publicity still for *Miss in Her Teens*—
Actress Emma King and Tori

FIGURE 45
Poster for *Miss in Her Teens*

FIGURE 46
Publicity still for *Two Down*—
Actor Alex Hassell

FIGURE 47
Poster for *Two Down*

"The other thing to do which is very neglected, is get a photographer to come in when you have your principal cast there to do some posed photos, some portraiture and pictures together. Because you'll always find that you've never got pictures of the people you want together at the same time in the film, or those pictures are inappropriate (for selling) so if you do some posed photographs and grab the actors during the day for 20 mins that will give you a montage of photos that you can then use."

—*Gareth Jones*

- Key Artwork—This is basically your poster as a layered photoshop file so distributors can rework and design it for the different platforms and take off elements like text. It's good to think about this as early as you can, so you can take some specific photos when you're on set for it. It's also good to have planned early so everything else can fit around it, so you create your branding for the film. It will probably get changed by various people as more and more voices are added to the conversation, so if you come up with a few ideas you might get them to choose one of them and at least you'll still have a bit of control over how your movie comes across. As you can see, *The Isle* had many different poster versions for the United States, the theatrical UK version, and the UK DVD version (see figures 48 to 52).
- Press Kit—This is exactly what it sounds like: an electronic pack that gets sent off to press and public relations people so they can have all the information they need to get stories about your film out there. They need a one-page synopsis and biographies of the principal cast and crew members, especially if any of them have done something big that press will like to write about, such as a composer that worked on a big indie hit. It also needs "production notes." I find these fun to write. It's the whole story of how you made your film, from writing to putting it together to actually shooting it all the way through to post-production and the finished product. Remember this is for the press so they want

FIGURE 48
Publicity still of Persephone

FIGURE 49
The Isle Theatrical Poster in the United States

FIGURE 50
Publicity still from the final scene

FIGURE 51
The Isle theatrical poster in the United Kingdom

FIGURE 52
The Isle DVD cover in the United Kingdom

fun, interesting stories that will sound good in a magazine about the upcoming release, or to give journalists an idea of what they could talk to you about.
- Synopsis of Production—Different to the synopsis of the film, this contains brief details on the key cast, director, producers, the running time of the movie, and a shorter synopsis of the film.
- Final Shooting Script—This is not the script that you had before you shot the film, but rather exactly what now happens in the finished thing. So, you have to sit and watch the film and write the script with exactly what happens now. I'd do this before your Combined Continuity and Spotting

List, as it'll be easier to just grab bits from this one and plop it into your separate columns on the Combined Continuity and Spotting List.

- Chain of Title—This is possibly one of the most important things on this whole list. These documents prove that you own the rights to the film, so you're authorized to hand it over to the distributor. This is where all three films have been different, so be prepared to do more than this, and I suggest you look up what some of these phrases mean so you get the right legal wording depending on the country you're making your film in. You will have needed to **register your script** somewhere so the certificates for your script with the names of the writers and the date written are registered. In the United Kingdom, we use The Script Vault. In the United States, the Writers Guild is used. We've been asked for both on one film. It doesn't cost much but is absolutely necessary. You'll need **contracts between the writers and producer** even if you're both of those things, saying where the rights lie: Are they given to the producer? Does the writer keep them but allow the producers to use the script? We had to create an **Inducement Letter** between us as producers and the company that we'd set up for the specific film laying down who owns the rights, again. You'll also need a **Directors Agreement** with whatever the deal is with them: Do they have any rights, for example, or do they hand them over to the producers? These are the basics but at least you know before you start that you need to get this kind of thing sorted out as you're putting your film and its finance together.
- Final Main and End Credits—This is the complete written credits taken from exactly what it says on the film.
- Billing Block—This is a precise order of all the credits set out as you'd have it on the bottom of the poster or on the back of the DVD.
- Full Cast and Crew Agreements—They usually say Key Cast and Crew, but we get everything together and send it all off, just in case. These need to be the full agreements and signed and dated by the right people. You can get standard templates for crew contracts but the actors' ones

will probably change for each project depending what you want from them and what you've agreed with their agents.
- Full Cast List—I don't think I need to explain that one. And yes, you've probably written this a dozen times already, but this needs to be on yet another separate document.
- Guild and Union Letters—As the United Kingdom doesn't really have guilds, this is more if you're working with people from the United States, or of course if you're filming there. This is a letter, signed by the producer, setting out all guilds and unions whose members rendered services on the picture. The letter must contain:

 - Details of each member (including complete social security number and loan out information where applicable)
 - Details of guild
 - Services rendered and remuneration provided
 - Days worked
 - Details of any "buy-out" of rights and method of buy-out
 - What residual obligations exist

- Copyright Notice—This is the bit at the end of the film determining where the copyright lies as in the billing block: Copyright Fizz and Ginger Films 2021.
- Copyright Registration Certificate—This only exists in the United States, but we were asked to do it for *The Isle*, so it's worth looking into earlier rather than later.
- Title and Copyright Reports—These are two separate things, and again we had to go to American companies to get these done. The Title Report is a document that you have to pay someone to create where they go out and search for anything similar or the same in title and report back if it's too close to what the actual thing is to see if you can use it. For example, in 2000 there was a South Korean film that was called *The Isle*, so they reported that but deemed the title okay to use as it was

not only a different enough kind of film but long ago enough for it not to cause any trouble. There were also things like computer games and books, but again as they were nothing like our movie, we were okay. We didn't know this existed until *The Isle* as we hadn't been asked for it before, which is why we didn't do it until the end, but we'd definitely do it differently next time, just in case. The Copyright Report is carried out by a lawyer that specializes in this; they research and look at everything to ascertain and confirm who they think has the rights to the film.

- Music Cue Sheets—There are templates for these, but they detail each track on your film and who wrote it, the timing of it, when it appears in the film, who has the rights, and which performing rights society is involved in keeping track of this for when the film is sold and making sure the composers are compensated, etc. The Music Cue Sheet must be in an industry standard format, a sample of which can be found at the ASCAP website: http://www.ascap.com/musicbiz/cue_sheet_corner/.
- Music Artist's Agreement—You need agreements for the composer to the producers and production company, agreements with the musicians, any songwriters, music supervisor agreements—everyone involved in any way, shape, or form, detailing exactly what's expected of them and what they can lay claim to and what not.
- Rating Certificate—Remember to budget for this. Sometimes the distributor will do this for you, and sometimes they'll expect you to do it. This is where you send the film off to either the British Board of Film Classification (United Kingdom) or Motion Picture Association of America (United States), and they watch your film and give it the age rating. You'll probably need to do this for the trailer too if it's being played in cinemas. They charge by the minute, so work out roughly how long you think your film will be when you're budgeting and put it in, just in case.
- Certificate of Origin—This seems like just another version of lots of things you'll have to do, and again look online for a template, but this

is a simple document plotting out exactly where the rights lie, which of the companies involved controls them, and who in the companies are involved.

- Errors and Omissions Insurance—This is Errors and Omissions insurance, which a distributor will absolutely insist on. This is so that further down the line, if someone suddenly tries to sue by saying they created the work, or that someone is now injured because of working on the film, even if these are found to be false, Errors and Omissions insurance will cover the costs of the lawsuit, etc. It's a very general policy just safeguarding everyone involved on the production side all the way up to the distributors, but the broker will require all of the Chain of Title documents in order to supply the Errors and Omissions insurance. Budget for this too!
- Final Budget—That's pretty simple. As long as you've been keeping a proper track of every penny, of course. And that's when your cashflow report will be very helpful. This is the budget listed with dates of when each line item has been spent. It keeps a running track of your incomings and outgoings, what went under budget, what went over budget, and what is left in your production account at the end.

Phew, glad that's over. These are just the basics, to be honest, and as I said it'll be different every time; some companies will be more diligent about what they want than others. Think of it like this: you need as much material as you can to help sell your film and as many ways to cover yourself legally through the entire process as you can think of. The main thing is to collect all this right from the start, rather than waiting until the end when a buyer or distributor comes onboard and suddenly demands all this stuff now, when it'll take an age to get together, especially as everyone will have gone on to other projects.

7

Getting Your Film Out There

> "The most valuable thing about *Richard III* was not what I got out of it but what other people thought I got out of it. I was thought to be a film person, I'd produced a film and got an award for it. 'Alright he's a proper filmmaker,' and subsequently I got to work with Brian Singer and Peter Jackson and changed my life totally and it wouldn't have happened without *Richard III*. It wasn't just my confidence it was other people's confidence in me."
>
> —Ian McKellen

Gathering the money is no easy task, making your film is fun but hard work, and finishing it can feel like moving mountains while someone else is constantly changing the landscape underneath you. Getting it seen by people is a whole other world of mystery and, we're afraid to say, pain.

We say mystery because most people who have done it, or who are involved in the distribution side, often aren't entirely forthcoming in what happens. Yes, that is partly because trade secrets are closely guarded because if filmmakers just started doing it themselves then there would be a lot of people with a lot less work to do, but it's also because, as with every aspect of this bonkers industry, there's no one way to do it and most people are just making it up as they go along.

There are tried and tested methods, and if your film is part of a big studio then that method will probably, but not always as we often see, work, but this book isn't for those kind of films—this is for those of a more "modest" budget. The gap between budgets is widening quickly, and most films now are either low-budget indies or big studio pictures, especially where the United Kingdom is concerned, and the days of mid-range films seem to be vanishing all too quickly. Maybe things will change, but as we're writing this there's certainly no sign of that happening; the gap just gets wider every year.

The idea here is to get filmmakers to start thinking about the distribution part of the process from the very beginning and take more ownership of what happens to the movie at the end of a huge amount of work. It's not particularly creative, so all of us on the making side would probably rather someone else do it to be quite frank—but remember that no one will ever care for your film as much as you do, and more often than not nor will they ever work as hard as you would. So who better to be involved in the selling and distributing of the baby you have slaved away on for countless days, months, and years than you? This doesn't mean you have to do everything yourself, and at the beginning it's imperative to get people on board and to learn from them, but it's also not just giving it over to someone who is just there to make a fast payday without caring what happens with your film. This may sound overly cynical, but we've been there ourselves and we know people who have given over the thing they've worked on for a decade only for it to be gobbled up and lost on a digital shelf never to be seen by anyone but your aunty.

"Lots of filmmakers self-release and are quite uninformed. People releasing a film theatrically, but not windowing properly will mean positive publicity may be wasted. No filmmaker can do this all on their own. A lot of the platforms have their own list of preferred people that they like to work with. A more

considered approach is needed, there's a timeline from theatrical release, to digital release, to First Pay TV window to First Free TV window.

A lot of filmmakers sadly don't understand the sales and distribution process. You can't make films for the tiny bullseye that is a Sundance winner and hope to flip the world rights to a studio or big SVOD player. It does happen, but it's really not very often sadly! Much better to make something with a distribution plan in mind and to consider the worst-case scenario. Also consider how it is going to sit in the current market. What makes your project different, what makes it stands out."

—*Mike Chapman*

Going into a project with knowledge of where you want it to go and how to get it there without having to rely on someone else to make your dreams come true is going to give you so much more power and ownership of the whole enterprise. In this chapter we'll take you through the journeys that our films have been through, including film festivals, sales agents and distributors and being your own agent, PR team and even cinema booker.

Our films' journeys have all been different not just because we were learning (and sometimes making mistakes) as we were working with each of them, but because the industry constantly changes and we had started Fizz and Ginger Films just as things were shifting hugely with the explosion of video on-demand and what the knock-on effect was for where films ended up. It also taught us that every film will, or probably should, have a different approach when it comes to distribution: what works for a folk horror might not work for a socio-political drama.

We want to be candid with what we do, the ups and downs, so some things that we did were just the wrong path, but we've learned, adapted, and moved on. All three films are out there to be seen, and we're being asked to work on the distribution of other people's indie films, so maybe we're getting the hang of it now.

The things we did and the advice we give here is because we have had to work with limited budgets, and we made most of it up as we went along and/or had no choice because of lack of funds. We absolutely encourage you to find your own way and learn some new tips and tricks and then be a pal and let the filmmakers that come after you know what worked for you!

FESTIVAL FROLICS

Our first film festival was with the mad short film *E'gad, Zombies!*, and it was the Cannes Film Festival in 2010. At Cannes there's a section called the Short Film Corner, which is a great little platform for shorts, but it is almost impossible not to have your short film accepted into it. We obviously thought we'd already conquered the film world by being accepted to this; we had Ian McKellen in bed with a zombie, and we were at Cannes!

The festival itself is ten days long, so we obviously booked ourselves in for the whole stint; we printed posters, flyers, pens, notepads, even car magnets to stick on the side of our rental as we drove around the Croisette. We spent a fortune. As we turned up on the first day the Short Film Corner was pretty quiet and we were once again reinforced in our thinking that this was very exclusive. The next day more young filmmakers arrived, and then more, and more; we soon realized that there are thousands of short films in the corner and then it becomes a battle to try and get people to see it. I'm not trying to take anything away from being accepted and involved with it at all; films do get rejected from it and just being at Cannes as a new filmmaker (I'm not going to say young again as we know plenty of people who start this mad path later on in life too!) is an amazing experience if you know how to use it to your advantage and don't get too dazzled by the red carpets and bright lights.

Those red carpets and bright lights are only a tiny portion of what the Cannes festival is actually about. Behind those famous steps that we see again and again full of the cream of Hollywood is a huge world of meetings where deals are being made every minute; films are bought and sold,

new partnerships are being created, and collaborations are being planned by people from all around the world. Even though in recent years it has quietened down somewhat because the industry has changed so much from a "market" point of view (it'll perk up again; the industry adapts to change, it always has), it's still the best place on earth for indie filmmakers to go and meet people from all parts of the business. Even if you can't get into the parties, there are always talks, networking events, and plenty of late-night accidental meetings at bars. And the good old Short Film Corner has a happy hour every day with cheap (well Cannes' cheap!) drinks to encourage filmmakers to meet, and they have talks from all sorts of industry professionals.

It's hard work though, all of it; it's expensive and it's exhausting, and you have to be prepared for everything. You need to get your accreditation if you don't have a film at the festival, which is free if you do it beforehand, but you have to be able to prove you're in the industry and might even need to send a picture of your business card, for example. On that note, get lots of business cards! In meetings at the festival, you swap cards before you even start the meeting.

Getting meetings actually isn't too hard; in fact it's kind of easier than normal as everyone is in that zone and all in the same place at the same time. We did spend months researching who we wanted to meet and working out how to reach out to them, however. We wrote hundreds of emails and got about thirty meetings in those ten days, which is pretty good going, I think partly because people were wondering who on earth we were and what the hell we wanted. Nothing came of any of the meetings—we had a weird comedy short film about eighteenth-century zombies—but it taught us a lot about what is expected, and also what different people in the industry actually did and why, and in what order. Although it was then that people started assuming the short was just a teaser for a feature, to which we quickly said, "oh yes of course," and then promptly started writing when we got back.

We also learned that 95 percent of people in the industry are, in the politest way possible, absolute bullshitters. I don't want to sound cynical; in fact it's quite liberating to know because you can quickly get taken in by people promising you the world without any way of being able to deliver. And because this book is all about taking more ownership of your film career, it's not a bad lesson to learn as quickly as you can. On a positive note, we met people at that first festival that we're still in touch with, not that we've worked with them all as such, but who have become part of that all-important network you need around you to support and encourage your projects; we do the same for them.

At that point we also hadn't worked with any kind of public relations people, so had to learn a whole new skill as we were going, and these are skills we're still using now because, as we keep saying, no one will ever work as hard for your project as you will. All our weird purchases of magnets and flyers and pens made us realize that you need to think about the world around your film, your branding I suppose. This was when social media was in its infancy (wow, that makes us feel old), and now so much of the public relations side can be digital, but people still like tangible goodies; having flyers and posters makes people think things are official, and it's all about sprinkling that fairy dust and making people believe in you and your film.

With our next short films, *Claude et Claudette*, *Blog Off*, and *The Humpersnatch Case*, we didn't really do many festivals at all; they were more for us to get more experience in different aspects of filmmaking as we wrote feature scripts. We went back to the Cannes Short Film corner a couple of times with them, but didn't put as much time into marketing them as with *E'gad, Zombies!* as they were more of an excuse to get us out there and if people saw them, great, but if not it didn't matter as we had learned that our time out there was best spent networking and expanding our circle of people in the industry. We were also learning that although you've made a short film, it doesn't mean people need to see it! They were

more for us to learn from than anything and certainly *Blog Off* should never be seen by human eyes again!

With *Miss in Her Teens*, we made a big error. We didn't do festivals at all but went straight to sales companies to see what they thought. The lessons we're talking about now, about how good festivals are for raising the profile of a film, building an audience, and getting reviews, were mostly learned in hindsight, especially when it comes to features. I'm not really sure why we decided not to approach festivals; maybe we thought that as it was sort of an odd project, potentially for universities to learn about that period of theatre, we wouldn't bother? Whatever the reason, we were foolish. A sales company in Canada picked it up and went off selling it, which sounds great, but without that surrounding support gained at festivals, without the reviews to get more press interested, it was an uphill struggle to get people to watch it even when eOne took it on to distribute. There's no point in having a film out if no one knows it's there, and a sales company works best when they have as much ammunition as you can give them, who in turn can give that to the distributor to hopefully do something interesting with. If you don't have the money for an elaborate public relations campaign, then festivals will give you that much needed ammunition.

We didn't really learn our lesson with *Two Down* either; at least not at first, and that's because we're too trusting. We were basically convinced by a sales company to skip festivals and that they could have it out within six months; you can probably guess where this is going. Skip to almost a year later and nothing happened; why would it? It's a low-budget dark comedy with mostly, at the time, unknown cast and filmmakers. So we decided to take action and start submitting it to festivals, but the problem with that is that once you submit you might be waiting the best part of a year to even hear if you're accepted; a lot of time had been wasted listening to people who were promising fool's gold.

This was the first time we'd really had to think about festivals with a feature film and people kept talking about festival strategy and what "tiers"

we'd go for, so we had to have an honest think about what kind of film we had made. There are books about festival strategy out there with lots of good advice, but most seem to say that you should start with the top festivals, known as tier one. These are things like Cannes, Sundance, Venice, and the BFI London Film Festival, basically the ones that my mum might have heard of, the ones with big red carpets and hugely famous actors. The thinking behind starting with these kinds of festivals is that if you give away your world premiere to a tier two or three festival, you can't go back to a tier one fest. If you have a film like *Two Down*, a slow-burn 1970s-inspired thriller with a tiny budget, it's just not going to get into those festivals. This is not to say the film isn't good; it's just that it's not the right kind of film for those sorts of festivals and that's absolutely fine. You have to be not just honest with yourself but think like someone programming the films. There are limited slots for films, and they're going to pick films that the press are going to talk about and will get tickets sold; it needs to be an event for them and if your film, no matter how brilliant, isn't going to do that for them, then it's much harder to get in.

"Accept that your first film is a first film. Everyone finishes their project and thinks 'this shit is the bomb, it's brilliant, I'm amazing, everyone is going to want this, I've finished it and its going to be the next big documentary on the market' and then it's obviously not because it's your first film and you love it because you've finished it. Manage your expectations, don't think your first one is going to be the be all and end all. (Submitting to) 120 festivals basically means that every morning for six months you're getting an email saying that your film's not good enough and it can be tough. I'd been told no before but the regularity was really tough and it stopped me wanting to make films for a bit. Managing your expectations to not knock your confidence."

—*Louis Devereux*

We say this to stop you wasting your time and money, not to dampen your dreams! If you submit to somewhere like Sundance in February,

you'll have to wait most of the year to find out if you're in (but if you think you've got a shot you absolutely go for it!). For something like *Two Down*, which had executive producers that people had heard of, it was still never going to happen, so it was better to focus our time and limited submission budget (we didn't know to include this in the film budget at the time so this was all going on credit cards) on places that it might actually have a shot at. We spent a lot of time looking at festivals that liked the sort of budget level of films that ours fit into (and it often really does come down to that realistically), and then researching what films they had screened before and how much support they would give to a film in getting word out there.

There are people that can do all this for you—working out a festival plan and submitting to festivals they have connections with—but they are going to cost money. There's nothing wrong with that route if you have the cash, but this book is about you working out where your money is best spent and learning about all aspects of the process; the best way to learn is to do. The time and effort you put into researching which festivals do what, where their focus is, and if they're worth your time and money is invaluable practice and training for later on. It helps you think about your film from a different perspective, the way people who want to sell it to an audience would think, which is often very different to how you as a filmmaker have been looking at your movie.

"People who help with your film festival planning, and all applications, they cost a shit load of money and basically all they do is put the film on Film Freeway and submit with one click. They sell you down a river of, 'we have personal connection here and we look after each film individually and we talk to the festivals before we send the films off' and then they don't do any of that. They really didn't hone down what festivals it should be sent to, they just submitted to the first ten festivals of every month. They were very smooth talking and cost a load of money. But what I've realised is that if you take a personal approach to festivals and speak to the person that's running it

beforehand and say this is the kind of thing that my film is, tell them what you're doing and ask if they'll be interested. And usually they're very honest and will either say, yeah it might get in give it a go, or no regardless of the quality it won't really fit in with the festival this year, maybe three years ago but not for this one. And that's saved me a lot in applications."

—*Louis Devereux*

This was something else we hadn't learned yet though, and with *Two Down* we did what people advised and spent a small fortune in time and cash submitting to festivals that, of course, were never going to screen the film and most probably never even watch it. That's another horrible truth about the festival circuit: there are countless festivals that will not watch your film even if you've paid your submission fee. This is why looking into them all via social media, seeing what other filmmakers have said and what press articles and reviews were written about films that have screened there in the past, should all be part of your due diligence when working out whether to spend the cash or not.

"We track around 5,000 films all together, that includes all the shorts . . . and we see approximately 2,000 films with 500–600 coming through open submissions. This is a mix of UK and international films. There are 12 people who do all the first viewing. It might then be recommended for a second view because it's an alumni filmmaker or the first viewer might think there's something of note that should be discussed or that we should investigate further. We don't programme to themes, but when we get to a critical mass of say 30–40 films, we step back and see if there's anything emerging, if there's a pre-occupation that filmmakers are sharing.

It can be cultural or social or political, or this year a startling number of debut feature films, where the filmmaker is quite mature creatively, they might have worked in television or theatre or a writer but are immerging fully formed with ambition and bold debut feature films."

—*Tricia Tuttle, director of festivals for the British Film Institute*

For a year and a half, *Two Down* got into lots of festivals, and we ended up with twelve awards from places around the globe. None were top tier festivals, but then nor was the film from that point of view, but they were good enough to attract press to write articles in nationwide newspapers beforehand and for reviewers to watch it before the festival and help build up a really nice audience for each place we visited. This was also the beginning of us really understanding how important it was to also be your own public relations team in all aspects of your film's journey, even if you have employed people to help you on that side. It was also the start of us truly realizing that no one will ever work as hard for your movie as you will. A lot of festivals will send out information to local press, reviewers, bloggers, vloggers, and whatever else they can think of, but you can't rely on that so you need to be looking into people in the area that may support you and let people know about your film. You can start this process as soon as you know you're accepted using social media to work out who may be around and willing, so start befriending as many people and groups as you can before the event and then send out calls to action closer to the screening (see figure 53).

The awards are not just an ego boost—although for those of us who worry about if anyone's going to like the thing you've spent years making, it is nice—but they all add a seal of approval for further down the line. They don't need to be from the huge festivals, although if you win big it's going to help (although sometimes not as much as you would think—you have to know how to use that moment in the sunshine), but it all adds up when you want to get your film out to a non-festival audience.

Another fun and helpful part of festivals are the Q&As after the screening. This is where a moderator will ask you questions and then usually throw it out to the audience after a while. Some moderators will be excellent and have a genuine passion for film and will have worked out some interesting things to say about yours and create a real discussion; some may not have even seen the movie. So, as always, be more prepared than everyone else. Most festivals will ask for a press pack, which can have info

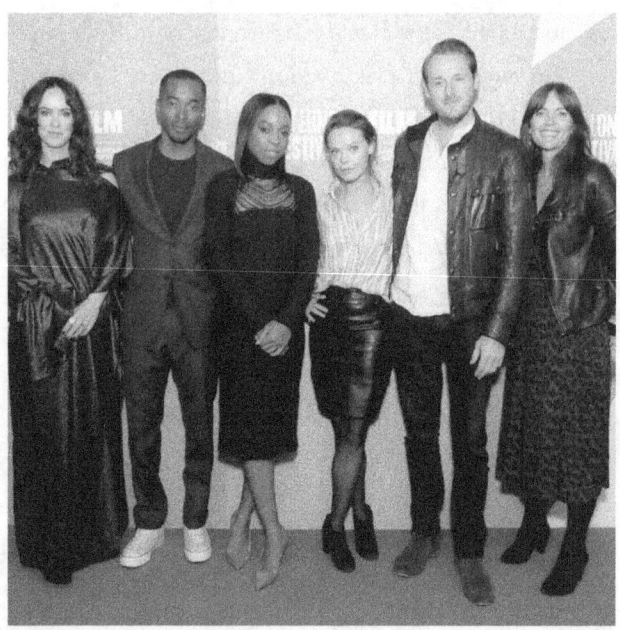

FIGURE 53
Meeting other filmmakers

on who's made it, the synopsis, and perhaps production notes. These are the entire story of the journey you've taken on the film: how it came into being, some interesting anecdotes about the actual production, that kind of thing. You could also maybe even add ten frequently asked questions about the film, and then you supply the answer. It's good practice to have thought about all this before you start any kind of publicity anyway as generally most people will ask the same questions, hopefully based around your film rather than generic thoughts. In this way you'll have fun stories that get the audience excited about you as a filmmaker too and take that away with them when they're jumping on social media to tell the world how much they enjoyed it.

If you can get some of the actors along too, it's going to bring in more audience. Some people like to see the filmmakers, and some love the chance to rub shoulders with actors; it's just another world for most people so use that to your advantage and let people know beforehand who'll

GETTING YOUR FILM OUT THERE 211

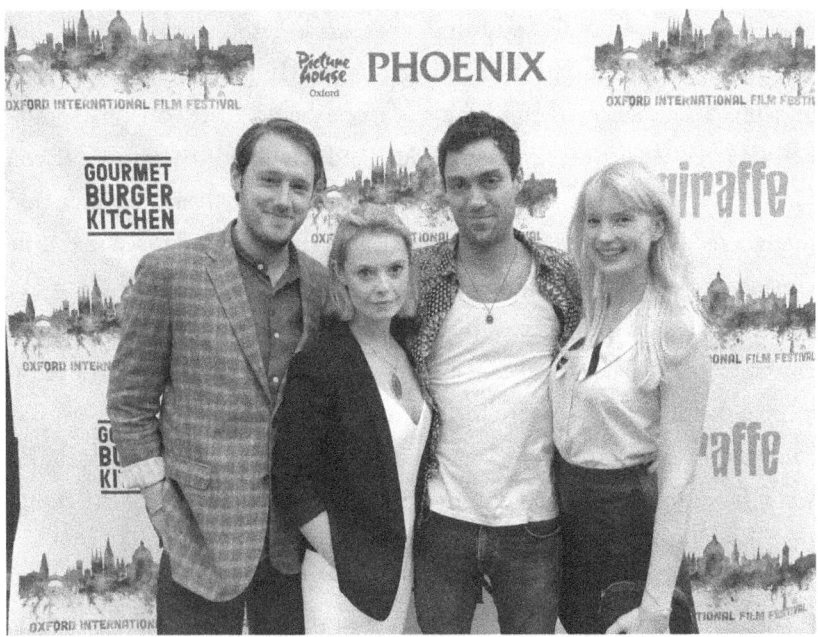

FIGURE 54
Visiting film festivals with cast

be at the screening (see figure 54). If your actors have been in things that the audience might know, use it!

"Crowd sourcing, whenever you put a tweet out you're building your tribe, everything is about that. Those fans will follow you forever because they're interested in what you're doing. You are your own brand, find that from the beginning and don't be scared of it. It's not boasting or being big-headed about it, you're building followers, building a tribe. Many will just disappear but there'll be a few hardcore fans who will follow you for the rest of your life. It happens to actors and it happens to filmmakers. As long as you're nice. That's why Q and As are amazing because they can come and meet you. As filmmakers I think it's very important to not shy away from who we are, and welcome people in and ask if they need help. You've got to give it back a little bit."

—*Giles Alderson*

Going to the festivals and bringing actors is going to cost money, but it's money very well spent. You'll get more visibility from the festival and bigger audiences than without anyone being there. So this should be budgeted when you're working out the finances for the movie, if you have that luxury. That along with money for posters, flyers, blu-rays, and digital cinema packages, which are basically a special hard drive that only cinema projectors can read. I'm explaining this because when I spoke to Neil from the Manchester International Film Festival, he said a huge amount of filmmakers still don't know what one is or that you'd need it to play the film. This is more for feature films as far as I'm aware, but you can look on the festival websites before you submit to find out what they'd want. There's no point in submitting if you don't have half of the things they'll ask for or the resources to pay for them.

The money part is something we hadn't learned when we budgeted the film two years earlier, and spending all that time getting *Two Down* into festivals cost us a lot. We didn't go to all of them, which was a shame as it was a chance to build the audience more and find new people to collect into the Fizz and Ginger network. It was, however, hugely useful and necessary as we were then in a position to go to a new sales company and give them not just the film, but a package of press articles, reviews, and awards: proof that there was an audience out there for it. As they were deliberating about whether to take it on, we were asked to be part of the Breakthrough section of the London Screenings held by Film London at the British Film Institute on the South bank. This is a place where sales companies, distributors, and all sorts of industry types come along to watch films from new filmmakers. When the sales company heard about it, they asked us to sign up before the screenings so they could then screen it as part of the selling section of the event. There's nothing like someone else saying they want something to make others stand up and take notice! We had been told we could invite some people too, partly to make it seem more popular to the distributors I

would imagine, so we asked some industry bods along and among those was Laura from Great Point Media. They are a film finance company who were at the time fairly new, having recently broken away from a larger company, so they were looking for films and Laura was impressed enough with *Two Down* to ask us to come and have a chat. When she found out how little we'd made it for she said, "If you can make *Two Down* for that, what else have you got?" I'm not sure this conversation happens very often, and I think we were partly in the right place at the right time, and they were looking for low-budget genre films and needed to do it quickly for various finance and (legal) tax reasons. We of course pitched something entirely different at first but realized that *The Isle* would fit with what they were after.

As we're on the festival part of our journey at the moment, we can skip to the end, as it were. We finished *The Isle* and as Great Point Media were also selling it, they took on the chore of submitting to festivals as we were quite keen to go down that route again. We knew that it would be good for us as Fizz and Ginger Films to be involved in festivals, but that also the kind of film we had made needed, we felt, to slowly gather an audience and reviews rather than just trying to sell it straight away. We are hugely grateful to Laura and the whole team to have taken a gamble on a slow-burn indie supernatural thriller, but I will say that at first I don't think the guy who was in charge of festivals entirely knew what to do with it. At first glance it looks like a horror, so he sent it off to lots of the typical horror festivals that deal with a very different kind of film, which is absolutely fair enough. It was never an easy sell and after a while we asked if we could maybe also submit to a few we thought it would work well in. They were normal festivals rather than genre ones, but we had researched places that had often had a space for one or two genre pieces, so we focused on those as *The Isle* is very much a festival film, by which I mean it's always going to have a kind of film-buff sort of audience rather than hugely mainstream at first glance (told you it was a gamble!).

We'd learned more about generating audiences through social media and a little more about public relations by this time, so we worked hard at getting people along and letting the world know what was going on (we still had more to learn at this point, but it was enough for the purposes of festivals). The aim of the festivals this time round, at least at first, was to see if people got the film or if we were just wildly off the mark. It's a subtle film where you're not sure if it's a drama or a ghost story, and we were worried we'd been too subtle. Festival audiences are an interesting mix of filmmakers, film fans, and people who are just interested to see what's going on, so it's a good testing ground. It's also probably the first time you'll see your film with an audience, which can be one of the most nerve-wracking things imaginable for a filmmaker.

One thing to remember about festivals is that there are multiple things happening at the same time and a lot of people there will have passes to the whole thing and often they'll go along to things without ever reading what it's about. This means that if they don't like something, they're more likely to walk out because there's always something else to see! What I'm saying is try not to be too upset if you get people walking out; no film will ever please everyone. Hopefully, it'll only be one or two and they very likely didn't know what it was they were watching anyway. It's also a good lesson for filmmakers to realize that very few films are universally adored, and you just have to suck it up and dress accordingly.

Our audiences were interesting as we got a much older crowd than we were expecting on the whole, which was helpful as it told us where we would have to focus our efforts further down the line, not that we realized we would be so involved in the distribution at this point, but it's good to watch your audience when the film is playing to see reactions of different groups. Some people then go away and re-edit their films based on these screenings; they're like the test screenings of bigger movies I suppose, if you can afford to do that. With *The Isle* we really pushed trying to get reviews to collect so the salespeople could use them to show potential

distributors what audiences thought of the film. And as we knew the sales team wanted to try and get the film to America, we submitted to various festivals over there, partly to see if there was an appetite for the film, and also to get some US laurels* and reviews for the poster.

Another note about festivals is that a lot are keen to help promote your film further down the line when you're distributing as they like to see that films they have backed are doing well. It's good for them to be seen to be picking winners, so let them know what's happening with your film and get them to let their audiences know that they can go and buy it!

"We actively seek to view second and third features, all based on the quality of the work, but we spend a lot of energy tracking and following up projects from filmmakers we have helped launch in the Festival. We are interested in helping to build an audience for filmmakers. . . . Festivals do have a role to play in helping audiences find new filmmakers so we're always interested in discoveries, filmmakers that audiences might not hear about otherwise. It's part of our role to say what's so exciting about them—and when people connect with that work it's really exciting. We try to keep track of every film that's been part of the festival that has a distributor and try to make sure that we're supporting that film when it's released."

—*Tricia Tuttle*

NAVIGATING THE SALES AND DISTRIBUTION DRAMA

The next part of a film's life is trying to get it in front of the general public. Most filmmakers don't seem to know about this side at all, which is fair enough—we didn't when we started. The problem is so many amazing films never see the light of day because filmmakers either don't know what to do next or give it to a company and then step back and expect them to work miracles. In the current climate, which is a little wobbly to

*These are the laurel leaf logos that you see on a lot of indie film posters. Every festival provides an image of their laurel if you've been selected or won an award.

say the least, the next part of the process is the biggest and hardest; sorry about that. But look at it in that if you're part of the process it means you get a lot more control over what happens with your film, so it won't just be dumped on a platform and lost in digital hell.

Things are changing rapidly at the moment with all the online platforms releasing digitally rather than theatrically.* In the not-too-distant past, this was considered to be a failing of the film if you couldn't get a theatrical release. "Straight-to-video" films were looked down on by the film establishment and some people still think like this, but in the next few years this will change more and more for various reasons, which we'll come to. Certainly, a lot of critics and television platforms will still favor a film that has had some kind of cinema release as it's a sign that there was an audience for it. It can also be a useful marketing tool to release in a few selected screens across the country for one off screenings or a Day of Days, meaning your film is released both in cinemas and digitally on the same day. And some of the bigger platforms are choosing to release their movies, made with huge names, for a couple of weeks in the theatres before being released on the digital platform, partly so that they qualify for the big awards like the Oscars and the Baftas.

Let's focus on what these two entities, sales and distribution companies, actually do and why they're different. Although again things are changing and more companies are melding together so the lines are blurring somewhat in some cases, but we'll stick to the traditional now for clarity, as much as that's possible in this industry!

You've had your film go to festivals and win a load of awards and everyone thinks it's great—fantastic. A sales agent may approach you, or you may approach them, to represent your film in the market. This is where we get away from the fun creative world of the actual making of a film and the supportive understanding realm of festivals; this is a market and there

*Theatrically meaning releasing in cinemas.

are a heck of a lot of products out there all vying for an audience's limited viewing time. The sales company will, for a percentage of what the movie makes and often hefty expenses, tout your film around to various markets that some of the big festivals have. In essence it's quite a simple role that sales agents play in the life of your film; they sell it.

"I knew Colin from Verve had distributed a Moving Image film that I was in and when I was writing *Real*, I looked at his slate and tailored it to the type of films that he took on. I sent loads of emails to him, even when we wrapped, the week after I wrote to him and said, I've got a film that I think you'll be interested in taking on and he didn't reply but I just kept emailing saying look you need to watch this. 100% I specifically targeted the distributor."

—*Aki Omoshaybi*

Places like Cannes, American Film Market, and Galway have a huge section working alongside the festival that the press don't really talk about and therefore the public don't realize, which is all about selling; it's an actual market where sales companies set up stalls and booths to entice the buyers—distributors—from all over the world as they walk around looking at posters set out on a table or in a catalog. If someone likes the look of a film, they'll ask to see the trailer, and if they like that they'll watch the film, or at least some of it, and decide if they want to talk about some kind of deal. These booths cost a huge amount of money, and that's why the sales company will put expenses into your contract, but before you sign anything we'd advise you set a cap, limiting the amount they can spend, otherwise the chance of you seeing any return will get further and further away.

The sales company might have to go to various festival markets around the world to get distributors on board with your film. Sometimes a buyer might be interested but has just bought something in the same genre so will wait until the next market and if the film is still available pick it up

then. Although you've then got the issue that some people think of your film as old and will question why it hasn't been picked up already!

This whole process can take some time, unless you have a big star in your film. Then the sales company might well have come on board before you've even made the film and have already pre-sold it to distributors. The question of who is bankable is tricky, and an actor may be the hottest thing out there one year, and then not really bankable the next. It's brutal and everyone has a slightly different opinion, but then that kind of sums up the industry. (Obviously if you get Tom Cruise you'll be fine, but if you have Tom Cruise you don't need this book, to be honest!)

"Look and see what a sales company has sold in the last three years, that always tells you what you need to know. Often, they'll ask you for a film with names and then you look at their website and the films they're selling don't have names."

—*Gareth Jones*

The sales company might be touting your film for a while before it hits the right time in the market, or it could even be down to getting the artwork right, which is far more important than we ever realized. It makes sense though: it's the first thing people see and what they will judge your film on. It's a visual medium and that includes everything around it, and as we're spending more time and money on digital platforms, which often don't give much away in the blurb about the movie, our first impression is the tiny thumbnail of a poster among dozens of other tiny posters.

"We've seen a lot of people sitting on films. Broadcasters, platforms, retailers, exhibitors etc will look at IMDB rating and if it's listed as being older than two years will see it as a library title. So, it's key to get filmmakers to release their films in time. . . . Producers also need to do their homework and ensure they have everything that is needed for their film to be released. Is your E and O policy in order? Did you get an onset photographer to get imagery

fit for artwork? All of this needs to be considered. Be realistic and have an awareness of what the market is. Sometimes I feel like people have never been to their local supermarket and browsed the DVD aisle or scoured through the rental section of their TV. Budgets are often so out of proportion, it's very tough for us to then see how we're going to bring the money back."

—*Mike Chapman*

Distributors are the people who will take on the film and make sure their country sees it, with any luck. We said take it on rather than buy it because although they're referred to as buyers, they don't always buy your film. Some will, of course, and the bigger the film, or the better it's done at festivals, then the more leeway the sales agent has to ask for a minimum guarantee of money upfront. Some won't do this though, and it'll be all about percentages further down the line; a sales company will, or should, fight for minimum guarantees but won't always win.

It's not easy to get to distributors directly; they have their preferred sales companies that they like to deal with and likewise the sales companies have spent time cultivating these relationships. A sales agent is there to broker the best deal for your film, hopefully, and will attempt to do that in every country, or territory as they're known. Each territory has their own distributors, so your film may well be taken on by several distribution companies and within a territory, different distributors will have different expertise. One might take it for theatrical, whereas another for home entertainment (digital platforms like iTunes and Amazon), and another again for DVD and television.

"In the UK we have a lack of distribution companies, over the last five years we've lost a lot. . . . There's a lot of noise, big films are dominating, like Marvel, and films are being bought for less. A UK distributor may only pay you a few thousand pounds for your film and that's not a fair reflection of what the UK used to be worth."

—*Gareth Jones*

This sales and distribution side of the industry is changing hugely and rapidly, and this is partly because of the digital platforms that are ever growing in number and the amount of content they are creating. A lot of distributors now create their own films and television shows and the amount of "originals" that are being made is extraordinary. In some ways, this is great for writers, directors, producers, and crew as it means there are lots of interesting work opportunities popping up. The question is, though, as the big digital platforms vie for your consumer subscription, how are they going to win that? What will entice people to sign up for one platform over the other? Only the very wealthy will be able to afford all of the subscriptions. So how will they find their customers? How will they lure us to them rather than their competitor? And the answer will probably be that each digital platform will have to create a clear identity of content for the consumer. One platform will perhaps have mainly kids' films and television shows and animation, whereas another will concentrate on drama and documentaries; another might choose to really focus on independent genre films.

The digital platforms are of course still going to sales companies to buy content as well, but it has meant that what they are prepared to pay for independent films has decreased substantially over the past few years. It's the old supply and demand conundrum. Lots of content creates a crowded market and so the price of things drops. This has begun to be reflected at places like the Cannes Film Festival, which has been significantly quieter for sales companies for the last few years. When we first started going in 2010 you'd walk along the Croisette up from the main festival and every hotel balcony had banners from all the sales companies that hired suites to use as their offices. It was crowded with buyers and sellers running around from meeting to meeting and huge amounts of money in deals would be made. These last few years have seen the majority of those banners come down, at first as people stopped hiring the very expensive suites and just meeting at communal places, and now

some people we've spoken to have stopped going altogether. The whole thing is hugely expensive for them; remember it's your film's "expenses" that are paying for them to be there.

What is happening is that some companies are becoming more than just one element of the whole process. There are companies which finance projects and that act as the sales agents too, and some even distribute their projects so they can reduce the number of people taking a piece of the money pot. These businesses are accessible to filmmakers and are usually actively looking for projects. On the whole, this means that they will have a lot of say about how your project is shot and delivered, and if they only give you the money on condition that they sell it, once you've handed it over there may not be much you can do about influencing the life of your movie afterward.

This is fine if the sales side of the finance company has the links to get your film seen by good distributors, but it could be a slow death if they don't and there will be very little you can do about it. This is another reason for you to learn more about this side of the process and taking more control yourself. If one of these fine establishments wants to give you money to make your film, though, it's pretty hard to say no; so just do your homework and look at what films they've done before and what happened to them. You could always try and write a clause into the contract saying that after a certain amount of time you get the rights back, at least for your own country, and see if there's another avenue. Yes, we are talking from experience!

We're not going to put any names of these companies here because they often get bought up by other companies, change names for various reasons, or just go bust; filmmaking isn't easy for anyone. A quick internet search will throw up a load of them though, and then it's up to you to have a look at what sort of movies they do, it they are approachable, what sort of level of filmmaker they work with, and if they look dodgy as hell or not.

> "Some of the major independents aren't buying so much anymore and focussing on larger releases. There's still money to be had, but the release model has changed drastically over the last 20 years for many distributors. Now it is all about targeting your audience and really being economic with spend, becoming smarter about how you reach audiences and making films that stand out. It's about quality as well and you want to have films that people are going to talk about."
>
> —*Mike Chapman*

As things change and the platforms continue to influence the market for independent film sales, there will be ways the indie moviemaker can get their film out there for the world to see. There are already places that allow us to do this: aggregators that you pay to help get films onto places like iTunes and Amazon. They're not distributors, so there will be no press and advertising—that's entirely down to you—and that means a lot of work and some money, but we'll get to that!

Self-distribution used to be a dirty word in the film industry but 1, who cares if it means people can see your film, and 2, it may be one of the only ways of getting modestly budgeted movies in front of an audience, especially as the industry adjusts after events like the effects of the COVID-19 virus. This may mean reducing budgets and finding clever ways of doing a lot with a little, but if we know this when we're writing and filming, we might just be able to create a new sustainable world of indie filmmaking.

This is all for feature-length films more than shorts, but it is getting easier to get shorts out there too and try to monetize them. With things like YouTube, Vimeo, Amazon, and more platforms popping up all the time, there are now plenty of ways of shorts getting a decent shot at a paying audience. Once again, you'll have to put up the money for a public relations person, or do it yourself, which will be cheaper but you'll still need some for ads and then a heck of a lot of work, but if you think it's worth it for your short, go ahead. I only say that because after

our first short together, *E'gad Zombies!*, we put it on Amazon for sale, which may have been a little presumptuous of us at the time! We didn't do that with the others as we realized that we had a lot more to learn and that we may come to regret having some of our previous work out there in years to come.

That kind of brings us to our features and what we did from a distribution point of view. A lot of what we've written here is borne out of the beautiful beast that is hindsight, which means that we didn't have a clue about this with *Miss in Her Teens*. As you know we also hadn't done festivals, so we didn't have a lot of ammunition that the sales company could use to sell it. Ian McKellen had narrated it and Simon Callow pops up at the end, but at the end of the day it's a weird comedy based on a "lost" two-hundred-year-old play—not a hugely easy sell. The sales agent did a great job and very quickly a huge distributor in Canada picked it up—we can't really mention names, but we bring this up because after about six years of it being out over there via this distributor we haven't had any figures, and therefore no money, from them. This led the sales company to cut all ties with them and then venture into distribution for themselves for when they released it in the United States, so you can see that people are deciding to spread out in what they do just to have some semblance of control.

We also didn't work on anything our side from the point of view of advertising, which is entirely our fault because we just didn't know that was what we should have done. In the good old days, the distributor would put up lots of money and make sure people knew about the films they were putting out there, but now many, mostly indies, are just dumped onto digital platforms in the hope that they'll magically be spotted and people will watch it. This was a few years ago, so everyone was getting used to this new way of watching movies and no one really knew what they were supposed to be doing, including the distributors. This huge company may one day give us figures and the money that we're owed, but

who knows. You're too small for the big guys to care about, so you may never know how well your film's done or see any money from it. Legally you can audit them, but the legal bills could well amount to more than what your film has made and, sadly, they know that. It's a terrible situation; it's not fair and something really should be done. It's not just us—it happens time and time again to independent filmmakers, to the small guys. But there's really very little you can do about it except keep a close eye on your film and work with people who you hope you can trust. We'll let you know what we find out if we ever get to that stage!

What we did learn from when it was released in the United States and a few other countries is that people really aren't paying a lot for each territory. It's up to the sales companies to try and get as much as they can, and the easier the distributors believe it is to sell, the more they may pay. It's why genre films and movies with big names that they can plaster all over the artwork are always easier to get out into the world, not as much work needs to be put in from their side. Having Ian and Simon involved helped, but they weren't main parts in the film so that could only do so much. You quickly realize that most of the work is going to have to be done by yourself. Yes, we're banging on and saying that again—don't rely on anyone else—but then that is the main thrust of this book so if we didn't pop in little reminders of why we're all here it'd be a little remiss of us.

We asked the agents to have a bash at selling it in the United Kingdom too, which they were very happy to do, but they did always say that, being based in Canada, their connections to the United Kingdom wouldn't be as good as in North America. Here was another lesson for us; well, a couple actually. For a start we should probably have tried to start *Miss in Her Teens* in our home country; some people get a bit funny if you've released somewhere else and then try and crack your country later on. And the agents were right and struggled to get much happening in the United Kingdom as they just didn't have the connections. We naively thought

that in this world of the internet and emails and online links to films that it didn't matter where in the world they were based. But part of an agent's job is spending time cultivating relationships, building trust and a network of people at the various distribution companies. It makes sense that the best connections that they'll have will be close to home.

So little *Miss in Her Teens* came out on the usual digital platforms in the United Kingdom and very few people knew about it. We hadn't learned about the power that is social media and what an amazing job advertisements on those platforms can do for a film, and we only did a tiny bit of press for it. This was partly because it had been so long; we'd moved on to other movies and just didn't have the time to devote to the poor thing. If we'd had a company in the United Kingdom look after it, it might have done better, but this was all part of the learning. And as you do more films, people do go back and watch older films that you've done, so as long as it's findable it'll still have an audience; it just might be in about twenty years.

By the time *Miss in Her Teens* came out, we were fully into things with *Two Down*; working on one film is a full-time job, let alone working on two. By *Two Down*, we had at least learned the importance of doing festivals, of picking up awards and reviews and that all important network of people who want to see your film and those that have seen it at festivals and want to support its journey forward.

We weren't patient though. As soon as someone approached us for US distribution and promised large amounts of money coming to us in the first year, we signed our new baby away. It was a new company so we couldn't do any due diligence to find out what other films they had and how well they had done; I'm not sure at that point we would have anyway. We know that if a film does well in the United States, the United Kingdom tends to follow, so we jumped at the chance to have *Two Down* with this new company that was spending a lot of money on their brand. Our thinking was that if they're willing to splash the cash chatting about

themselves, they'd put that same hard work and money into all the films. Just reading that back really does make us sound incredibly innocent, and at this point we still were I suppose.

The film was dumped onto their platform and left to shrivel and die in the midday sun. You can probably tell that we *still* hadn't worked out that no one was going to do anything about the public relations side of things and that we needed to step up and do it. It did, however, do what we wanted it to for its home territory and a UK sales company picked it up; with the festival wins, reviews, and a release in the United States, it made it easier to sell in the United Kingdom, and they quickly got some great people to take it on. It was bought by Sky Cinema and became one of its few five-star films for the next fifteen months, which was great exposure for us, and then helped them sell the film to various European countries and then China, which was a big surprise for us as it's such a small indie film and China tends to take on Western films only if there are big names or plenty of action. For some reason, the little film really resonated with people who saw it, but again having the US distribution helped at the beginning.

We had finally, yes finally, figured out that people can't watch something they don't know exists! In this instance, we worked with a public relations person, and they started the ball rolling. This is when we started to see that even when spending a fairly large amount on public relations companies, it's still not enough. This is partly because they often focus on things in print, which are great and still feel proper, but they also don't reach as many people anymore. Unless those print pieces make it online, the circulation is rather limited, as fun as it is to collect them. That's not to say that they're not helpful: print pieces still give that air of being official. They might also encourage some lesser-known online publications to spread the word, and these may be more useful to you in the long term. The online articles and reviews can more easily be shared with your

network of friendly film fans all around the country and then shared again and again, allowing dialogues about the film to be started.

Doing this really helped our audience, but we hadn't seen how effective actual online advertisements could be on all the usual social media platforms. That would take an entire other feature film, and our growing mistrust of anyone to work as hard as you'd like them to, to fully appreciate the power of being bombarded twenty-four/seven by social media ads.

At the time of writing this, we're in the middle of things with *The Isle* and have learned, and are still learning, thankfully, about new ways of getting this creation, which we've spent three years on, out into the world. *The Isle* is a bit of an odd film in that it's not that easy to put into a box, at least it wasn't when we first finished it. The finance company who helped put it together has the sales rights, and they couldn't quite work out what they had on their hands, which is fair enough. They started to sell it as a horror, which it definitely isn't, though it could be seen as such at first glance; it's a drama with supernatural elements, but what category is that? This was just at the beginning of the term "folk horror" being properly acknowledged and in mainstream circulation when it was being discussed with distributors.

We were particularly concerned about the United Kingdom, as we wanted it to have had a good life in its own country. This way, other countries would more likely take it seriously. This is when we set about getting it to festivals, not just for all the helpful things that happen at them, but to gather up some laurels; put laurels on a poster and immediately people know it's a festival film. Having reviews from them also helped show people the kind of film it was too; absolutely not a jump scare gory horror!

In the meantime, armed with reviews and laurels, the sales team got a US distributor on board who said they loved the film and really wanted to work with us on it. They were going to release it in theatres in ten cities across

the United States at the same time as putting it onto video on demand (platforms like iTunes, Amazon, Hulu), DVD, and then later television networks like Showtime. They were also going to be spending a decent amount of money on print and advertising to let the country know about it.

Although we'd wanted to start with the United Kingdom, we also knew that so few British films make it to US cinema, let alone hard-to-place, modest-budget indies like *The Isle*, that we had to go for it. We also knew that when we said to people in the United Kingdom it was being distributed in US cinemas, it was going to make life a lot easier on home soil, which it absolutely did. There were a few bumps in the United States along the way, but we'll get to that, and they're always good learning moments. (Can you sense a pattern here? Try something, bump, learning moment!)

We won't go too much into how it all happened in the United States because we didn't have a lot to do with it at the time from an organizational point of view, but we watched and were very much included in how it was going, and what it did was teach us what was actually needed for the UK release. And that's really the main point, and yes we have taken some time to get to it; as filmmakers we're usually kept very much away from this side of things until it's too late, and what we all need to start doing more is learning how it works from their perspective so we cannot just contribute to those discussions, but be the ones in charge of what happens to our film.

The American distributors had what we considered a pretty large print and advertising budget for all the advertising, which in a way is great: it's the only way anyone will know it exists, and the United States is a big country so you need a fair amount of money to reach as many corners of it as you can. Then comes the downside: they have to recoup all of that money first before any of it comes back to the movie investors, let alone the filmmakers. It all depends also on how that money is spent, and unless you're involved in it, you'll maybe never know. We had conversations via

email about dates and where it would be screening, and we suggested we come out to help with press and if they wanted to do a Q&A screening. They're always a big draw, and it's great for filmmakers to do because it's always interesting to see what a real off-the-street audience reaction is rather than just what your friends, family, or film festival devotees think.

Talking to our US distributors, they seemed to totally get what we were trying to do with the film, and we were confident they'd be able to sell it in a way that the audience would also understand what kind of film it was; as we said earlier, we always knew that it wouldn't be entirely easy, even the new term "folk horror" wasn't quite right. We were sent over the new poster they'd created: our ghost of Persephone standing in the middle of the woods staring out at us. It is reminiscent of a lot of horror films that have come out over the past ten years: *The Conjuring*, *The Witch*, *Insidious*. With *The Isle*, we were trying to create something that felt more like the older sort of slow-burn creepy films of the 1960s and 1970s, and although the poster doesn't say slasher horror, it definitely leans more toward "horror" rather than "psychological folk-thriller." We learned that in the end it's a business for distributors and they want people to buy tickets, click on links, or buy DVDs as that's how they make money and in turn that's how you the filmmaker gets to see some money back.

So, if that means they have to push your film into a box and sell it as something that it isn't necessarily, then they will. This also went for the trailer, which they recut. We hadn't experienced this before on the other films. They made it feel like there's a lot more action and classic jump scare moments in the film as well as changing our ethereal, creepy music to a much faster paced score. It was actually very well done and got lots of people watching it, into the millions in fact. The problem was, it didn't look like our film.

On all the platforms in the United States, it was under "horror" rather than "suspense" or "thriller," or even "drama." It did mean that lots of people bought it, but as we discovered there can be a backlash. Some of

the people expecting a jump scare horror with plenty of blood were disappointed, and they tended to be very vocal on the internet; this was our introduction to the dark world of fake accounts and trolling of which we experienced our fair share during the US release of *The Isle*. Although it did work both ways and there were also lots of people who watched it who don't usually like "horror" (we're guessing they were made to watch it by a partner?!); some people were pleasantly surprised to discover that there isn't any blood and gore and loved it. They wrote lovely things about it and encouraged likeminded people to watch the film, so to those people we thank you!

We did get a load of press out of it all and the critics really got behind the movie, thankfully. It had been arranged that we would chat to a lot of the people reviewing it to talk about the process, and I think that helped as we could let them know what kind of film we were trying to make and counter some of the people shouting loudly about the lack of gore. As a filmmaker, I like to read reviews of people who have spent years watching thousands of films and learning to critique for a living, but we learned that the majority of people will more likely listen to the ordinary moviegoer. This is not us complaining at all; it in fact made us realize that for the United Kingdom we had to get certain areas of the public behind it before the film even came out, to go alongside the reviews. And in a way it does make sense: you're more likely to believe someone you know, or in this world of social media at least electronically know.

It's why on the whole print budgets have been reduced and companies are spending the money on digital advertising: they know that word of mouth via social media platforms has a far bigger impact than scores of costly adverts in papers and magazines, which people are less inclined to engage with these days. And on the whole, for our purposes of trying to get people to watch our movie, social media was a very valuable tool.

We're not being ungrateful about the US release of our tiny indie film; quite the opposite! We are hugely honored to have had our film in US

cinemas and that so many people came out to watch and enjoyed it. We just look at everything as learning moments to try and make things work better the next time around. We're still a little undecided on whether it pays off to package a film as something slightly different to what it actually is. It's a fine line perhaps between getting sales for your film and misleading your potential audience. What are the stakes of that and the ramifications? Maybe trusting in what you've made and believing that your film, albeit perhaps something that is slightly outside the genre box, will find its audience and an audience that will appreciate it. Is that more valuable than getting sucked into the imagined glory of cinema releases and driving sales to make money?

Anyway, let's get on with this learning we keep banging on about. How did we take what we'd figured out from the US release into our UK one? We kind of needed *The Isle* to have a half-decent life to be able to access the next level of our career; as much as we were very happy and proud of what *Two Down* did, the very loyal audience we found wasn't really big enough to do what we wanted, and we weren't sure how to capitalize on the film's success at the time.

"There's no point in making something that nobody ever sees. Doesn't help your investors, doesn't help you and your reputation and your career going forward. Films are hopefully designed for a cinema distribution but you have to realise with a smaller film you're going to have to have a more targeted release."

—*Gareth Jones*

Once the US release had happened, we started talking to our executive producer, Gareth Jones, who used to be in film sales as well as an entertainment law, and he'd recently set up his own distribution company. We started to hatch a plan to see if we could get the sales rights back from the finance company and work on the release ourselves. Although Gareth had been through this process before, we never had so we thought it was a

great way of finding out the nuts and bolts of what happens at this stage, partly so we could have more control over what happened with *The Isle* to make sure it wasn't just dumped on some online platform to be forgotten within a week, but also that next time around we may even be able to factor in certain things and put things in place before we've even started shooting. We also wanted to be in with people on this side and talk to distributors about what it is they're actually looking for, which would save everyone time in the long run. Instead of us slogging away on a script for years only to find out that a certain genre bubble has already burst, we can try and be ahead of it so we have various things prepped and ready to go.

Speaking to the sales team, they told us they'd had people inquire about the distribution rights in the United Kingdom but that they weren't happy with what they were offering, which was great news to us if not them. We drew a contract up with Gareth saying that we would endeavor to get between five and ten cinema screenings and then take it to home entertainment with Lionsgate and Elevation for video on demand and DVD, respectively. Obviously at this point we had no idea if we could actually make that happen, but at least now we knew that we would work harder than everyone else to give it a go.

IN CASE WE HAVEN'T MENTIONED IT, REMEMBER THE GOLDEN RULE: NO ONE WILL EVER WORK AS HARD FOR YOUR PROJECT AS YOU!

This point is very important for almost every part of what happened next. We were taken along to meet a cinema booker; they are exactly what they sound like: they shop your film around to cinemas to see who will take it and then arrange the dates and get the physical materials to them. We didn't want a huge cinema release partly because it was going to cost a fortune. There are various ways you can do a cinema release; a cinema chain will book it in for a week at first and you get a percentage, which is

quite rare for an indie film unless the director or actors are "names" and if it doesn't do well in the first weekend it will get pulled by the cinemas at the end of the week. You can "four wall" cinemas where you simply buy out a week or two's worth of screenings at various theatres, but this not only costs money in addition to what you then need to spend (an enormous amount) on print and advertising to make sure you fill those seats, which is a huge gamble for something like *The Isle* where people had already proven they didn't know what box to fit it into.

So, we decided to do what more and more UK indies are doing and go for a Q&A-led run. We've been to dozens of these type of screenings at indie cinemas as you get amazing directors chatting about how they got their film made. We arranged to meet this booker, which was very exciting for us as it was our first glimpse behind the curtain into how it all actually happened. He was very nice, and we got on well but very quickly we realized he hadn't seen the film, the trailer, or even knew what it was about. We'd created an interactive document which had the synopsis, info on the filmmakers and cast, links to reviews, the trailer, pictures, and the entire film, and he hadn't looked at any of it apart from the poster (the document comes in handy later so don't despair as we did at this point!).

Needless to say, we weren't hugely impressed and although he said he'd have a look at it, when we mentioned that we wanted to release in cinemas in May as we wanted the home entertainment to happen in July, he basically said it couldn't happen that quickly but maybe we could get one or two cinemas to agree.

At this point we'd like to refer you to the golden rule, which I believe we've mentioned once or twice?

We agreed to let him go away and watch the film as it would be him putting a plan together for which cinemas to approach and how. In the meantime, already feeling that this wasn't going to end well, we decided to send a few emails out to see who would be interested. Of course, we had an advantage as we knew what to sell the film as and also what not to sell

it as; we also targeted cinemas around the country which made sense for us to screen at, such as where we had some kind of audience base: family, places we went to school, areas we had filmed in.

Sure, we didn't give the booker guy much of a chance to go and see what could be done, but on the other hand we'd given him all the information two weeks before we met. After two weeks, we already had eight cinemas agreeing to take it on and were in discussions with others. We would be over the amount we had promised the salespeople, and as the weeks went on we added more as other cinemas heard how it was going and we could show them reviews as they came in.

Now, that might all sound fairly easy, and in a way it is—it's knowing your product and therefore knowing what to sell it as in an interesting way (without lying) when you're telling people about it—but it's a lot of work and we understand that if it's not your own project you might not be willing to spend twelve hours every day researching cinemas to see what kind of films they screen, then tracking down the best people to speak to and entering into a discussion to convince them to take your film on.

We knew when we'd start our Q&A tour, which meant we had dates to get things together. Bear in mind we were learning this as we went along and had to rely partly on guess work and partly on asking people more experienced than us what on earth we did next. The problem there, we discovered, is that everyone is making it up as they go along; there's no one way to do anything, which in a way is very freeing.

We now had a mixture of fun things to do, and some not so fun things. We had to organize getting the film rated with the British Board of Film Classification, which is the little age certificate that every film needs to have in the United Kingdom if you're showing it to a paying public. So, you book in a time slot after filling out various forms, then send the digital cinema package over for them to watch and judge. You can ask for a certain rating—not that you'll definitely get it—and then explain why you think it should be that rating.

Think carefully about this part. For *The Isle*, we wanted a fifteen as it said that it's a mature drama that has elements not for the eyes of children. Anything lower would have diminished the supernatural element suggesting it was for youngsters, and anything higher would have implied that there are elements like gore, strong violence, and nudity, of which there are none.

We got the certificate we wanted and got the digital cinema package copied with the ratings card at the beginning, with just enough time to be able to send out to all the cinemas. Digital cinema packages can be fairly pricey to get made so we had to work out the lowest amount we needed to get by. On that note we created a diary for the release, which had days of when the film and posters should be sent to where, and also when advertisements in papers and online campaigns should start for each screening.

Our public relations experiences were, shall we say, varied, but we'd learned by now that even if someone else is officially doing that job, no one will know your film like you; with limited budgets people will, and can, only do so much for your project. If you're not paying them very much, you won't be at the top of the pile because they'll have to be working on other things, which is fair enough. Having said that, we've heard plenty of stories from people who spent a lot of money on big public relations companies only to be hugely let down and end up doing the bulk of the work themselves.

A film, which shall remain nameless, had three hundred thousand pounds spent just on the print and advertising alone, and the movie's budget was about a million; they absolutely did not see that money well spent. Most of it was spent on a premiere, and this wasn't the kind of film that warranted one at all; it had a few minor names that some people would have heard of, but this was the public relations company thinking that if they threw all the money at one night, paying for television celebrities to go and be photographed, then their job would be done. The theory was that everyone would notice what was going on and decide to watch it when it came out. Not many people did.

> "Publicity, there are professional PR companies in film that will cost you a lot of money, they aren't necessarily suited to independent filmmakers unless you use them in a very limited way, but what I have found is that certain individuals that used to work at these companies and then go freelance, can be good, go by recommendation. Individuals rather than the companies tend to be cheaper and work harder. Publicity is an important factor, but with any aspect that you're dealing with ask around, ask other people who have made films like yours, or who's films you admire, people are very open to sharing their experiences. They might not share their finance contacts with you, but they might well share their experiences. . . . A negative assessment can save you a lot of time and heartache."
>
> —*Gareth Jones*

We spend a lot of our time in the film parts of social media, and we didn't see one advertisement for the movie, nor in any papers or magazines. So, it goes to show that it's not all about how many dollars you have: it's about putting the time in to work out where whatever money you do have should be spent. In fact, it's much like filmmaking in that sometimes if you don't have a big budget you have to think of clever ways around problems that money would normally solve.

Anyway, back to *The Isle*. In the United Kingdom, there's something called the Film Distributors' Association, which you have to inform if you want to be on their radar as they let film journalists and reviewers know about upcoming films. More importantly, if you want to have an official press screening you need to book it in with them so they'll spread the word. We didn't know about this and weren't informed by our press people that this was necessary until it was too late; when we tried to book, there were no slots left. We were moving pretty quickly at this point, so things do get missed, but it was another learning point for us, and therefore you!

We could still have a press screening, but the problem was that it would have been hard to let all the reviewers know, and more than likely they'd be at official ones, which they only attend on Mondays and Tuesdays.

Maybe we should have done one anyway, but you need to hire a nice screening space that they can get to easily and provide drinks and maybe snacks. If no one came, we would have lost quite a bit of money, so we decided not to have one, which meant it was now up to us to try and reach out individually and offer them online screeners to watch. There's nothing wrong with that, but you ideally want people reviewing it to see it on a big screen with good sound and no distractions, not on a tiny laptop with the dog barking at you.

So, with the first Q&A screening in London racing toward us, we organized a "talker" screening at a screening room in Soho, London. We invited people through social media—friendly faces and people we knew might tell their followers about the film's imminent release and gave them as many drinks as they could carry into the screening room. It was just to give us a little boost a couple of weeks before the release (and in theory one week before the official press screening), so we could start that word-of-mouth advertising.

With the previous films, we'd slowly been getting to know film press people and cultivating online relationships with them. On the whole, they don't mind you saying hi because they need films to talk about as much as you need them to talk about your film. Just be nice and don't pester too much! So we started to let press people know what was happening as we didn't have long before the release and needed to get people talking about it and reviewing it.

As our screenings were all across the United Kingdom, we also had to attack each area two weeks before and decided to take out advertisements in papers. We hadn't learned they're a bit of a waste of time at this point! We asked people at screenings where they'd heard about the film, and they all said social media. We also had interviews in the papers come out in the week leading up to the release and ran online advertisements.

We'd worked out that you can't just bombard people with "watch our film!" over and over for too long before they get bored. We mixed the

online campaign with pictures of the film, but also a lot of behind-the-scenes photos, which gave our soon-to-be audience an insight into what went into making the movie. People love seeing behind the curtain, as long as what's behind is fun. This is an important thing to remember when on set: take lots of behind-the-scenes shots and stills of the scenes. This doesn't mean a load of pictures of your cast and crew hanging out and drinking beer. As lovely as that is for you to look back on, make sure the stills are interesting to an outsider and show people working!

We also got in touch with people in whichever area we were going to next via social media who listed themselves as film fans: we said hello and let them know about the film. Most people responded and if they couldn't make it, they were happy to let people know about the event. It took a long time to do this, and it felt as if we were never off our laptops—well, we weren't—but it paid off and word spread and then more people were asking to see the film. It's another reason to have a selected cinema release rather than four-wall: to build expectation and hype and make people want to search it out like it's a rare commodity.

We also ran online competitions for tickets for each screening, getting people to retweet or share the competition to enter, meaning the word spread again. When we arrived in the next city, we'd take photos of us next to the poster in the cinema and us at local attractions, anything to create some buzz and show that the filmmakers and actors would be there for the audience to come and talk to after the screening, which people get very excited about. There's just something that happens to people when they've just seen a film with an actor and then they get to talk to them, which is why it's so important to try and get actors along to the Q&As. You'll have to arrange and pay for travel and accommodation, but them being there could make all the difference in ticket sales.

After all this work and managing to get lots of great reviews, Gareth used it all to show Lionsgate that there was indeed an audience for our

movie and that they liked it. It's great to have your film shown in cinemas, but at the end of the day you can sort of look at it like a huge advertising campaign for when it comes out on home entertainment, which is when you can really get people watching it. And all those people who couldn't get to see it on the big screen but heard about it through months of online adverts and people saying nice things will mean they'll go and seek it out when it finally arrives on video on demand and DVD.

We still worked really hard with social media campaigns for the video on-demand and DVD releases, letting people know when it was coming out, but a lot of the groundwork was done with the theatrical release. We had a following of people who had seen our low-budget indie film already at the cinema and they were shouting about it, which as we know is far more effective than us doing it. We had messages from people we knew in other countries saying they'd seen people talking about it on social media, so we knew the months of hard work had done the job. The fact that it's an indie film with a modest budget made it seem like it had come out of nowhere, and people felt like they'd discovered something. This in turn gave our audience a certain sense of ownership of the film and a desire to protect and promote it.

YOU NEED MORE THAN YOUR MOTHER TO KNOW WHO YOU ARE!

I think you've got that we're fully on the pro–social media wagon as one of the best ways to promote your film, but it took a while for us to understand how important it is, not just for your film but also for you as a filmmaker. Self-promotion may feel icky to you, but you need to build up that network of people you'll work with, people who will support you in whatever way, as well as your audience.

If this seems obvious, we apologize, but we also know filmmakers and actors who are still dead against it, and that's just a shame as it's not just helpful for when you have a project you need to tell people about. It's very

important to have you out there in the film world, most of which takes place in dark rooms often by yourself, so you need to stay connected to what's happening.

On that note, there are so many networking opportunities that you can find out about through social media (yes, we hate networking too; even as trained actors the idea of being in a room and walking up to strangers filled us with dread for years). It's usually the only way a lot of people advertise these networking things because it's free and they can connect to hundreds of people in a second.

We got better at this part of it, and the more projects you've done the easier it is to have something to talk about, but as you go off to festivals with your film, a great place to network, it's good to get as much practice in as you can as you never know who might be in the room and looking to distribute a film just like yours. When we started out, we somehow kept being invited to amazing things at places like Cannes, but we mostly stood in the corner drinking gin hoping we could slip away quietly, as soon as possible; this was ridiculously British of us, but there we go.

You'll know now that the entire point of this book is to help you be more self-sufficient no matter what part of the industry you're in, and that means being your own public relations company too.

It takes time to build your network because without a network none of us would survive the indie world, at least not for long, so it means supporting other people's projects too and helping by being their public relations company sometimes. Then, when the time comes, they'll do the same for you.

You may get asked to be on panels, which is a tremendous way of connecting and growing your network. Just going to them and watching is invaluable, and most end with some sort of drinks bash afterward to chat to the panelists and find new people with whom to connect. If we're on panels, as people switch off pretty quickly if what you're saying is too dry, we try to be a mixture of interesting and funny (with varying degrees of

success I'm sure!) and we try to be approachable and down to earth. That's not something we were able to do straight away though, we practiced and prepped for each one including researching who else was on the panel, who was asking the questions so we could be interested as well as interesting, and got better the more we did.

You get the idea here: in this world of diminishing budgets and lack of time in an overcrowded market, you need to be more than just an excellent filmmaker—you need to be an equally amazing salesperson, of yourself and your film. You might not like it at first but the more you do—especially when you see the results from your hard work—you'll start to enjoy it. Promise.

Here are the most important things you're going to need, for whatever film you're promoting and yourself:

Social Media—What a surprise, at the top of our list is social media. Get yourself on all the current platforms (we're aware that in the coming years these will change as things always do).

> *Facebook* is good for connecting to friends and family to tell them about projects and screenings. You can also add specific pages for each of your films and get people to follow them, but more importantly it's where you run advertisements from. You can boost posts and then select exactly where you want the ads to run, who sees it by selecting what their interests are, how long it runs, and how much you want to spend. Once you get the hang of it, which won't take long, it's an amazing way of getting thousands of people to see when you have screenings or when films are coming out, and you can run several at the same time, targeting different areas, and they won't cross over.
>
> *Instagram* runs in the same way as it's owned by Facebook, which does make things a lot easier as it's all the same kind of settings.

I'd recommend tailoring each one to the different platform though (they do give you an option to run the same on both), but with Instagram you get to add all your lovely hashtags that will quickly let people who like your kind of film find it. And think about these hashtags to try and bring some of your, or the film's, brand into it. You should also adapt for different screenings in different areas of course, such as #Seattle or #London, and find other hashtags that people in the area use for film-related things. Of course, Instagram is visual based, but then so is film, so you'll need lots of pictures at the ready including publicity shots, screenshots, and behind the scenes to add into the mix. Or if it's just for yourself, a mixture of work and things that show your personality and interests, but you don't need to reveal your private life and favorite food if that's not your thing!

Twitter, or "Film Twitter" as our section of it is called, is vast. We honestly find it a bit strange when people in the film world aren't on it. It may not be around forever but at the moment it's the place that filmmakers, writers, reviewers, and journalists spend a lot of time, so you have to be a part of it. It's a fantastic way of connecting with an audience but also the industry. Half the people who reviewed *The Isle* were in our network on Twitter, and we just reached out to them when we knew things were beginning to happen in the United Kingdom and let them know what was going on. Within minutes (because Film Twitter never sleeps!), we would have people asking for screeners to watch the film. We always add a picture to a Tweet as you get so many more responses and you can add all your thought-out hashtags, links to screenings, where you can buy it—all the fun stuff. Advertisements can be expensive on Twitter, unfortunately, and we often only do a day's worth on special occasions because you put a budget in and

it's dependent on clicks not days, so what we'd spend in a week on Instagram could go in a day on Twitter.

A **website** is such a good way of having all the information about your film in one place and makes it very easy to find when people, cinemas, festivals, and journalists, search for it. Keep it fairly simple and with the same branding as your other artwork so it all ties in. On *The Isle*'s site, we just have a homepage with an image from the film, the title, the tag line, and a line from a review saying how good it is.

Then we have a page to the synopsis, one to links of reviews (again with one eye-catching line above it from each), where you can watch it (be that screenings at festivals, cinemas, or when it's on video on demand and television), and contact details. In the United States, people have a page that will show the press kit, which we'll get to, with a button to download it. We had one when we were doing the rounds with the film, and it's a good way for journalists to have all the information so they have all the names, pictures, and story in front of them in one place. You can also link your social media (sorry, mentioned it again), so you get more traffic there too.

We'd also say have one for yourself whatever you do in the industry. It's all about visibility and making yourself searchable as quickly as possible, and then having all your work in one place. Anything to make other people's lives easier!

Press kits are needed for festivals and the public relations part of when your film is being distributed. You need a nice strong title page with a cool image that shows off your film with the title and maybe contact info.

Then you need a page with your logline, which is the whole narrative boiled down to one or maybe two lines, and the synopsis. At this stage try and keep it concise to a couple of pages at most; this is for busy

festival people and journalists, and you want to make their life easy so they're more likely to be on your side.

Then a page with the director's biography and a statement from them about the film. Keep it interesting and entertaining as it may be used in print somewhere; it's like they've interviewed you without having to do anything.

Next are brief bios of your key personnel, producer, writer, DOP, composer, and any of the team who might have done other interesting things or won some good awards.

Like with the website, have links to reviews and articles with quotes to show the kind of thing it is. It's all about selling at this point.

Some people put the whole list of credits on here too, and it can't hurt—the idea is so the journalists don't make any spelling mistakes, but we also try and reduce the amount of words if possible as people don't like reading masses of text in these situations, so it's up to you.

We like to scatter photos across the press kit to give a vibe of the film, but public relations people often don't, so again go with what you feel. We do have a link to a Dropbox file that has a stack of photos that they can download and add to sites or articles. On that note, **publicity shots and production stills** are needed: most papers and magazines want official high-resolution photographs.

IMDB (the internet movie database), started by film fans in England as a way of keeping a track of their favorite actors and filmmakers, is the world's biggest source of all things film and the first place any of us in the industry will go when a project or person is mentioned in a conversation. When your project is eligible, it's been accepted to festivals, or has distribution, you can add it to the database along with all the info, trailers, photos, and awards. Then you must remember to keep it up to date as things change and progress. You can only submit

things to IMDB; you can't just change it yourself even if it's your own film, so you have to have a little patience as the team at IMDB check everything and then update it.

Actually, and this is not an advertisement(!), it's very handy to pay for IMDB Pro as it lets you access information about upcoming projects that haven't even been announced, details of who is working on them, and often contact details.

Screeners are either links or physical copies of the whole film that you have to send out into the industry. This is how festivals will watch it and later how people will more likely review it unless you can pack out your press screening. Most will be online, so you'll need a secure link on something like Vimeo or YouTube where the person needs a password, for example. This way you can change the password after a certain time too, in case it starts to get passed around.

On that note, it's good to have a Vimeo channel to keep all your trailers and films together so you can easily bash out links, and do the same on YouTube too, especially with trailers, as some review sites may work with one platform but not the other.

A **press release** is handy for festivals and for public relations for the release too, or even if not you could hand it to the public relations people who might tinker with it, but again you'd have some control about what's going out.

They're nice and simple and just need to give a little bit about what the film is, who they should contact for more information, and what's happening with it: festival premieres, cinema distribution, whatever you'd like the journalists to know. Then who the filmmakers are, briefly what they've done, and likewise with the cast and a few of the crew, especially if they've done interesting and well-known things. We'll stick the one for *Infinitum: Subejct Unknown* here so you can have a look.

Blue Finch Films signs

Infinitum: Subject Unknown (completed)

Infinitum: Subject Unknown is a sci-fi feature film from Fizz and Ginger Films, the duo behind *The Isle* and *Two Down*. Written and starring **Tori Butler-Hart** and featuring **Ian McKellen** and **Conleth Hill** (*Game of Thrones*), the film is co-written and directed by **Matthew Butler-Hart**.

Blue Finch Films had been following the film's progress since shooting began in the lockdown and have now signed a distribution deal for the United Kingdom, Ireland, Australia, and New Zealand.

At the beginning of the coronavirus lockdown, Matthew and Tori decided to try something they've been thinking about for a while, although it is ended up being somewhat more extreme than they were imagining. This is a feature film shot with just the **two of them on set** and the crew working remotely, footage being sent to the editor, VFX artist, and colourist at the end of each day to make sure everything was going to plan.

Infinitum: Subject Unknown is in a way an introduction to a larger world which appears in the feature script INFINITUM, which is now also being turned into a TV pilot for the United States and a graphic novel.

Synopsis

The film follows Jane (Tori Butler-Hart) who wakes up in a strange attic, in a parallel world, with seemingly no way out. We soon realize that she is stuck in a time-loop, destined to relive the same day over and over with little memory of her doing it before. But with each "reset" she starts to remember more and begins to piece together what may be happening to her, with clues pointing to a Professor Aaron Ostergaard (Conleth Hill) and Dr. Charles Marland-White (Ian McKellen).

As she makes her way to the mysterious Wytness Quantum Research Centre to find a way to stop it, she begins to get glimpses into other worlds and other versions of herself. But each time she seems to be getting closer to an answer, she is immediately reset back to the attic she fears, to once more start her journey to learn the truth.

As she travels from the city to the hidden research centre, she sees that the world is entirely empty. There is evidence that life was once here,

houses, cars, and zeppelins hovering above, but everything is boarded up and abandoned. At night, however, Jane sees torches and helicopters in the distance and discovers that soldiers are searching for her, adding to her desperation to get to the research center and look for answers that might send her home.

Once inside the center, the laws of time become erratic and Jane sees glimpses of people who are clearly living in another world, but whose actions are having an influence on the one she is trapped in, and those effects are growing worse with every reset.

Notes to Editors

Director/Writer Matthew Butler-Hart and Producer/Writer Tori Butler-Hart

Director Matthew Butler-Hart and Actress/Producer Tori Butler-Hart set up **Fizz and Ginger Films** in 2009 and together they write and produce independent films. Their second theatrical feature, **Two Down**, won awards around the globe before a limited theatrical run in the United Kingdom, and was executive produced by Stephen Fry and Sir Derek Jacobi. **The Isle** was released theatrically in the United States and the United Kingdom, and is still being released around the world. It stars Conelth Hill, Alex Hassell (Netflix's upcoming **Cowboy Bebop**), and Tori Butler-Hart.

Fizz and Ginger Films were Screen International "Stars of Tomorrow" in 2013 (along with HOST's Rob Savage), and **The Isle** was released in 2019, on VOD and DVD by Lionsgate. They have recently been commissioned to write a book for US publisher Applause on independent filmmaking.

Cast

Tori Butler-Hart (*Jane*) As well as being an actress, Tori co-runs Fizz and Ginger Films and is a writer and producer in the United Kingdom and United States. **Film and television credits include** *The Isle, Two Down, Edie, Keeping Rosy, Miss in Her Teens, The Tales of Hoffman, Doctors,* and *Home Again.*

Ian McKellen (Dr Charles Marland-White) Ian has been in the industry for decades and is a legend of both theatre and film. He is best

known for playing Gandalf in *The Lord of The Rings* and *The Hobbit* trilogies, and Magneto in the X-Men franchise.

Conleth Hill (*Professor Aaron Ostergaard*) Conleth has worked for many years in theatre both in England and his hometown of Belfast and is best known as Lord Varys in *Game of Thrones*. **Film credits include** *The Isle, Two Down, Shooting for Socrates, Keith Lemon: The Film, Salmon Fishing in the Yemen, Perrier's Bounty,* and *Whatever Works*. **Television credits include** *Game of Thrones, Dublin Murders, Vienna Blood, Suits, Inside No.9,* and *The Life and Times of Vivienne Vyle*.

Contact:

Put the details of either the public relations people you're working with, or the sales or distribution company.

And finally, **business cards** are essential for all your networking and meetings. At Cannes when you're in a meeting that you've booked weeks in advance, the first thing anyone does is exchange business cards. You should have lots with you at all times. We've also found it helpful to have at least some white space somewhere as we write down where we've met someone and why we met them to remind us further down the line.

"You don't do what you do to become rich, I didn't become an actor to become rich. Always the work."

—Ian McKellen

Glossary

WHO YOU'LL MEET ON SET

Depending on the level of the project you're working on, the crew number will vary considerably, but this is your basic breakdown of who you'll meet, who you need to know, and what they all do.

Director On a film, the director is the holder of the vision of what the final thing will look and feel like. All departments work closely with them to make sure they're all on track to deliver the vision. On a television show, they may have a lot less control, the vision usually being the producer's, and the director is there to serve that vision and to get the performances out of the actors.

First Assistant Director The first AD runs the set. They are the link between the director and the camera team. You can think of them as the director's righthand person; usually the director will be working with the actors, rehearsing and blocking things, meanwhile the first AD is keeping things running with the crew and making sure that the shoot is running to schedule; after all, they're the ones that put the shooting schedule together.

On a Ron Howard film, for example, the first AD might be the person who gives the actors the director's notes.

Second Assistant Director Next is the second AD. They work very closely with the first AD, and in constant radio contact usually. Most of the time the second AD is in the production office sorting out the call sheet for the next day of filming and arranging all logistics concerning actors.

The second AD is one of the crew members that actors will probably see the most as they are in charge of traveling the talent to costume, makeup, and then to set, although on larger projects it might be the third as well.

Third Assistant Director The third AD will either be assisting the second AD with actors arriving to and from set, and looking after actors when they're waiting to be called to set, or they work closely with the first AD on set and will be the point of call for actors to ask any questions when on set.

Runners and Floor Runners Floor runners remain on set and will help lock down the location, keep people quiet when shooting is happening, and assist the third AD. Runners are the other people that are quite literally running all over the place; they could be focused more on the production team or the camera or lighting teams. The teams like to keep their own runners to themselves so it's always best to know who "belongs" to which team so as not to step on toes when you need a favor!

Director of Photography This is the person in charge of the camera team working closely with the director to achieve the desired shots and look of the piece. They may be the person operating the camera as well, but often they will have a camera operator to do that. As they're in charge of the look they work closely with the gaffer, who uses the lighting to create what the DOP is wanting to tell the story.

Focus Puller/First Assistant Camera, Second First Assistant Camera, and Clapper Loader This is your core camera person that works with the DOP and camera operator. Your first assistant camera is usually the focus puller; this person may be glued to the side of the camera, constantly pulling the shot into focus as the camera moves, but often they now use remote follow focus, which means that the focus puller can sit anywhere in front of their own small monitor.

The second assistant camera will assist the DOP, camera operator, and first assistant camera with the lenses and assembling equipment. The clapper loader takes camera notes and keeps track of all the takes and shots with the clapper board, placing it in front of the camera each take, and "dropping the sticks" of the board, which will help connect the sound to the picture in edit.

Grip The grip team are the people who do a lot of the heavy lifting. On a small budget, this can be setting up a track and dolly for the camera to run along when getting smooth long shots, or on bigger budgets might mean large jibs or cranes used to shoot through upper story windows.

Lighting: Gaffer and Sparks The lighting team consists of a gaffer, who heads up the team and works with the DOP to create the correct lighting for the mood or set of the scene. They have a number of sparks who work with them to help set up or change the lighting rig. This might not mean using actual lights all the time. When filming outside, they will often be the people setting up a "bounce board" (white or black polystyrene) or holding a reflector to shift more light onto actors.

Sound Recordist and Boom Operator Quite often forgotten because they tend to be very quiet, the sound team will be the ones who mic the actors up. They will want to conceal a mic pack somewhere in the costume, usually clipped onto a waistband or in an elasticated sound

belt. The mic wire then feeds up to the microphone which will usually be taped to the actor's chest.

The boom operator is the person who stands with their arms in the air holding a long pole.

Sound might ask for a *wild track* of the scene; this will mean you stand around the mic and run the scene with all your lines, as you've just played them, but without any movement. This can be handy when you get to the post-production side as it can save time and money to reduce your time doing automated dialogue replacement.

They might also call for quiet and record *room tone*, which means you just stand very still and quiet for a minute! This will be laid under the whole scene to make the room seem alive and can also hide any odd changes in the feel of the sound when you're cutting from different shots.

Production: Producers, Line Producer, Production Manager, and Location Manager The producers have put everyone together and found the money to make the project. They get a say in pretty much every aspect of the production from pre-production all the way through to the movie's release.

There's a whole team hidden away managing all aspects of the production. These include the following:

Line Producer—They work closely with the producers and find the crew heads of department. They also put together the budget and make sure that the right amount is spent on every item listed on the budget.

Production Coordinator and Manager—They work in the pre-production stage to plan and book all aspects of a production be it caterers, filming permits, and utilities, and they oversee the day-to-day running of the project with assistants to help them.

Location Manager—They find all the locations that will be used during the filming and will make sure that everything is working when the shoot is taking place.

Production Designer, Art Director, Set Dresser, and Props The production designer works closely with the director and DOP from the beginning. They head up the design team and work with the costume designer and makeup designer to create a unified vision for the project. The art director will be on set to make sure this vision is carried out, and the set dressers and prop departments help make that happen. This department can have any number of people, including carpenters and painters involved in building the sets.

Makeup Designer, Artist, and Assistants Often some of the most fun, and most eccentric, people on set, the designer is in charge of the look of all the actors and they work closely with the director and DOP. On an indie project, they most likely will also be the makeup artist, the person actually applying the makeup, but on a bigger project they design all the looks and oversee the work of the artists and assistants. The artists and assistants will keep track of the continuity of how the actors look throughout the film, which is no easy task.

Costume Designer, Assistants, and Dressers Often also part of the lovely and eccentric side of the team, the designer again works with the director and DOP to help create the look of the world you're all creating. The team might be creating original costumes to be handmade for the actors from scratch, or sourcing costumes from one of the massive costumiers (e.g., Angels). Actors may have a dresser assigned to them, again to ensure continuity of look throughout a project.

Clients If you're working on a commercial, you will probably have the clients and public relations teams sitting in on the shoot. They are usually

from a non-creative background but will often want to give notes. These can seem completely inappropriate and unachievable, partly because they're not filmakers and don't know how it works so you just have to smile and do your best. They're paying you so you'll have to accept this way of working as fast as you can!

TERMS AND PHRASES YOU MAY HEAR

Automated Dialogue Replacement (ADR)/Looping During post-production, some of the dialogue lines that were recorded on set might not be good enough quality for the final film, or the director might decide that they want to change the actor's performance slightly by altering the intonation of a line. The actors come to a sound studio and stand in front of a screen playing the scene and have to lip-sync to their original performance.

Back to One or Firsts This is a request for actors and crew to reset to their first position at the top of the shot.

Banana An actor may be asked to walk in a "banana"/curve toward or away from the camera.

Base (Unit Base) This is where you'll find the green room, trailer (Winnebago), honey wagon (porta loos), and production offices.

Billing This refers to the order that actors are listed on the billboard (e.g., the credits and poster). Agents fight very hard for top billing (being listed first) or having an "and"!

Call Sheet This is what is usually sent out the night before, to tell everyone what time they have to be on set the following day. It includes contact details of heads of department, locations, scenes that will be shot, actors make-up and costume call times, and what time each team will be required on set. See figure 25 for an example and learn how to read one!

Cheat You might have to ask an actor to cheat their position or distance from another actor or piece of set when they change lens or shot. To an actor this may feel weird and unnatural, but through the eye of the camera it will read correctly.

You might also have to ask them to cheat their eyeline toward the camera, often when moving in for close-ups. This might mean they end up directing their performance toward the camera operator's shoulder, or they might put a bright tape cross on the edge of the camera for you to look at.

Extreme Close-up This shot is just of an actor's face or eyes.

Clean and Dirty A clean shot means that there is just the actor in focus on the screen. A dirty shot would involve another actor stepping into frame so just their shoulder or head can be seen in the foreground.

Closed Set If you're doing a scene of a sexual nature or that requires nudity you should be working in a closed set. This will mean only skeletal crew and the director are present in the set.

Continuity This can include a script supervisor or continuity person. They will be following the actor's lines and action and let them know if they've done something different each take, or if they're saying the wrong line!

This also refers to an actor's performance continuity. It is up to the actor to keep a track of what they're doing with their props in a scene. Keeping actions with food or props similar each take will help the editor enormously. Poor continuity may result in having to cut some good moments.

Craft Services This is the snack bar; you can ask a runner or third AD for anything from craft if you need a little coffee or Jaffa cake to keep your energy up, which you're going to need!

Day Out of Days This is something that tells the actor what days they're needed ahead of starting the project. Of course, it might change during the shoot, but on the whole it shouldn't. Known as a DOOD.

Day for Night This would be listed in the call sheet and means that you will be shooting during the day but that it will be made to look like night, so avoiding a night shoot.

Flipping or Swinging the Lens This means they're changing the lens, which means there will be a small lull of action on set, but not enough time to grab that next coffee.

Flying in or Traveling This refers to actors being brought to set (can also be used for a piece of equipment or set, so acts as a warning to be careful).

Golden Hour or Magic Hour This is the time of day when the light is quickly fading or sun is coming up. Because the light is changing so rapidly it only allows a small amount of time to shoot in. You will be required to work quickly and be on point.

Hero This refers to a prop or car usually. Often used in advertisements for the starring item that is being advertised, the "hero" prop.

Insert This is a close up shot usually of some action (i.e., dialing a number).

Final Touches This is when makeup and costume will check actors for last minute touch-ups before you shoot. Don't go anywhere.

Make the Day If an AD tells you they won't be "making the day," it means they've run out of time and will be picking up the missing shots/scenes tomorrow (or when schedule allows).

Mark (and Sausage) After a scene is blocked, marks (usually tape) are put down in various places in the scene to let the focus puller know where the actor will be at a certain point in the scene. If they don't hit their mark, they'll be out of focus.

If they can't find their mark during the scene, the camera team might give them a small bean bag that you can feel with your feet when you hit it. Looks a bit like a sausage.

Martini (not used very often) The last shot of the day.

Master Shot It's the entire scene with all the actors from beginning to end.

Medium Shot A shot roughly from the belt line up. This can be of single or multiple actors.

Most Favored Nations This is a clause in your contract that means that anything it refers to is at the same level or equal to all other cast or crew (e.g., "Solo accommodation with en suite bathroom and travel to and from set in shared car on MFN basis").

Moving On Seems self-explanatory (it means end of scene), but people sometimes think it means another shot, etc.

Keep Warm When filming outside or somewhere cold, a costume person will (or should) rush up to the actor with a large warm coat, sometimes known as keep warms. They're nice like that.

Hotties Again, the costume people might ask if you want hotties, which are hand warmers, which you can also stick in your shoes, pockets, etc.

One-er This is one continuous shot. Unlike the master, this is probably going to be how the whole scene will be seen, no editing, and maybe will follow you around. So, if a mistake is made by anyone you'll have to go back to firsts.

Open Up The director, camera people, or AD might ask the actor to open up a bit more. They want the actor to turn toward the camera a bit more.

Over the Shoulder This is pretty simple. The camera will be shooting over the shoulder of one actor to the other actor, and vice versa. Remind the actors to stay alive when this happens, but to also be aware of when they might mask the other actor.

Overlap This request will probably come from sound. In a scene with more than one actor with dialogue, sound will want to have a "clean" take of everyone's dialogue. In a wide, you're alright to overlap lines slightly, especially if it is stipulated in the script that people are talking over one another. But on close-ups, they should ask for no overlaps as these will be added back in during the edit.

Pan This is when the camera is stationary but rotates from one side of the frame to the other.

Pick-up This is an instruction usually from the director or DOP. It could be because they want to get a certain line or reaction again, or there was a technical problem and they need to recapture a section without having to shoot the whole scene again.

Rushes or Dailies This is all the footage that was shot during the day. On larger projects, the executive producers may ask to be sent the dailies to review, but the director and DOP may sit down at the end of the day and review them as well. It's a way of checking if everything was obtained or if anything needs to be picked up. Some actors ask if they can sit in on the dailies and view their performance; it's a good way of keeping track of their character arc, but some directors don't like actors to watch them. We personally think if an actor has a better understanding of what is coming across and what isn't, it can only help.

Second Unit Found on larger projects, the second unit will have a different second unit director, DOP, and crew. They work on other elements that don't necessarily need the main director and leading actors. It could be action sequences, green screen effects, or locations far from the main shoot base.

Single/Two Shot A single shot is with on one actor in the frame, though not necessarily a close-up. A two shot is with two actors in the same shot!

Slate On the clapper board, each scene, shot, and takes are recorded. These are called slates.

Stand-ins This is someone who stands-in for the actors while the camera and lighting teams are setting up. On larger projects, they may well be asked to read in some lines and block out the movement of the scene and even shoot sequences where the face can't be seen. They'll be a similar height and size to the actual actor. On most lower-budget productions, a runner or even the actors themselves might be asked to stand-in to be lit.

Talent A term for actors.

Treatment and Synopsis A treatment is exactly what happens in the script, like a review without critical analysis; it's mainly used by producers to grab the attention and interest of potential investors or cast. A synopsis is a much shorter version of just the key points of the script.

Turn-over A term sometimes called by the camera operator and sound recordist just before "action" is called. It means that both camera and sound are recording.

Turn-around This is the time between end-of-day wrap and next day call time. In the United Kingdom, you have to legally have an eleven-hour turn-around.

Turning Around/Crossing the Line This is when the camera physically turns around to shoot the other side or other actors, and this is often when the question of "crossing the line" comes up.

Crossing the line is when actors' eyelines opposite each other or sitting around a table don't match up. It looks like someone's looking one way and the person opposite them is looking a completely different way.

Video Village This refers to the chairs set up around the monitors. This will include the director, any producers, script supervisor, costume, makeup, clients, etc.

"Watch Your Back" Crew say it all the time on set, and it basically means they're coming through, probably carrying something heavy, and they need you to please move out the way.

"That's a Wrap" Called at the end of the shoot day, usually by the AD or an actor can be "wrapped" before the end of the day. The AD will say "you're wrapped for the day" or "that's a wrap on Jane," which means you've finished filming on that project.

That is indeed a wrap from us. We really hope this book helps and lets you see that as a filmmaker you have so much more power over what you do and how you do it if you're prepared to put the work in. We can't wait to see your stories!

Index

A
A.D.R., 254
Adams, Steven, 32, 57, 60, 64, 75, 82, 90
AFM—American Film Market, 217
A Will and No Will (Play), 11
Agents, 4, 7, 15, 61, 104, 112, 113, 151, 195, 254
Akinade, Fisayo, *114*, 164
Alderslade, Andy, 146
Alderson, Giles, 9, 82, 83, 84, 121, 150, 151, 156, 168, 177, 211
Amazon, 4, 219, 222, 223, 228
Anderson, Gillian, 26
Angel Investors, 91
Annie Hall, 171–172
Art Director, 100, 108, 137, 253
ASCAP, 196
Assistant Director, 65

1st, 249
2nd, 250
3rd, 250
Audio Stems, 187
Austen, Jane, 24

B
BAFTA, 2, 21, 216
BBC, 81, 95
Bell, Kirsty, 57, 99, 185
Bettany, Paul, 14
BFI London Film Festival, 32, 56, 72, 74, 79–81, 92, 94–95, 206
Bible, 102
The Big Sleep, 18
Billing Block, 194–195
Blade Runner, 5, 171–172
Blog Off, 204
Blue Finch Distribution, 154, 246,

Booker, Christopher, 25
 The Seven Basic Plots: Why We Tell Stories, 25
Boom Operator, 251–252
Breathless (feature film), 17
Bright Young Things (film), 39
British Board of Film Classification, 196, 235
Butler, Graham, *19*, 51, *114*

C
Callow, Simon, 223
Call Sheet, 125, 126, *127*, 254
Campbell-Moore, Stephen, 115
CAN—Casting Advice Notice, 113
Cannes Film Festival, 17, 202–204, 206, 217, 220, 240, 247
Catering, 116
Chain of Title, 105, 185, 194, 197
Chapman, Mike, 154, 201, 219, 222
Chiaroscuro, 19
Cibber, Colley, 11
Cinematographer, 63, 100, 169
Claude et Claudette, 17, 20, 204
Closed Captions, 186
Color-correcting, 181
Composer, 100, 175, 179, 190, 196, 244
The Conjuring, 229
The Conversation, 142, 148
Coppola, Francis Ford, 142
Costume Designer, 100, 108, 110, 111, 112, 253

Cottle, Matthew, 143
Craft, 134, 255
Creative Scotland, 56, 80
Crowd Funding, 82, 90
Culture Test, 76
The Curse of The Buxom Strumpet, 16, 25, 27, 50

D
Dailies, 156, 258
Dane, Chris, 83
D.C.P.,–Digital Camera Package, 186
Deliverables, 58, 105, 184–185
Devereux, Louis, 45, 107, 173, 206, 208
Digital Stills, 187
Directors Agreement, 194
DOOD—Day out of Days, 66, 69–70, 72, 255
DOP, 100–101, 108, 112, 119, 120, 121, 122, 146, 157, 159, 244, 250
Double Indemnity, 18
Dropbox, 102, 112, 244
Dune, 5

E
Editor, 100, 101, 172
E'gad Zombies, 11, *14*, 223
Eilean Shona, 45, 156,
E.I.S.—Enterprise Investment Scheme, 75, 87–88
eOne, 15, 205

E.P.K.,–Electronic Press Kit, 186
Equity, 102
Errors and Omissions, 105, 197
Eyre, Richard, 46

F
Facebook, 241
Film Cymru Wales, 81
Film London, 33, 212
Film London Microwave, 81
Film Noir, 18
Film Socialism (feature film), 17
Fizz and Ginger Films, 1, *14*, 16, 102, 201, *210–211*, 213
F.D.A.—Film Distributors' Association, 236
Foley, 175, 177–178, 187
Ford Foundation, 75
French New Wave, 17–18
Fry, Stephen, 34, 39, 47, 62, 91, 93, 116, 130, 137, 152, 167, 169, 172, 176

G
Gaffer, 250–251
Game of Thrones, 99, 143, 164
GAP Finance, 56, 74, 88
Garrick, David, 11, 42–43
Godard, Jean-Luc, 17
The Godfather, 47
Godwin, Gini, 144
Goldfinch, 57, 75
Gorilla, 65

Grading, 181–184, *183*, 187
Great Point Media, 56, 92, 99, 213
Grip, 251

H
Hackman, Gene, 142, 148
Hanks, Tom, 13
Hart, Chris, *118*
Hart, Wendy, 135
Hassell, Alex, 50, 99, *108*, 143, 164, *189*
Hill, Conleth, 50, *52*, 99, 144, 162, *163*
Hitchcock, Alfred, 134
H.M.R.C., 76–77, 88
Honeyball, Ben, 142
Honeyball, William, 172
Howard, Ron, 13, 250
Hulu, 228
The Humpersnatch Case, 18, 19, 204

I
IMDB, 15, 218, 244–245
Inducement Letter, 194
Ingenious (Production House), 15
Insidious, 229
Instagram, 241–243
Insurance, 104–105, 128
Investor Pack, 91
The Isle, *107*, 31, 35, 38, 40, 83, 99, 107, 120, 147, *149*, 152, 153, *155*, 158, 159, *163–165, 168,*

185–186, 190, 196, 213–214,
227–236, 242–243;
artwork, 190, *191–193*
budget, 92
casting, *115*
catering, 117, *118*
costume, 110–111
location, 45, *46*, 52, 156, *161*
music, 179–180
post-production, 178, *182*
production design, 108, *109*
iTunes, 154, 219, 222, 228

J
Jackson, Peter, 150, 199
Jacobi, Sir Derek, 91
Jeeves and Wooster, 16
Jones, Gareth, 16, 49, 58, 64, 77, 79,
87, 91–92, 190, 218–219, 231,
236,
Jules and Jim (film), 17

K
Kane, Tom, 179
Key Artwork, 190
Khaou, Hong, 33, 60, 62, 95, 138,
171
King, Emma, 50, *114, 188*

L
Lang, Fritz, 19
Lee, Ben, 20

Lilting (film), 33, 60, 81, 95
Line Producer, 58, 65, 137–138, 252
Lionsgate, 15, 24, 232, 238
Location Manager, 125, 128, 147,
252–253,
Lock, Stock and Two Smoking Barrels,
16, 91
Love's Last Shift, 11

M
M (film), 19
Macara, Laura, 92
Macklin, Charles, 11
Makeup Designer, 100, 108, 253
The Maltese Falcon, 18
MANDY (Casting Database), 9
Manzie, Nick, 24
Marvel, 219
Matheson, Margaret, 15, 21, 63, 80,
94–95
McCracken, Cameron, 15
McKellen, Sir Ian, 8, 12–14, 25, 43,
47, 52, 62, 97, 103, 134, 150,
155, 158, 199, 202, 223, 248
McKenzie, Phil, 61, 75, 78, 90, 95
Minimum Guarantee, 74
Miss in Her Teens, 11, 42, 43, *44, 45*,
91, 119, 120, 135, *136*, 138,
139, 140–142, 147–148, 205,
223–225;
artwork, *188*
budget, 90

INDEX

catering, 116–118
costume, 110, *111*
location, 52
post-production, 176–177
Montague, Felicity, 142, *143*
Movement Order, 126
Movie Magic, 65
MPAA, 196

N
Netflix, 4, 77

O
Oldman, Gary, 6
Omoshaybi, Aki, 22, 95, 122, *123*, 149, 172, 180, 217

P
Partridge, Alan, 142
Pathe, 15
Press Kit, 190, 243–244
Pride and Prejudice and Zombies, 24–25
Production Book, 102
Production Designer, 108, 112, 122, 126, 133, 137, 144, 169, 253,
Production Manager, 125, 138, 252
Pye-Jeary, Anthony, 91

Q
QC Report, 187

R
The Rag Factory, 20
Real (feature film), *123*
Recoupment Schedule, 80, 85, 86, 91, 93
Release Forms, 128–129
Reno, Jean, 13
Rhys, Nick, 50, *108*, 143
The Rift, 173
Risk to Capital, 88
Ritchie, Keith, *118*
The Rivals, 10–11
Rockefeller Foundation, 75
R.O.I.—Return on Investment, 90
Rose Bruford, 6
Royal Central School of Speech and Drama, 6

S
S.A.G.—Screen Actors Guild, 61, 69, 102
The Script Vault, 48, 194
Screeners, 237, 242, 245
Screen Scotland, 81
Screen International, 24
Seale-Jones, Caspar, 174
S.E.I.S.—Seed Enterprise Investment Scheme, 74, 85–88, 92
The Seven Basic Plots, 25
Sheridan, Richard Brinsley, 11
Shell (feature film), 15

Shot-list, 101
Showtime, 228
Sid and Nancy, 15
Sky Cinema, 226
Soft Money, 21, 56, 72, 74–75, 79–81, 94
Sound Recordist, 141, 251, 259
SPV—Special Purpose Vehicle, 56, 87–88
Staunton, Imelda, 26
Stripboard, 66, 69, 72, *73*
Stocco, Sofia, 144
Storyboards, 101, 120, 160
Sundance, 201, 206
Sutherland, Gil, 20, 50

T
Tautou, Audrey, 13
The Third Man, 18
Top Sheet budget breakdown, *59*, 72, 91
To Tokyo (feature film), 174
TriForce Film Festival, 2
Truffaut, Francois, 17
Tuttle, Tricia, 208, 215
Twitter, 83, 242

Two Down (feature film), *51*, *52*, 68, 92, *108*, *115*, 119, *143*, *144*, *147*, 150–151, 154, 182–*183*, 205–209, 212–213, 225, 231;
artwork, *189*
budget, 90
location, 50, 103, 117, 142
production design, 108
Tyrell, Dickon, *118*

U
U.K. Tax Credit, 72, 74, 76, 85, 87

V
Vile Bodies, 47
Vimeo, 222, 245

W
Wallington, Pete, *121*
Whishaw, Ben, 60
The Witch, 229
Wodehouse, P.G., 16
Writer's Guild of America, 48

Y
YouTube, 17, 222, 245

www.ingramcontent.com/pod-product-compliance
Lightning Source LLC
Chambersburg PA
CBHW051210170526
45166CB00005B/1835